Lee Hammond's big book of DRAWING

INCLUDES COLORED PENCIL!

D0825739

Lee Hammond

NORTH LIGHT BOOKS
CINCINNATI, OHIO
www.artistsnetwork.com

The following artwork appeared in previously published North Light Books (the initial page numbers given refer to the original artwork; numbers in parenthesis refer to pages in this book).

Hammond, Lee. How to Draw Lifelike Portraits from Photographs © 1995. Pages 58-61, 80, 92-95, 112, , (12, 17, 28-29, 33-34, 42-43, 46-47)

Hammond, Lee. Draw Real Animals © 1996. Pages 8, 29-31, 33-34, 36-41, 44-49, 56-57, 64-66, 68, 70-73 (70, 73-79, 84-103)

Hammond, Lee. Draw Real People © 1996. Pages 6, 8, 26-29, 31-34, 36-40, 41-42, 44-48, 51-52, 54-57, 61-62, 64-65, 70-73(4, 16, 18-27, 30-33, 35-41, 44-45, 48-59)

Hammond, Lee. Draw Family & Friends © 1997. Pages 18-19, 52-53, (66-69)

Hammond, Lee. Draw Real Hands © 1997. Pages 18-19, 60-61, 52-53 (60-65)

Hammond, Lee. Drawing in Color: Flowers & Nature © 2000. Pages 24-25, 31, 33, 37-79 (3,190-237)

Hammond, Lee. Drawing in Color: People and Portraits © 2000. Pages 25-26, 29-50, 52-61, 63-64, 66, 71, 76-79 (128-169)

Hammond, Lee. Draw Horses © 2001. Pages 10-11, 13-15, 18-21,24-25, 30-31, 34-35, 48-55, 5, 68 (6-11, 13-15, 71-72, 80-84, 104-113)

Hammond, Lee. Drawing in Color: Birds © 2001. Pages 10-12, 13, 18-25 (114-116, 117-127)

Hammond, Lee. Drawing in Color: Animals © 2002. Pages 2, 30-34, 37-39, 43-48, 55-56, 59, 60, 64, 65, 69 (2, 170-189)

Hammond, Lee. Draw NASCAR © 2004. Page 16 (116)

Other fine North Light Books are available from your local bookstore, art supply store or direct from the publisher.

08 07 06 05 04 5 4 3 2 1

Library of Congress Cataloging in Publication Data
Hammond, Lee.
Lee Hammond's big book of drawing/Lee Hammond. -- 1st ed.
 p. cm.
Includes index.
ISBN 1-58180-473-3 (pbk. : alk. paper)
1. Pencil drawing--Technique. I Title: Big book of drawing. II. Title
NC890.H27 2004
741.2'4--dc22 2003059289

Edited by: Pam Wissman and Bethe Ferguson
Designed by Lisa Buchanan
Production art by Tari Sasser
Production coordinated by Mark Griffin

ABOUT THE AUTHOR

Polly "Lee" Hammond is an illustrator and art instructor from the Kansas City area. She owns and operates a private art studio named Take It To Art,* where she teaches realistic drawing and painting.

Lee was raised and educated in Lincoln, Nebraska, and she established her career in illustration and teaching in Kansas City. Although she has lived all over the country, she will always consider Kansas City home. Lee has been an author with North Light Books since 1994. She also writes and illustrates articles for other publications, such as The Artist's Magazine.

Lee is continuing to develop new art instruction books for North Light and is also expanding her career into illustrating children's books. Fine art and limited edition prints of her work will also soon be offered. Lee resides in Overland Park, Kansas, along with her family. You may contact Lee via e-mail at Pollylee@aol.com or visit her Web site at www.LeeHammond.com. *Take It To Art is a registered trademark for Lee Hammond.

Metric Conversion Chart

To convert	to	multiply by
Inches	Centimeters	2.54
Centimeters	Inches	0.4
Feet	Centimeters	30.5
Centimeters	Feet	0.03
Yards	Meters	0.9
Meters	Yards	1.1
Sq. Inches	Sq. Centimeters	6.45
Sq. Centimeters	Sq. Inches	0.16
Sq. Feet	Sq. Meters	0.09
Sq. Meters	Sq. Feet	10.8
Sq. Yards	Sq. Meters	0.8
Sq. Meters	Sq. Yards	1.2
Pounds	Kilograms	0.45
Kilograms	Pounds	2.2
Ounces	Grams	28.4
Grams	Ounces	0.04

CONTENTS

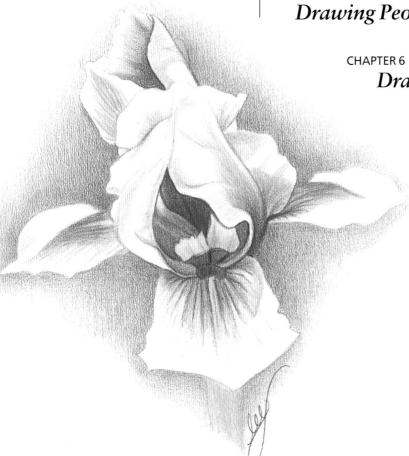

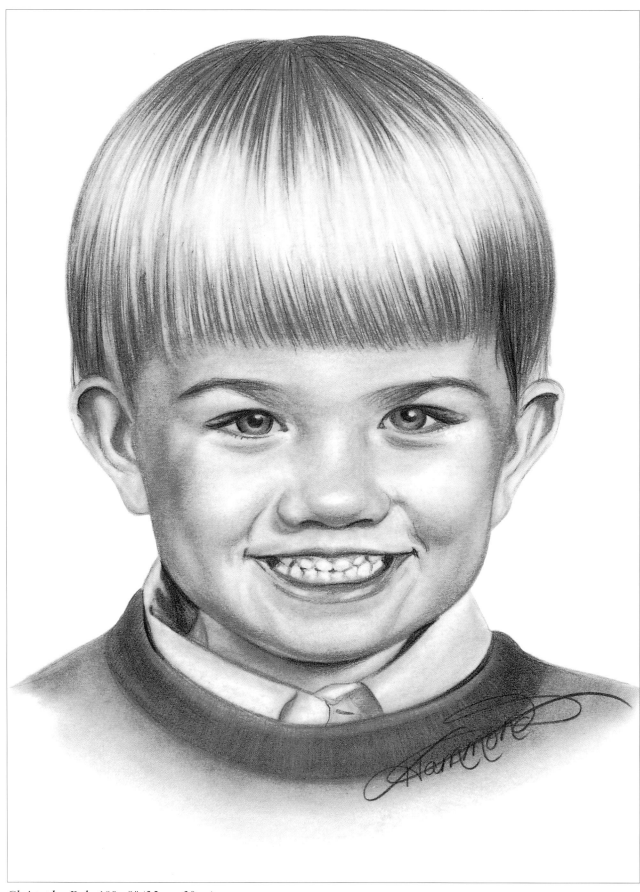

Christopher Dale, 10" × 8" (25cm × 20cm)

You Can Do It!

This is a drawing guide for anyone who wants to create realistic artwork. After working for many years with beginning artists of all ages, I have found that the most common stumbling block is not "What should I draw?" but "How do I make my drawings look real?"

You can create realistic drawings, but first you must learn to change the way you "see" your subject matter. I know it sounds difficult, but it isn't as hard as it sounds. The key is seeing everything you draw as nothing but large and small shapes, all connected together, much like those of a puzzle.

The information in this book will arm you with everything you need to know to teach yourself how to draw realistically. The principles apply to all subject matter you may want to draw in the future.

Practice is the true secret to learning. Each exercise in this book will help you commit certain drawing principles to memory, literally changing the way you see things. This is lifelong information; it's not faddish or trendy. It was there for the Old Masters, and it will be there for as long as people study art.

If you are a young person, you will have a true advantage by studying this information at an early age. If you are an experienced artist, you will be able to verify what you've practiced all along and reach even better results than you've ever had before.

By purchasing this book, you receive a gift—a gift of now knowing how to become a better artist, and what to do to see improvements on a daily basis. With dedication and lots of practice, you, too, can make it look real!

Your ability to make your drawings as polished as the ones in the book may take some time to develop. Don't worry! The improvements you'll see immediately in your work will inspire you. Your drawings may not look like mine right away, but they will be more realistic than anything you have done before, and that alone will keep you trying!

Some of these concepts may be new to you. It will be strange but exciting to make realistic drawings for the first time. I have seen the excitement in my students when they first apply these techniques to their drawings. This is a book to grow with. You, too, can have wonderful results. It is something to work for, a goal. It can be achieved with some regular practice and determination. Have fun!

Materials & Techniques for Working in Black & White

You cannot do quality artwork with inadequate art materials. My blended-pencil technique requires the right tools to create the look. Don't scrimp in this department or your artwork will suffer. I have seen many of my students blame themselves for being untalented when it was their supplies keeping them from doing a good job. The following tools will help you be a better artist.

Smooth Bristol Boards or Sheets—Two-Ply or Heavier
This paper is very smooth (plate finish) and can withstand the rubbing associated with a technique I'll be showing you later in the book.

5mm Mechanical Pencil With 2B Lead
The brand of pencil you buy is not important; however, they all come with HB lead—you'll need to replace that with 2B lead. These pencils are good for fine lines and details.

Blending Tortillions
These are spiral-wound cones of paper. They are not the same as the harder, pencil-shaped stumps, which are pointed at both ends. These are better suited for the blended-pencil technique. Buy both a large and a small.

Kneaded Eraser
These erasers resemble modeling clay and are essential to a blended-pencil drawing. They gently "lift" highlights without ruining the surface of the paper.

Typewriter Eraser With a Brush on the End
These pencil-type erasers are handy due to the pointed tip, which can be sharpened. They are good for cleaning up edges and erasing stubborn marks, but their abrasive nature can rough up your paper. Use them with caution.

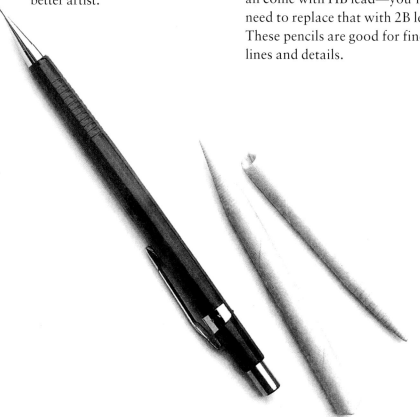

A Mechanical Pencil and Blending Tortillions
Mechanical pencils are great for fine lines and details, and you never have to sharpen them. Tortillions are the secret to my whole technique, so be sure to buy a large and a small tortillion.

Horsehair Drafting Brush
These wonderful brushes will keep you from ruining your work by brushing away erasings with your hand and smearing your pencil work. They will also keep you from spitting on your work when blowing the erasings away.

Pink Pearl Vinyl Eraser
These erasers are meant for erasing large areas and lines. They are soft and nonabrasive, so they won't damage your paper.

Workable Spray Fixative
This is used to seal and protect your finished artwork. "Workable" means you can still draw on an area after it has been sprayed. It fixes, or sets, any area of your drawing, allowing you to darken it by building up layers of tone without disturbing the initial layer.

Drawing Board
It's important to tilt your work toward you as you draw to prevent distortion that occurs when working flat. Secure your paper and reference photo with a clip.

Ruler
Rulers help you measure and graph your drawings.

Acetate Report Covers
Use these covers for making graphed overlays to place over your photo references . They'll help you accurately grid your drawings.

Magazines
These are a valuable source of practice reference material. Collect magazine pictures and categorize them into files for quick reference. A word of warning: Don't copy the exact image. Many photographers hold the copyright for the work, and any duplication without their express permission is illegal.

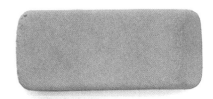

Pink Pearl Vinyl Eraser
This soft eraser is good for large areas and lines, and it won't damage your paper.

Typewriter Eraser
This eraser is good for stubborn marks, but use it with caution. The abrasive nature can damage your paper if you push too hard.

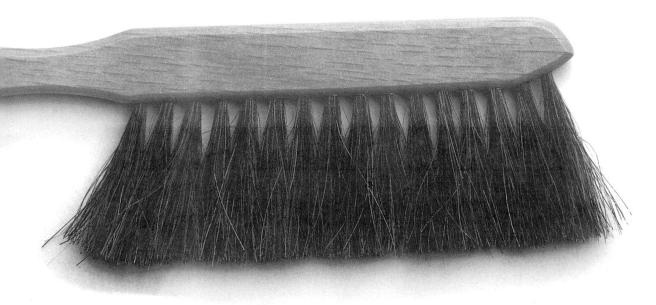

Horsehair Drafting Brush
This is a great brush to clean off any erasings.

BASIC TECHNIQUES: GRAPHING AND SHAPES

In order to apply the principles of blending and shading that you'll learn in this book, you must first have an accurate foundation to build on.

When you draw, everything you look at should be viewed as a collection of interlocking shapes. One shape will lead to another. Try to see the subject not for what it is but more for what it looks like.

It's essential to accurately draw the basic shapes that make up your subject before you begin the blending phase, as it is very difficult to change or alter them once darker tones are in place.

Doing the puzzle exercise below will show you that you can draw anything accurately. It is easy to draw shapes when they don't look like recognizable objects. It is only when you recognize something that drawing its shapes becomes difficult, because you will draw from memory instead of observation.

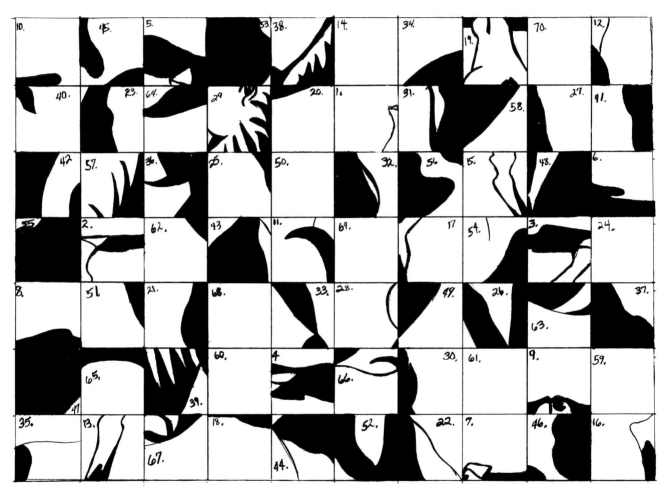

Puzzle Pieces
Begin to train your mind to see all objects as shapes. Here, as you can see, I have divided my subject into a series of unrecognizable shapes. Draw exactly what you see in each box in the corresponding box on the next page.

1	2	3	4	5	6	7	8	9	10
11	12	13	14	15	16	17	18	19	20
21	22	23	24	25	26	27	28	29	30
31	32	33	34	35	36	37	38	39	40
41	42	43	44	45	46	47	48	49	50
51	52	53	54	55	56	57	58	59	60
61	62	63	64	65	66	67	68	69	70

Put the Puzzle Back Together

This puzzle exercise may seem a bit juvenile at first, but it is an excellent chance to practice drawing shapes. Each one of the boxes has a number and a shape drawn in it, but none of the individual shapes clearly resemble anything in particular. Draw the shapes in each box in the corresponding numbered box. Do not try to figure out what you are drawing. This will only cause you to start drawing from memory without even knowing it. Just draw what you see as accurately as possible. When you are finished with this puzzle, turn your work upside down to see what it is.

GRAPHING EXERCISE

You can break down anything you see into the same type of puzzle by placing an acetate grid over a photograph. This technique is also referred to as mapping. You can also copy the photo and draw your grid on the copy. By studying the shapes in each individual box, the image becomes more abstract. You can further your objectivity by turning the photo upside down, which will make it even more unrecognizable.

With your pencil and a ruler, very lightly draw a graph with the same number of squares on your drawing paper. It is important to draw very lightly, as these lines will need to be erased later on. Use the same size squares as the grid you drew over the photo in order to make your drawing the same size. If you want to make the drawing a bit bigger, simply use larger squares on your drawing paper.

If you draw the shapes inside the boxes accurately, all of the lines will connect properly and create the desired shapes. Be sure to get everything, including shadows and highlights—these areas should be viewed as shapes also.

When you are finished and you're sure that you have drawn as accurately as possible, gently and carefully remove your grid lines. Do not erase your line drawing! Be sure to save the drawing you create during this exercise for a demonstration later in the book.

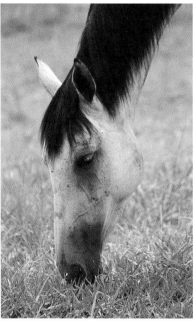

Reference Photo
This is a beautiful photo of a horse. The size of the face and the lighting make it a perfect candidate for drawing.

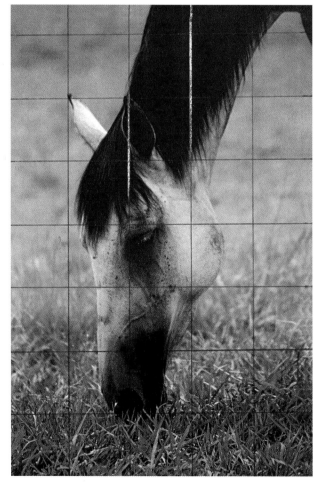

Create the Grid
By placing a grid over the photo, you can create the same puzzlelike exercise as the one on the previous pages. Turn the photo upside down as you work to be sure you draw what you see and not what you remember.

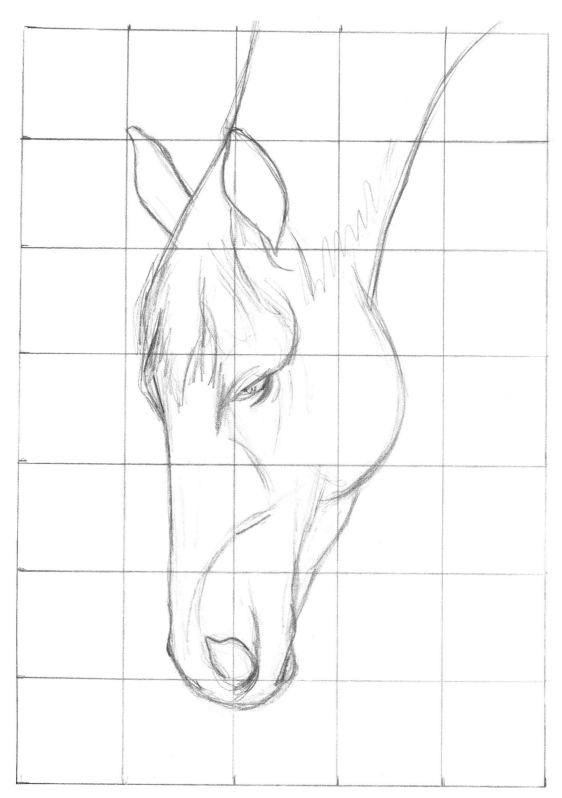

An Accurate Line Drawing

Use the photos on the opposite page to help you create an accurate line drawing. Don't try to draw the horse right away. Focus on drawing the shapes within each box. The image of the horse will slowly begin to appear.

CREATE THE APPEARANCE OF DIMENSION WITH SHADING

You cannot create a realistic drawing using only outlines. The key to realistic drawing lies not only in the accuracy of shapes but also in the appearance of dimension achieved through shading. It's critical to train yourself to see the effects of light on your subject matter and strive to replicate that with careful placement of light and shadows on your line drawing.

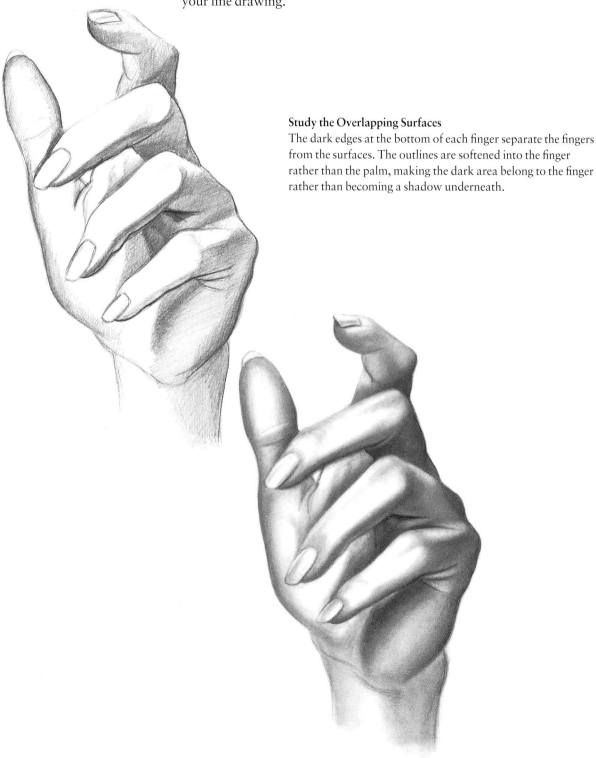

Study the Overlapping Surfaces
The dark edges at the bottom of each finger separate the fingers from the surfaces. The outlines are softened into the finger rather than the palm, making the dark area belong to the finger rather than becoming a shadow underneath.

THE FIVE ELEMENTS OF SHADING

To draw realistically, you must fully understand how lighting affects an object. There are five elements of shading that are essential to realistically depicting an object's form. With any of these elements missing, your work will appear flat.

1. Cast Shadow
This is the darkest tone found on your drawing. It is always opposite the light source. In the case of the sphere, it is found underneath where the sphere meets the paper. This area is void of light because, as the sphere protrudes, it blocks light and casts a shadow.

2. Shadow Edge
This dark gray tone can be found in the area called the shadow edge. This area is where the sphere is turning back away from you.

3. Halftone
This is a midgray. It's the area of the sphere that's in neither direct light nor shadows.

4. Reflected Light
This is a light gray. Reflected light is always found along the edge of an object and separates the darkness of the shadow edge from the darkness of the cast shadow.

5. Full Light
This is the white area, and it's the strongest point where the light source is hitting the sphere.

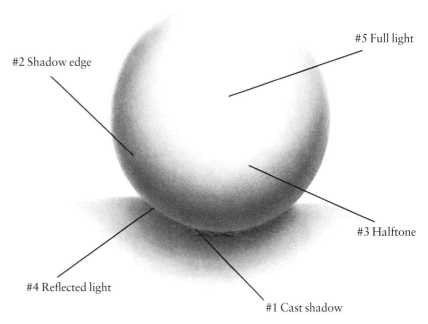

Five Elements of Shading
Look at this sphere and observe the five elements of shading.

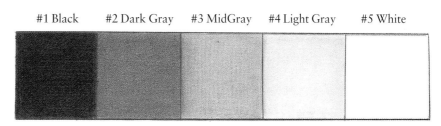

#1 Black	#2 Dark Gray	#3 MidGray	#4 Light Gray	#5 White

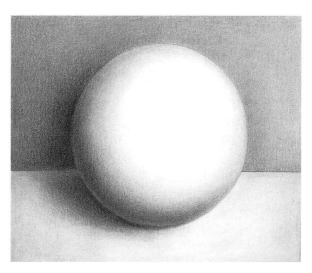

Contrasting Edges Indicate Shading
In order to indicate a light edge of an object, you must place it against a dark background. As you can see in the sphere above, the darker background makes the entire drawing seem less intense. The tones of the sphere seem subtler in contrast. Notice how there is no discernable outline around the sphere. All you see is tone against tone, which creates the edges.

USE BLENDING FOR SMOOTH, EVEN TONES

To create smooth blending, you must first learn to use your tools and apply the pencil lines properly. If the pencil lines are rough and uneven, no amount of blending will smooth them out. Take a look at the examples below. The sample on the left shows poor pencil application. Notice how the scribbled lines look sloppy.

In the sample to the right you can see how the lines are blended very close together, making it almost impossible to see the white areas between them. Try this technique yourself!

First, apply the lines closely, and in an up-and-down fashion, fill in the pencil lines. Add tone until you build up a deep black, and then lighten your touch and gradually

get lighter as you move to the right. By going back and forth, overlapping your tones, you will make it look gradual. You do not want to see where one tone ends and the next begins.

When you've finished applying the pencil, blend your values out with a tortillion. Use the same up-and-down, back-and-forth motion you used with your pencil. Lighten your touch as you move right, and gently blend the light area into the white of the paper until you can no longer tell where it ends.

If choppiness appears in your blending, you can use some tricks to correct them. First, squint your eyes. This helps blur your vision and allows you to see the imperfections by making the tones seem more

intense. The dark areas will appear darker; the light areas, lighter.

Should you see any unwanted dark spots in the drawing, take a piece of kneaded eraser and roll it between your thumb and forefinger to create a point. Gently lift the dark spot out by stroking it lightly. Never dab at it; that will make it uneven. This is not really erasing but drawing in reverse. It is a controlled technique of adding light.

After you are done lifting dark spots, squint your eyes once again. Look for light areas that are too light. Gently fill them in with your pencil. Your blending should now be smooth and gradual. Don't be discouraged if it doesn't come easy for you the first time. I make my students practice this over and over.

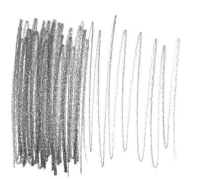

Incorrectly Drawn Tones
The scribbled application of pencil lines makes this impossible to blend out evenly.

Correctly Blended Tones
From dark to light, this is smooth and even in its tones.

What Is a Tortillion?
A tortillion is nothing more than paper wrapped into a cone shape. Never use the tortillion on its tip. This will cause it to collapse. If the tip does become blunt, straighten out a large paper clip and gently stick it into the other end to push the point back out.

Hold It at an Angle
This is the proper angle for using the tortillion.

Practice Blending a Sphere

Blending is one of the key steps in creating realistic drawings. You will be using this technique for every demonstration in this book. Start off on the right foot by practicing blending on this simple sphere.

PENCILS USED

Use either an Ebony pencil or a graphite pencil.

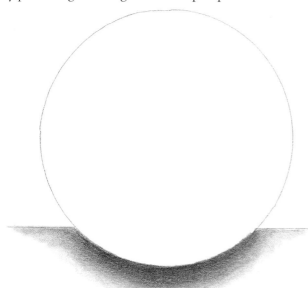

Step 1: Apply the Cast Shadow

Begin drawing the sphere by first tracing a perfect circle. Apply the darkest tone to the cast shadow area below it. Can you see how this creates the illusion of a tabletop?

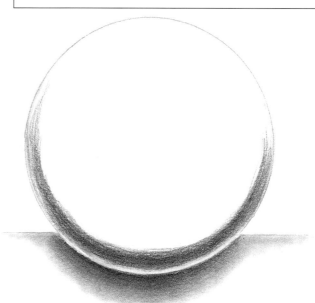

Step 2: Apply the Shadow Edge

Apply a dark gray tone to the shadow edge area. Be sure to make it parallel to the edge of the circle.

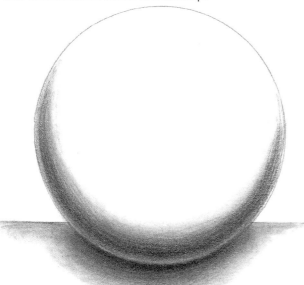

Step 3: Blend the Tones

Gently blend the tones with the tortillion, going "with" the shape, until they fade into the full light area of the sphere.

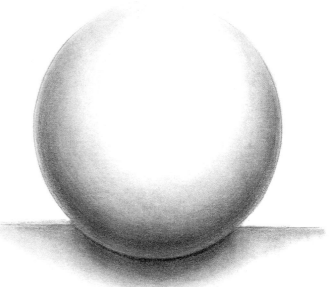

Step 4: Finishing Touches

Continue to add tones and blend until your sphere looks like the one above. Squint your eyes and look at your drawing. If there are any imperfections in the blending, use your tools to correct them.

Drawing People in Black & White

What makes a good portrait? It is more than just how a person looks. It has a lot to do with the "lighting" or contrasts. (Contrast is light areas showing up against dark areas.)

Look for photographs that have one dark side and one light side. This gives you shadows to draw and gives the artwork more interest. Front lighting, which lights up the whole face, can be nice too, if there are plenty of dark areas next to and below the face. Contrast is very important.

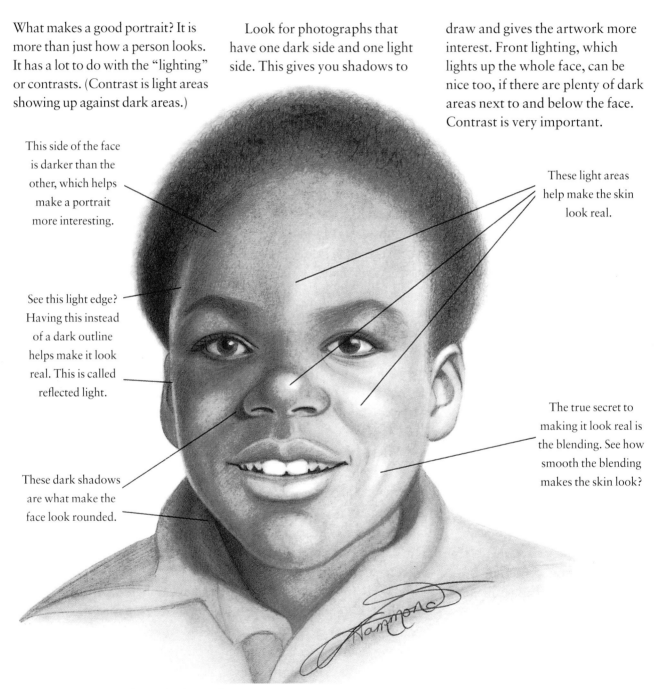

This side of the face is darker than the other, which helps make a portrait more interesting.

These light areas help make the skin look real.

See this light edge? Having this instead of a dark outline helps make it look real. This is called reflected light.

These dark shadows are what make the face look rounded.

The true secret to making it look real is the blending. See how smooth the blending makes the skin look?

Contrasts Help Create the Look of a Good Portrait
In this example, I have pointed out certain things to look for when choosing a reference photograph. Look for a photo that has contrasting light and dark sides, which will add interest to your drawing. Your artwork can be only as good as the photo you select.

CORRECT FEATURE PLACEMENT

In these illustrations you can see that the face and head can be divided into sections. Line 2 marks the halfway point on the head—from the top of the skull (line 3) to the bottom of the chin (line 1). Students are often surprised to see the eyes as the midway point and want to place the eyes too high. There is the same amount of distance between the top of the head and the eyes as there is from the eyes to the chin.

Line 4 is the halfway point between the eyebrows (line 5) and the chin (line 1). There is the same amount of distance between the eyebrows and the base of the nose as there is from the base of the nose to the chin. You can also see how the ears line up between lines 5 and 4.

The dotted vertical lines show the relationship of the eyes to the nose, mouth and chin.

Now study the profile at right. The vertical line through the ear represents the halfway point between the back of the head and the cheekbone. There is the same amount of distance between the back of the head and the ear as there is between the ear and the front of the cheekbone.

The vertical line in front of the eye shows that even in profile, the middle of the eye lines up with the corner of the mouth. The slanted lines show the angles of the ear, eye, neck and lips.

The back of the head is really much shorter from top to bottom than the front. If you draw a line back from the bottom of the nose and the ear, that is where the base of the skull meets the neck. The neck is not vertical but tilts forward.

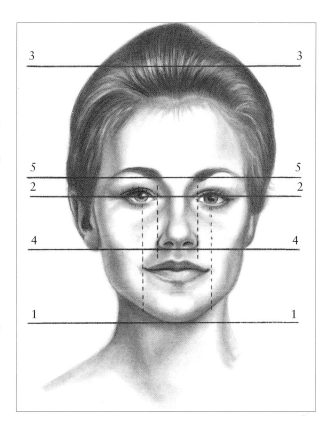

Placement and Proportion Are Key
Accurate proportions and proper placement of features are essential to creating a realistic portrait. Study these two illustrations to help you better gauge the features for your drawings.

SHADE THE FACE

Compare the shading on this face with that of the ball below. They are very similar, don't you think? Faces and heads are very round, so all of the same principles of shading round shapes apply. It is the lighting and shadows that make this face look real. If you removed the eyes, nose and mouth, you'd have a sphere!

Remember, it is the light that creates the shadows. The shadows will change depending on where the light is coming from. These three examples show how different the face looks when the light is coming from various directions. Always pick photos with interesting lighting to work from.

Seek Out the Shading Elements
Look for the five elements of shading on this face. Without them, the face would not have its rounded appearance.

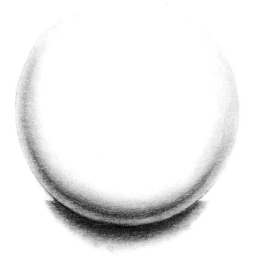

The Shaded Sphere
A solid understanding of the sphere will help you draw rounded objects realistically!

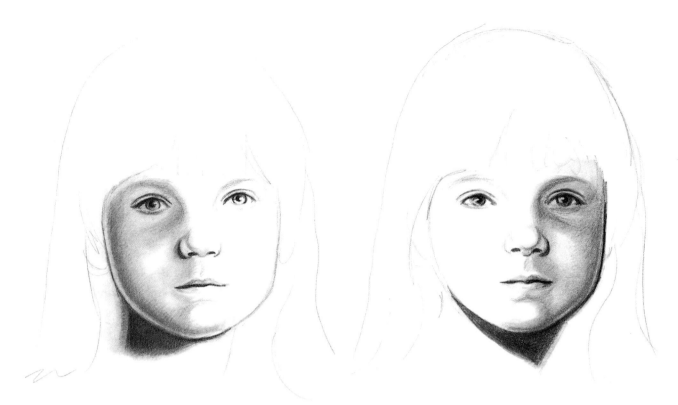

Light Coming From the Right
Here you can see how the direction of the light causes the right side of her face to be in full light and, therefore, containing the lightest tones and highlights. Her left side is in shadow, containing the dark tones and cast shadow.

Light Coming From the Left
Once the direction of the light changed, the light and dark sides switched positions.

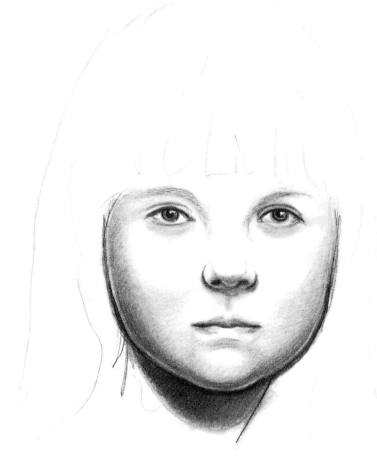

Light Coming From the Upper Front
The lighting is more even in this example. You still clearly see the difference between the light and dark areas, and they are more evenly spread across the face.

STUDY THE NOSE

The nose may seem like a funny place to start when learning to draw the face, but it is so much like a sphere that you will soon see why I do it this way.

Magazines or your family photo albums are ideal resources for reference pictures. Each picture will be different, so study it carefully. Look at each pose and see how the direction of the face changes the way the nose and other features look. Also, notice how the skin tone and lighting are different for each one.

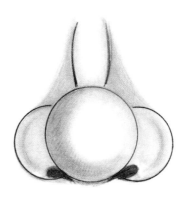

Break the Nose Down Into Three Spheres
The nose is really like three spheres hooked together, one in front with one attached to each side. Although this drawing doesn't look exactly like a nose, it shows how the nose can be seen as shapes.

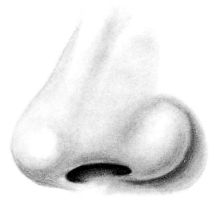

Light Shining from the Left
The light is coming from the left causing the right side of the nose to be in the shadows.

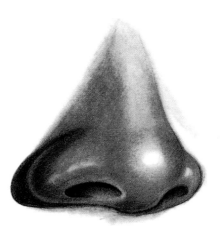

Light Shining from the Right
The light is coming from the right causing the left side of the face to be in shadows.

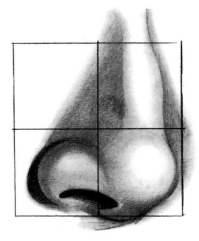

Light Shining from the Front
The light is coming from the front. Notice how the bridge of the nose has the lightest tones and highlights.

Draw the Nose

Use your graphs and practice drawing a variety of noses. Remember to use the same shading elements as for the sphere.

PENCILS USED

Use either an Ebony pencil or a graphite pencil.

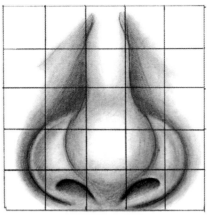

Reference Image
This nose is similar in shape to the one on the previous page, but I changed it a little bit to make its shape look more real.

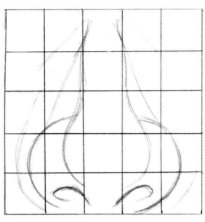

Step 1: Graph the Nose

Draw a grid with ½-inch (12mm) squares on your drawing paper. It should have five boxes across and five boxes down. Complete the line drawing of the nose. The graph helps you see the nose as just shapes. It is important to see all the various little shapes that make up this drawing.

#1 #2 #3 #4 #5

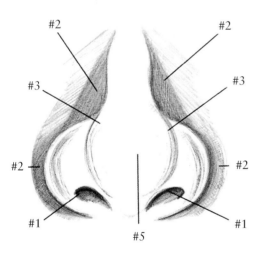

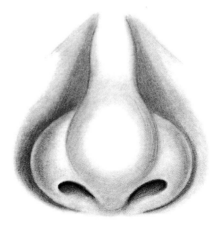

Step 2: Remove the Graph and Begin Shading

Once you are sure your line drawing looks correct and is accurate in its shape, erase your graph lines.

Start by applying dark and medium tones with your pencil. Look at how the tones are numbered to match the five-box value scale above. You must see the tones as shapes, too.

Step 3: Blend the Tones

Blending creates your halftones (#3) and light gray areas (#4). Be sure to blend around the curves as you did with the sphere.

FOLLOW THE LINES OF THE MOUTH

When drawing a mouth, remember these guidelines:

- The top lip is usually darker than the bottom one.
- The bottom lip has highlights.
- There are light shadows all around the mouth.
- Never draw an outline around the mouth.

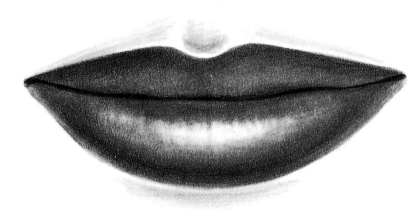

Look for the Highlight
See the bright highlight? It makes this mouth look moist.

The Basic Shape
The top shape of the upper lip looks kind of like a squashed M. The little space between the nose and the mouth resembles a U.

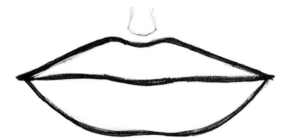

Never Outline to Indicate Form
Never draw a hard line all around the lips like this! These lips look like a cartoon. Women's lips will sometimes appear darker, and the outline may be more pronounced due to makeup, but be sure to soften it out to an "edge," not a bold line.

Look at the line between the lips. It's very irregular; in some places it looks thick and fat, and in others it seems very thin. Each corner of the mouth resembles a comma, or a tear shape. This is called the "pit." This is a very important thing to include in your drawing, because it makes the mouth look realistic, not flat and pasted on the front of the face.

Draw With Shadows
Sometimes lips are very light in color. These lips were drawn not with lines, but with shadows above and below. Except for the line between the lips, I drew this mouth with a used tortillion.

Draw a Closed Mouth

It is easier to draw the mouth with the lips together so you don't have to deal with the teeth. Follow this step-by-step guide to make these lips look real.

PENCILS USED

Use either an Ebony pencil or a graphite pencil.

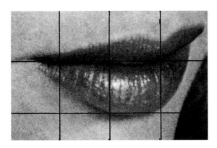

Reference Photo
Study the placement of this mouth inside the boxes. Notice that the mouth is somewhat turned, facing the right. This means you see less of the right side and more of the left.

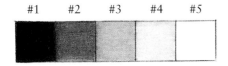

| #1 | #2 | #3 | #4 | #5 |

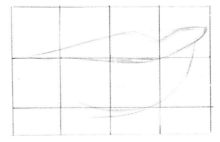

Step 1: Draw the Mouth

Draw the mouth using the grid lines as a guide. See how one vertical line of the graph cuts through the center of the upper lip? Your memory will want to draw the entire mouth with that in the center, not off to the right. Always draw what you see in front of you! Graphs will keep the shapes where they belong.

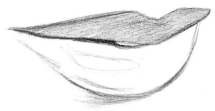

Step 2: Draw the Mouth

Erase your graph, and apply #1 dark to the line in between the lips and where the lips part inside the left corner. Apply #2 dark gray to the upper lip and below the lower lip.

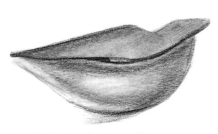

Step 3: Darken the Lower Lip

Apply #3 halftone gray to the lower lip, leaving a spot for the highlight. Darken the right side of the lower lip to more of a #2 (refer to photo above). Blend until smooth!

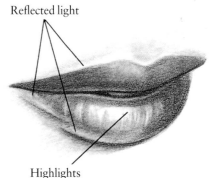

Reflected light

Highlights

Step 4: Finishing Touches

Pull out highlights with the kneaded eraser. Add shading above and below the mouth. Notice the light edge around the lips? This is reflected light.

Draw an Open Mouth

Drawing an open mouth can be intimidating at first, but using a grid will help you simplify all of the basic shapes. Once you have the drawing down, it's really all a matter of shading.

PENCILS USED

Use either an Ebony pencil or a graphite pencil.

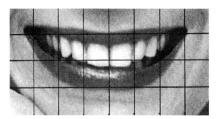

Reference Photo
I used a smaller graph with this one. This is helpful for placing the teeth. Each tooth has to be the right size, the right shape and in the right spot.

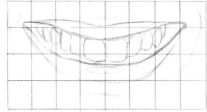

#1	#2	#3	#4	#5

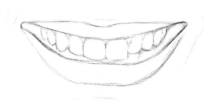

Step 1: Graph the Mouth

Draw the mouth using the grid. Watch your shapes! (Remember these aren't really teeth after all; they are little shapes that go together to look like what's inside a mouth.)

Step 2: Study the Drawing

Remove the grid and look at the line drawing. Can you see the little shapes that are between the teeth? Can you see the little triangular shapes created by the gums? These shapes will help you get the form of each tooth. Also, don't ever draw a dark line between each tooth. This makes them look like corn on the cob or piano keys.

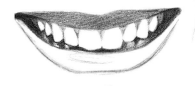

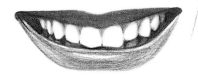

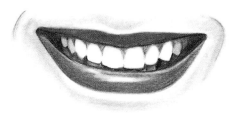

Step 3: Begin to Shade

Darken the inside corners of the mouth (#1) tone and under the teeth. Look for the small shapes of the bottom teeth. Even though they are hard to see, they are important. Apply #2 tone to the upper lip. With a dirty tortillion, put some blending into the gums. Blend below the teeth.

Step 4: Blend the Upper Lip

Blend the upper lip until it is smooth. Apply #2 tone to the lower lip, leaving reflected light around the edge and the highlight in the center.

Step 5: Blend the Lower Lip

Blend out the lower lip. Don't worry if you go into the highlight area. You can use the kneaded eraser to lighten the highlight to make it look shiny. Take a dirty tortillion and apply shading around the mouth where you see it.

Draw the Nose and Mouth Together

Now that you know how to draw the nose and mouth, why not try to put them together? Take your time and you'll be amazed at how easy it all comes together!

PENCILS USED

Use either an Ebony pencil or a graphite pencil.

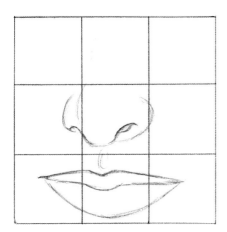

Step 1: Line Drawing

Using grid lines to help you place the features, copy this simple line drawing for the following step-by-step demonstration. Use the value scale on the opposite page.

Dark areas #1

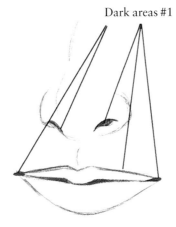

Step 2: Begin the Dark Areas

Add the dark areas to your line drawing (#1 on the value scale).

Dark areas #2

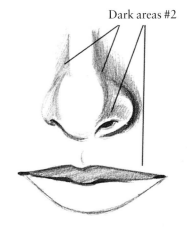

Step 3: Add the Shadow Areas

Add the gray areas of shadow (#2 on the value scale).

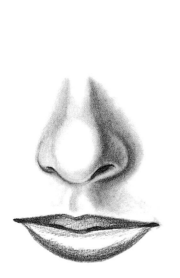

Step 4: Blend the Nose

Blend out the entire nose and down to the upper lip. Add more darks (#1) to the lip areas.

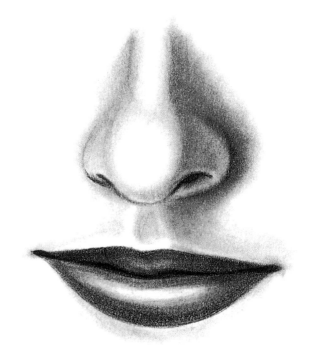

Step 5: Blend the Lips

Blend out the lips to finish. Lift out the highlight to make the lip shine.

THE EYES HAVE IT

Eyes are beautiful! They are my favorite things to draw. An entire drawing can be made around a single eye. In the drawings on this page you can see the eye is just shapes. An eye looks more like puzzle pieces than any of the other feature. I have numbered the pieces below to help you see the various parts that make up the eye.

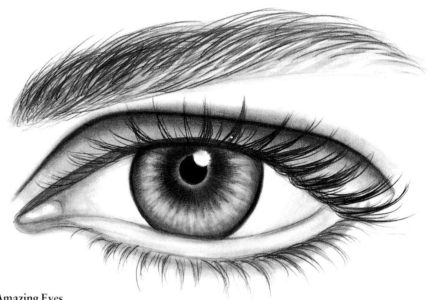

Amazing Eyes
We've all heard that eyes are the windows to the soul, and I just think they are some of the most wonderful things to draw.

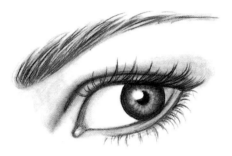

See the Eye From a Different Angle
See how this eye is looking at you from an angle? Because it is turned, you see a lot of the white of the eye on the left of the iris and hardly any on the right. Also, see the lower lid thickness below the iris? Notice that eyelashes on the bottom come off the lower line, not the one next to the eye.

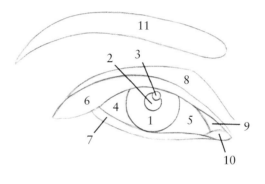

Break Down the Eye
This line drawing of the eye is made up of the shapes shown below. Try not to look at the eye as one difficult shape, but instead as eleven easy shapes.
1. Iris
2. Pupil
3. Catchlight (or flash)
4. and 5. White of the eye
6. Upper lash line
7. Lower lid thickness
8. Upper eyelid
9. and 10. Corner eye membrane
11. Eyebrow

NOTE

You will notice that the "catchlight," or flash, is half in the pupil and half in the iris. No matter how many catchlights you see in your photo, your drawing will look better if you only use one in each eye. This time, I stress *not* drawing what you see. (Artistic license!)

"EYE DO" (AND DON'T!)

Here are some guidelines to remember when drawing the two eyes together:

- The distance between the eyes is equal to one eye width.
- Draw a line down from the inside corner of each eye and you usually have the width of the nose. (This is a general rule and doesn't always apply.)
- Draw a line down from the center of the eye and you will usually have the outside corner of the mouth (that is, with no smile).
- Eyes are in the middle of the head (see page 35). Don't draw them too high! If you measure from the chin to the eyes, you will find the same distance from the eyes to the top of the head.

This is a list of what *not* to do when drawing eyes:

- Don't outline the eyes.
- Don't make eyelashes hard and straight.
- Don't scribble in the eyebrows. Watch those shapes!
- Don't draw the round iris and pupil. Use your stencil.
- Don't forget the catchlights (these eyes don't have any).
- Don't have the eyes looking in two different directions. The two eyes work together.
- Don't let your blending get rough and uneven. Remember: smooth and gradual.

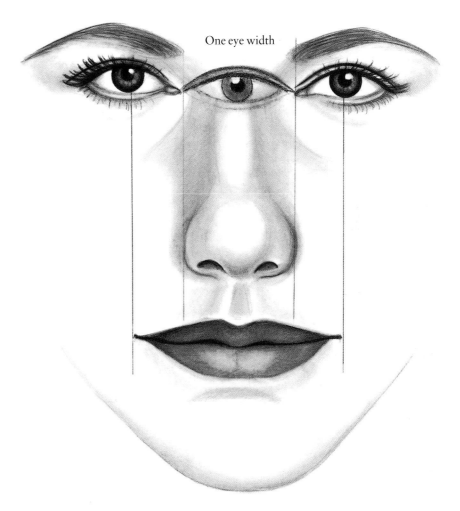

One eye width

Example of Well-Drawn Eyes
Following the guidelines on this page will help you create a realistic-looking face. Look back on pages 20-28 for information on the individual features.

SHAPE THE EYELIDS

The lens of the eye creates a bulge where it protrudes. This bulge can be seen when the light reflects off of the eyelid.

On these examples, notice how the shape of the eye is clearly evident beneath the eyelids. Whenever a surface protrudes farther than the rest of the object, the light will be stronger there. Practice drawing these examples, keeping in mind the shape of the eyeball itself and how it is creating the shape of the eyelid.

Take your graph and lay it over these illustrations for practice. Apply the five elements of shading, and practice judging your tones referring to your five-box value scale (see page 13). Go through magazines and your own photos and study the eyes in various poses. See if you can identify where the lens is catching the light and causing a highlight on the eyelid.

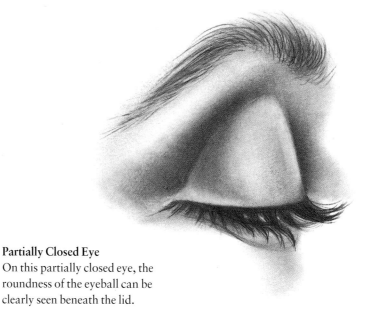

Partially Closed Eye
On this partially closed eye, the roundness of the eyeball can be clearly seen beneath the lid.

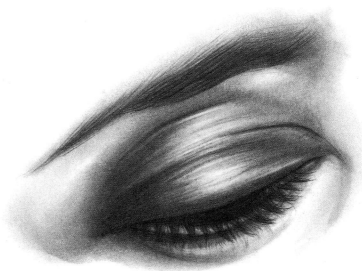

Look for the Areas of Reflected Light
Light is reflected where the lens of the eye stretches the eyelid.

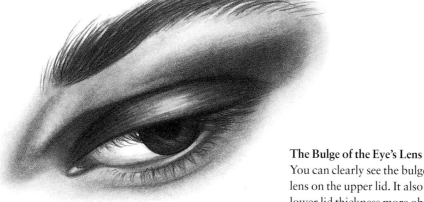

The Bulge of the Eye's Lens
You can clearly see the bulge of the eye's lens on the upper lid. It also makes the lower lid thickness more obvious.

MASTER THE ANGLE OF THE EYE

By looking at a side view of the eye, you can see how different our guidelines become. The iris, which will usually dominate the eye, can no longer be seen well. Also, the catchlight appears more like a streak than a spot or circle. The lens area where the eye bulges is almost clear and allows light to pass through it. The overall shape of the eyeball itself is very pronounced beneath the eyelids.

When the face is seen from the side, only one eye will be visible.

The bridge of the nose will completely block the view of the eye on the other side. Notice how the eyebrow protrudes due to the brow bone.

The upper eyelid protrudes farther than the lower one, as can be seen in all three of these illustrations. There is an approximately 30° angle created by the way the eyeball sits inside the bony structure of the face. Always keep this angle in mind when drawing a profile.

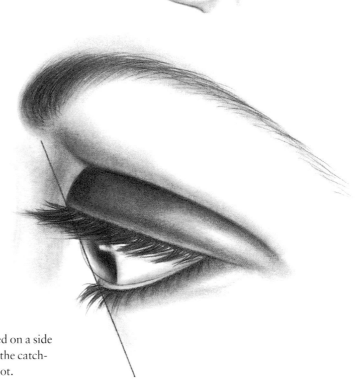

Watch for the Bridge of the Nose
The bridge of the nose blocks the view of the other eye. Most people do not realize how far back the eye sits in the face.

The iris no longer looks like a full circle; it is now a circle in perspective, which is called an ellipse.

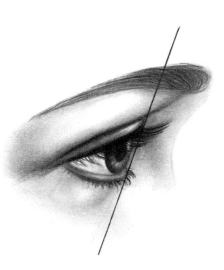

The Upper Lid Protrudes
The upper lid protrudes more than the lower lid, creating approximately a 30° angle.

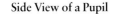

Side View of a Pupil
The pupil and iris are distorted on a side view. The lens is "clear," and the catchlight is no longer a circular spot.

TELL A STORY WITH THE EYES

It's no wonder people say that the eyes are the windows to the soul. You can tell a lot about people by just looking into their eyes.

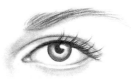
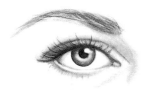

Defining Characteristics of Women's Eyes
Women's eyebrows usually have more of an arch to them. The eyelashes seem longer and darker, especially if they're wearing mascara.

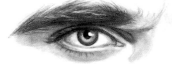
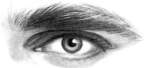

Male vs. Female
It is easy to see which eyes are male and which are female. Men's eyes differ mostly in the eyebrows, which are usually larger and closer to the eyes. See how these actually come down over the eyelids? Also, the eyelashes aren't as obvious.

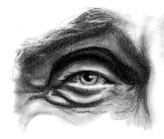
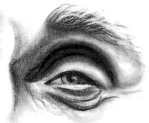

Signs of Age Are Apparent Around the Eyes
You can also get an indication about the age of a person by looking at the eyes. Notice the wrinkles and creases around the eyes, especially at the corners.

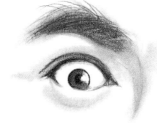
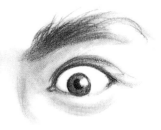

Emotions Are Evident With the Eyes
Eyes can tell you a lot about people, such as what emotion they are feeling. Here, the eyes are wide with either shock or anger.

EYEBROWS AND LASHES

No eye would be complete without eyebrows or lashes. The key to making them looks real is to make each stroke look like soft, individual hairs, not harsh lines.

Never Use Hard Lines for the Eyebrows
The line on the left looks hard and straight. The line on the right is softer and curved. It was drawn with a quick stroke. Flick your wrist and the line will become thinner on the end.

Follow the Direction of the Hairs
Eyebrows can be large or small, thick or thin. Just draw the overall shape first, then start to apply little hairs. Look at the direction they are growing in the picture and apply your pencil lines in that direction. Never just fill in the eyebrow with heavy dark pencil lines.

Fill In the Hairs and Blend
Continue to draw hairs until they start to fill in, and then take your tortillion and blend the whole thing out.

Darken As Necessary and Add Highlights
Add hair strokes again, until it gets as dark as you want it. To soften it a bit, make your kneaded eraser into a point, and with the same quick strokes, lift some light hairs out. It is this finishing touch that really helps make it look real.

Never Use Harsh Lines
Eyelashes should not be drawn with hard lines either. These lines are much too hard and straight.

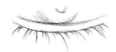

Draw the Eyelashes in Clumps
Eyelashes grow in clumps and are drawn with curving, tapered lines.

Don't Outline the Lower Lashes
Don't ever draw a line all around the eye with lower lashes like this.

Draw the Lower Lashes
This is what lower lashes should look like. They come off the bottom of the lower lid thickness and are shorter than the upper lashes. See how some of them are shorter than others? They, too, grow in bunches.

Draw the Eye

Now it's time to put all the lessons together. Be sure to use long, tapered lines for the eyelashes and eyebrows.

PENCILS USED

Use either an Ebony pencil or a graphite pencil.

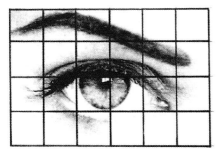

Reference Photo
Use this reference photo for the following demonstration.

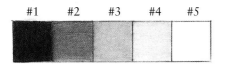

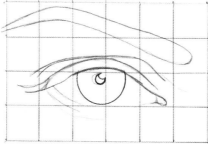

Step 1: Graph the Eye

Draw the eye on your graph paper. Not only do you need to see the eye as shapes, you need to see the shapes created within the graph lines. The iris and the pupil are perfect circles in nature. Drawing these incorrectly can make the eyes look odd. This is where you will use your circle template or stencil.

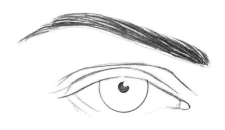

Step 2: Head

Remove the graph. Use a stencil to crisp up the circles. If you are drawing two eyes, remember to use the same circle for both eyes. The catchlight should be placed half in the pupil and half in the iris.

Start to fill the eyebrow with pencil strokes and darken the pupil.

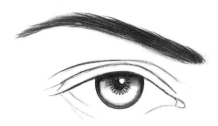

Step 3: Darken the Iris and Pupil

Add some dark tones (#1) around the outside edge of the iris and around the pupil.

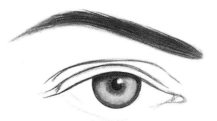

Step 4: Blend and Lift Out Highlights

Blend out the eyebrow and the iris until the iris is a #3 halftone. Don't lose your catchlight! Lift some light out of the iris with your kneaded eraser to make it look shiny and enlarge the catchlight. Finally, fill in the lash line with #1 and #2 tones. (It is lighter in the middle above the iris.)

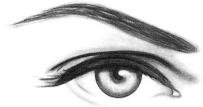

Step 5: Finishing Touches

Blend some tone above the eye. Soften the lower lid thickness. Blend a little into the white of the eye to make the eye look round. Pull some light hairs out of the eyebrows. This eye doesn't have many eyelashes showing, just a few coming off the sides.

Take a Closer Look at the Eye

Because the eye has many more details than the rest of the facial features, I have used the ½-inch (1cm) graph to isolate the shapes more effectively.

> **PENCILS USED**
>
> Use either an Ebony pencil or a graphite pencil.

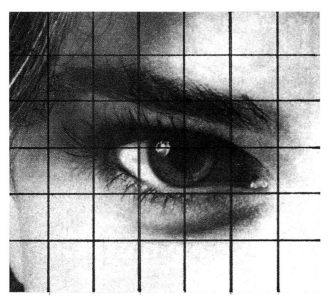

Reference Photo
A ½-inch (1cm) graph will help isolate the shapes and make them easier to draw.

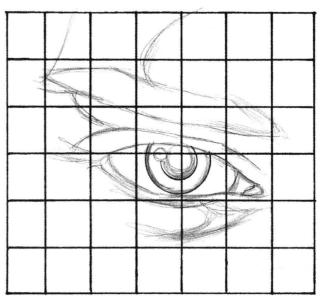

Step 1: Begin to Graph the Basic Shapes

Start with the iris. Freehand it in for placement, and then trace around a circle template to make it perfectly round. The iris is one of the only perfect circles in nature and should be drawn accordingly.

Using your template again, draw in the pupil. This, too, is a perfect circle, and is always centered in the iris! Place your catchlight, which is the flash reflecting off of the eye, half in the pupil and half in the iris. If your reference photo shows more than one, eliminate all but one.

Once these circular shapes have been placed, draw in the rest of the surrounding shapes. Let their placement inside the graph guide you. Be sure that all of the shapes are correct before you erase your graph lines.

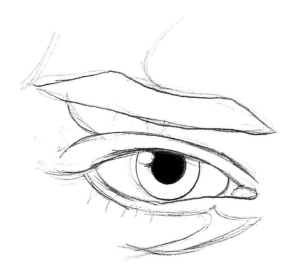

Step 2: Complete an Accurate Line Drawing

In this line drawing, notice how the shadow shape under the eye has been drawn in. Also, look at the area below the iris. The shape of the lower eyelid has thickness to it, and the bottom of the eye isn't just outlined. Look at someone's eye right now, and you will see this detail. It is an extremely important element and is almost always left out in beginners' drawings.

Step 3: Develop the Patterns in the Eye

Start to develop the patterns in the eye and the shadows both around the eye and on the eyeball. Don't forget your catchlight. Fill in the eyebrow as a solid tone for now, and do the same with the lash line. Individual hairs come later.

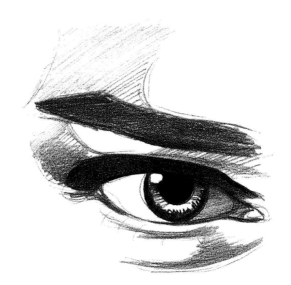

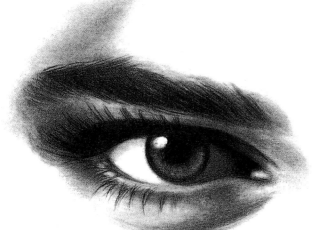

Step 4: Blend the Tones

Create the roundness of the eye by blending the tones. They should be very gradual and smooth. This is when the lashes are put in. Apply them as clumps, not single hairs. Use quick strokes, tapering the line at the end. The bottom lashes are much smaller and thinner, but are still in groups. The eyebrows are also made up of tapered pencil lines, following the growth of the hair. Unlike the lashes, they are gently blended out.

THE EARS

See how the ears fit together with the rest of the features? Like the other features, there is a formula for their placement to remember.

The top of the ear is directly across from the bottom of the eyebrow. The bottom of the ear is directly across from the bottom of the nose. When seen from the side, the ear is about in the middle, between the back of the head and the front of the eyes.

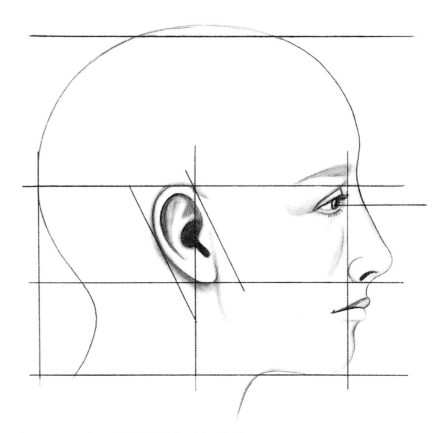

The Eyes Are Always in the Middle of the Head
See the line coming out from the eye? If you measure from the bottom of the chin up to this line, you will find that the distance from the top of the head down to the eyes is the same. The eyes are really in the middle of your head! In all of the portraits in this book, you will be able to see that this is true.

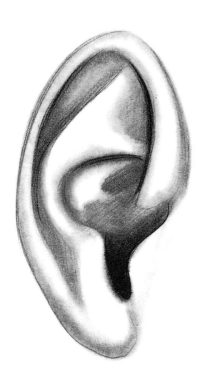

The Ear Has Many Little Shapes
The ear has a lot of light and dark areas, doesn't it? It is also full of different shapes, some inside the others. But this is good, because it is easier to see the ear as puzzle pieces that way.

PUTTING THE EARS WHERE THEY BELONG

This illustration shows how the face area is divided into equal parts (from chin to hairline). The eyes and ears are in the middle section. In many portraits, the face is looking straight ahead, so the ears are at an angle—you can't really see them entirely.

A Typical View of the Ears
This is how you will usually see the ears in a drawing, although most of the ears are covered by hair. Look through magazine pictures and draw as many different ears as you can find.

Hairline

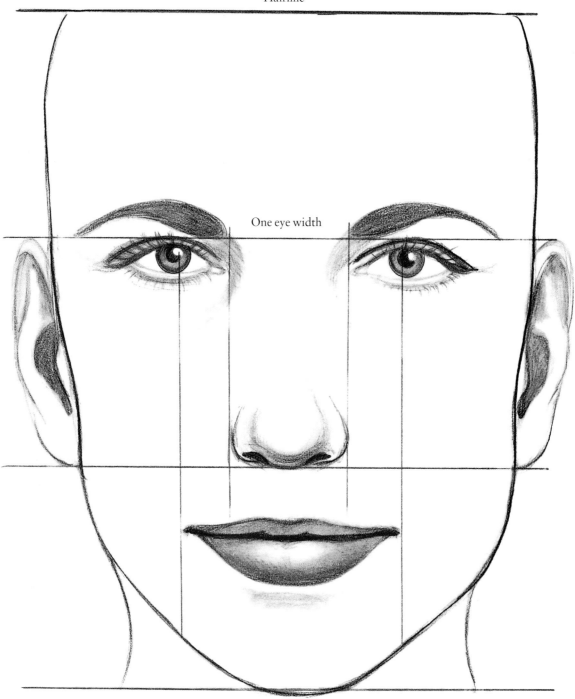

One eye width

LEE HAMMOND'S BIG BOOK OF DRAWING

Draw the Ear

Let's try an ear using, step by step. Remember, the ear is made up of lots of little shapes. Take your time, and place the shadow areas correctly.

PENCILS USED

Use either an Ebony pencil or a graphite pencil.

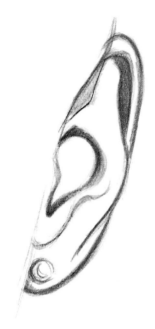

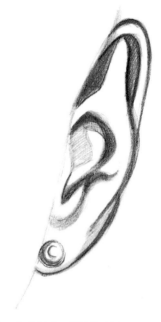

Step 1: Start With a Line Drawing

Place your graph over the illustration above. Draw the ear, and be sure it's accurate. When you feel good about it, remove the graph lines.

Step 2: Darken the Shadow Areas

Add your #1 darks as indicated in the above image.

Step 3: Add the Middle Values

Add your #2 areas.

#1 #2 #3 #4 #5

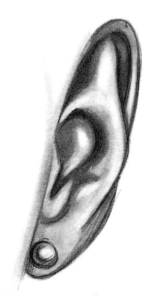

Step 4: Blend and Lift Out Highlights

Blend until the whole ear is a gray halftone. With your pointed kneaded eraser, lift out some lights to make the ear look shiny in places.

Put It All Together

You should be very proud of yourself. If you have used the book step by step, you now know how to draw all the parts of the face. Congratulations! Let's take all you have learned so far and put it all together. You'll take a line drawing and make it look real, step by step

Double-check your line drawing. With all of the practice you have had, your skills have become more fine-tuned, and you might be able to improve on it. Check all of your shapes, and when you are happy with your drawing, remove your graph.

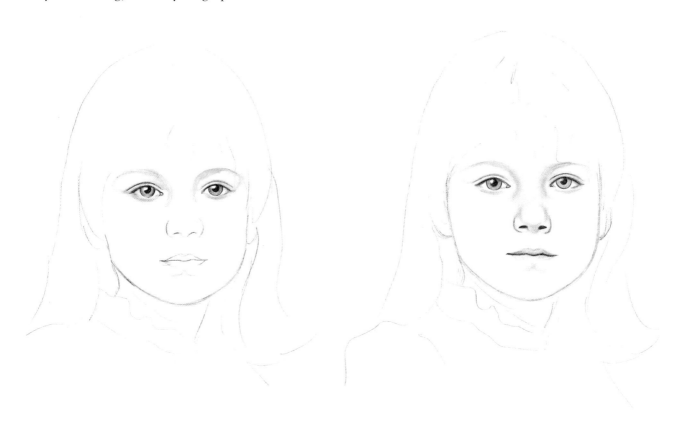

Step 1: Complete the Eyes of the Portrait

Work on the eyes until you think you've done the best you can do. Use your stencil for the iris and the pupil, and don't forget the catchlight. Look at the eyebrows. They are very light, with not much detail.

Step 2: Complete the Nose and Mouth

Move down and finish the nose and mouth as shown. Go back and review noses and mouths if you need to. Again, keep working on them until you are satisfied.

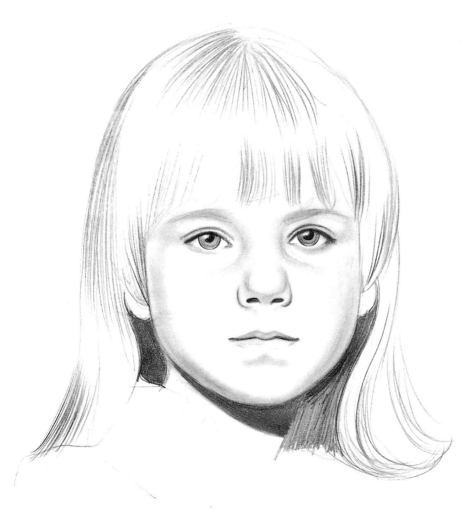

Step 3: Shade the Face and Cheeks, Then Begin the Hair

Refer to page 13 if you need help with the shadow placement. Add the dark areas next to the face, under the ears and on the neck.

The final detail will be the hair. Let's take some time to understand it. Like all of the other features, it has a formula to follow in order to make it look real.

Band of Light

Remember when we compared the roundness of the head and face with the roundness of the sphere? That roundness is also seen beneath the hair and shows up in the hair as light areas. Wherever the head is the roundest and the hair is sticking out the farthest, you will see light.

See the light area across the forehead? This is called the "band of light." The forehead looks round because of it.

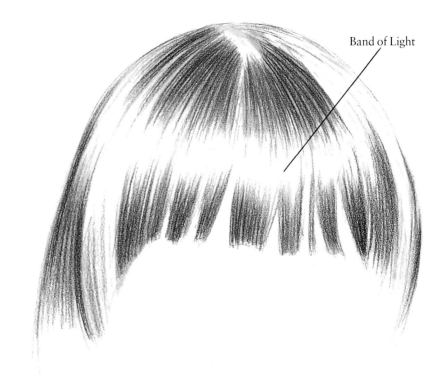

Band of Light

Draw Shoulder-Length Hair

People think that because hair is the last thing to draw it is a quick finish. Well, it is the final touch, but it is far from being quick! Drawing hair so it looks real requires time and patience, but it is well worth the effort.

Follow along as I show you how to do the shoulder-length hair. I have left out the face, but you continue ahead on your drawing. You should at this time have the face fully drawn and blended.

Step 1: Draw the Hair as One Large Shape

Add some shading under the bangs. Hair creates shadows on the skin, so this will help keep the bright white of the paper from shining through.

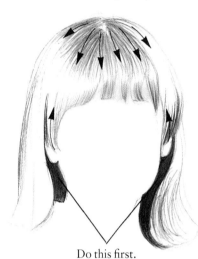

Do this first.

Step 2: Apply the First Tones

Apply quick pencil marks going in the direction of the arrows. See how it goes down from the top where the part is, and up from the bottom of the bangs? Keep applying the pencil lines until it starts to fill in. You can see the band of light starting to form where the pencil lines don't quite meet. Keep your lines smooth; don't ever scribble.

Step 3: Blend Everything Out

Blend in the same direction that you applied the pencil strokes. Don't ever blend across!

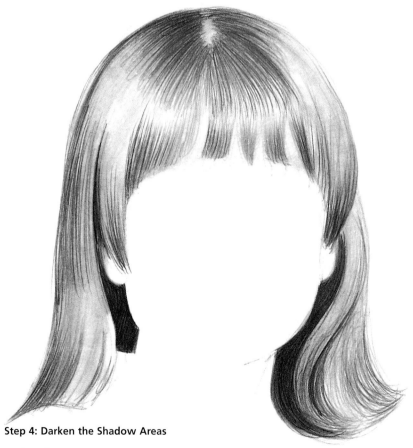

Step 4: Darken the Shadow Areas

Darken the areas one more time. Use the same procedure as you did when you first applied your pencil lines.

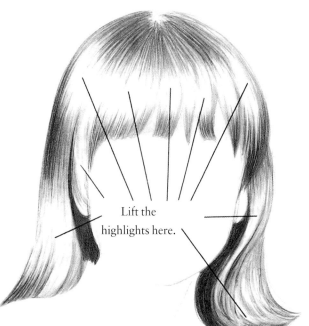

Lift the highlights here.

Step 5: Lift Out the Highlights

Flatten the eraser between your thumb and finger to create a long, flat edge. Using quick strokes, pull out the highlights where I have indicated. You will have to reshape your eraser's edge with every stroke. If the marks don't always look great, you can go back and forth, adding darks and lifting lights.

Step 6: Finish the Details

Add a little bit of the shirt collar to help it look real, and sign the artwork. You do not have to include all of the clothing. You are not just copying a photograph. By adding and changing some things and leaving other things out you are making it your own creation, a true piece of art.

You don't have to sign every practice thing you do, but anytime you complete an entire portrait, you should finish it off with your signature. Some people use only their first name or last name; some use only their initials. You do whatever you want. Have fun!

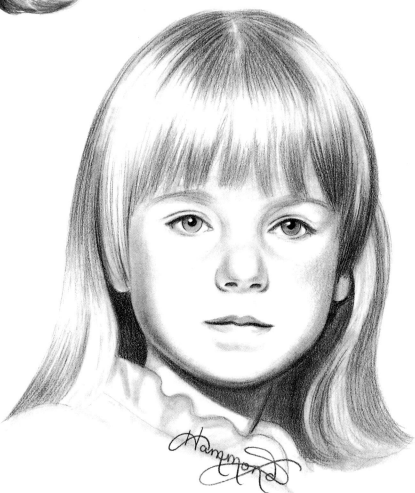

Draw Long Hair in a Ponytail

Like anything else, begin the hair with a line drawing. Look at the hair first as a solid shape, drawing its outside dimensions. The details of the hair will be built up slowly in layers.

In this example, you will draw from the bangs into the light area and from the base of the ponytail up into the light. This light area, which follows the round contour of the head, is called the band of light.

Repeat the three-step process of applying the darks, blending the tones into one another, and picking out the highlights until the volume builds up and gives you the fullness that you need. Don't stop too soon! It will take a while to create the right balance.

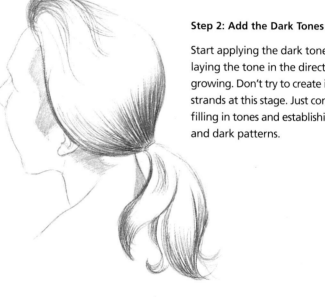

Step 2: Add the Dark Tones

Start applying the dark tones of the hair, laying the tone in the direction the hair is growing. Don't try to create individual hair strands at this stage. Just concentrate on filling in tones and establishing the light and dark patterns.

Step 1: Draw the Shape

Draw the hair as a solid, overall shape in your line drawing.

PENCILS USED

Use either an Ebony pencil or a graphite pencil.

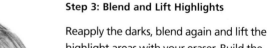

Step 3: Blend and Lift Highlights

Reapply the darks, blend again and lift the highlight areas with your eraser. Build the hair up in layers until you are satisfied. Let some of the pencil lines resemble hair strands on top of the blending. With your tortillion, gently soften the outside edges of the hair, all the way around, to keep it from looking hard.

Draw Short, Wavy Hair

Curly or wavy hair is done very much the same way as straight hair, except each curl or wave has its own set of lights and darks that must be drawn independently, and then blended into the others.

Never try to create the light areas of the hair by drawing around the white of the paper. The highlights are actually the light reflecting off of the top, outside layers of the hair. If you leave these layers out, it looks as if you are seeing through the hair. You must lay in your tone, blend everything out and lift the highlights out with the eraser. This keeps the light on the outside layers where it belongs and softens the pencil lines, creating a gradual transition from dark to light.

PENCILS USED

Use either an Ebony pencil or a graphite pencil.

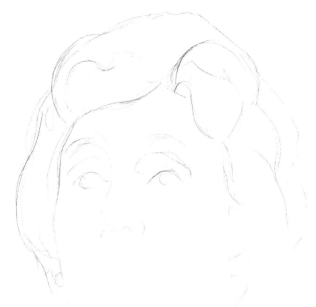

Step 1: Draw the Shape

Start with your basic outline, showing the overall shape and direction of individual waves and curls.

Step 2: Apply the Dark Tones

Squint your eyes when looking at your reference photo to see the light and dark patterns created by the hair layers and curls. Apply the tones, going in the same direction as the hair.

Step 3: Blend and Lift Highlights

Blend out the hair, redefine your darks, and pull out the high-light areas with your eraser. (Use your typewriter eraser for extremely light areas, but then soften them with your kneaded eraser. The typewriter eraser tends to leave sharp edges.) Watch how the lights and darks merge on each individual curl or wave. Keep building up tones to create the necessary volume. Finally, soften the outside edges with your tortillion.

Create Curly Hair

Curly hair can be fun to draw. Since all hair should be drawn in the direction of the hair's growth, curly hair is really just a bunch of little circular pencil marks. Try your hand at this short hairstyle. It's not as hard as it looks. Use circular, squiggly lines.

<div style="border: 1px solid black;">

PENCILS USED

Use either an Ebony pencil or a graphite pencil.

</div>

Lighter on the outside edges.

Darker close to the head.

Step 1: Start With a Basic Outline

Fill in the shape with tight circular pencil lines. Keep it lighter toward the outside edge.

Step 2: Blend Out the Hair

Blend it out using the same circular motion.

Step 3: Lift Out the Light Areas

Put your kneaded eraser into a point and use a dabbing motion to lift out light areas. Keep the light on the outside edge and reapply some darkness to the area closer to the head.

Try Your Hand at This Drawing
For fun, take a small graph and draw this person. For even more of a challenge, try to draw the other hairstyles, and use the skills you now have for drawing people to finish the faces.

Loosen Up With Long Hair

This exercise will give you some practice drawing long, straight hair. This is probably the easiest hairstyle to draw; because of its long strokes, the hair direction is easy to establish.

PENCILS USED

Use either an Ebony pencil or a graphite pencil.

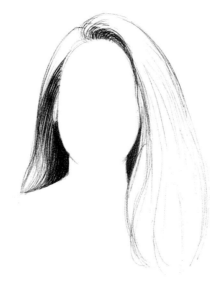

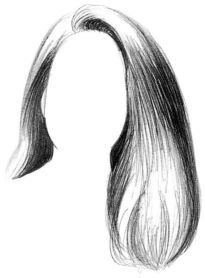

Step 1: Start With the Basic Outline

Fill in the dark areas beside the neck. Start to fill in the dark strokes on the left side and above the forehead. Watch for the direction the hair is growing.

Step 2: Continue to Fill In the Hair

Use very quick, long strokes. Pay attention to the light areas and don't fill them too much.

Step 3: Blend Until Smooth

Blend out the whole thing to give it a soft, smooth look.

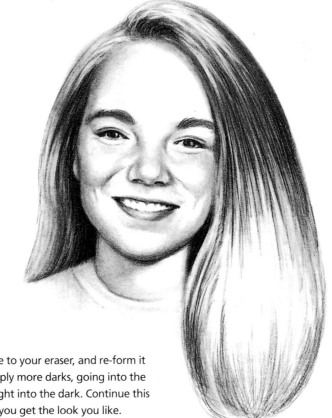

Step 4: Pull Out the Highlights

Remember to keep a sharp edge to your eraser, and re-form it after every couple strokes. Reapply more darks, going into the light areas, and pull out more light into the dark. Continue this back-and-forth procedure until you get the look you like.

Draw Short, Straight Hair

Short hair is usually not as difficult to draw as long hair, but it's still important to show the thickness of it. The softness will be created by blending, and the layers will be created by the highlights that are lifted with the erasers.

Watch how the hair creates shadows on the forehead and the face. This makes it look as if there is some space between the hair and the skin. Soften the shadows under the hair so the hair and skin work together. When rendering the face it is important to complete the tones of the forehead and allow the hair to come over it. If the the forehead is left white underneath, it will not look real.

Step 1: Draw the Shape

Indicate the basic shape with a few lines.

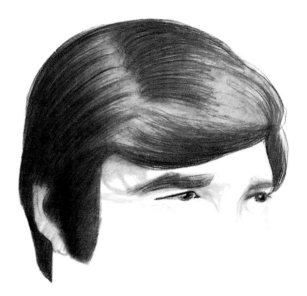

Step 2: Follow the Direction of the Hair and Apply the Tones

Apply the darks, following the hair direction. Since this hair is so dark, blend out the first layer of tone and apply the darks again.

Step 3: Blend and Lift the Highlights

Blend again, apply the darks one more time and lift your highlight areas. Gently soften the outside edges with your tortillion. Blend the shadow areas on the forehead. Also, render the ear, paying attention to the way the hair goes over it, causing shadows there, too.

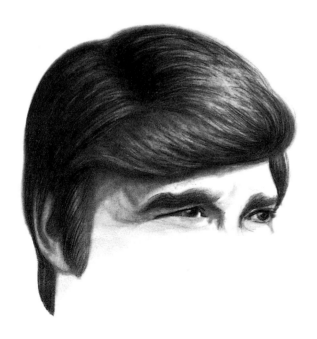

PENCILS USED

Use either an Ebony pencil or a graphite pencil.

STEP-BY-STEP DEMONSTRATION

Draw Short, Curly Hair

The soft, full look is created by the same principles of lights and darks, with blending to soften it and highlights to show volume.

PENCILS USED

Use either an Ebony pencil or a graphite pencil.

Step 1: Draw the Shape

Begin with the line drawing that gives you the basic shape to build on. Fill in the shape with small, tight circular pencil marks. This will give you some fullness.

Step 2: Blend the Hair and Create the Shadow Areas

Blend the hair out using the same circular motion used to apply the pencil marks. Darken the areas around the part of the hair and in front at the shadows areas. Blend these out again.

Step 3: Apply the Finishing Touches

Reapply the dark areas with even tighter circles than before. Soften the hair a little bit with your tortillion, and begin to lift some highlights using a dabbing motion with the sharpened point of your kneaded eraser. Repeat this process until the hair reaches the fullness and softness needed to make it appear real. Once again, be sure the outside edge is soft, and apply the shadows on the forehead.

DRAWING PEOPLE IN BLACK & WHITE 47

Draw a Profile

It is good to practice as many different poses as possible so you can begin to understand the facial features and how these poses change their appearance.

By completing these projects one by one, you will gain a lot of practice and skill. The procedure of rendering will start to become easier for you and will become habit if practiced enough.

<table>
<tr><td>PENCILS USED</td></tr>
<tr><td>Use either an Ebony pencil or a graphite pencil.</td></tr>
</table>

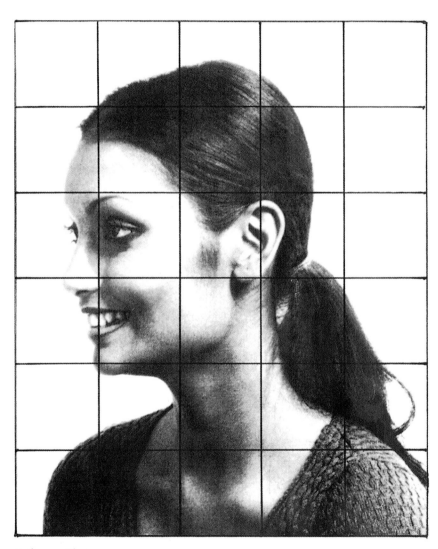

Reference Photo
Study this photograph closely. You will see that it has extreme areas of light and dark. Look at these areas as shapes. It will help you place things within your graph.

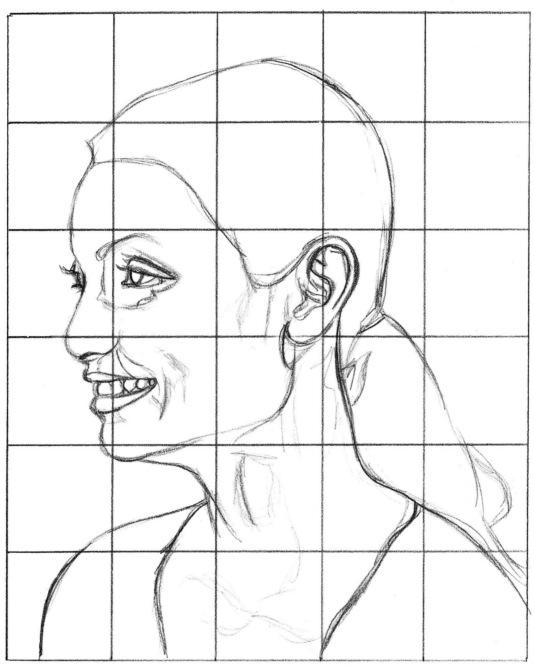

Step 1: Graph the Profile

After lightly sketching a graph on your drawing paper, begin to draw the profile one box at a time. Can you see how I drew in the shadow areas as shapes? I know this looks funny, but it helps keep things in the right place. Take your time and strive for accuracy. Be especially careful when drawing in the teeth. It is easy to get the shapes wrong, and it will change the likeness if they are drawn incorrectly. When you are sure your drawing is as accurate as you can get it, erase the graph and continue on to the next step.

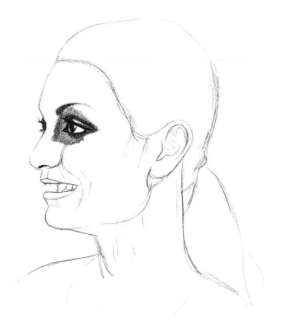

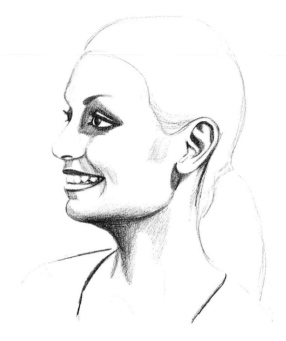

Step 2: Draw In the Shadow Areas

Place the dark shadow in the eye area and draw the eye itself. This shadow is a #2 tone on your value scale, a little darker where it meets the nose. Don't forget to draw in the small portion of the eye you can see behind the nose.

Step 3: Continue to Add the Tones

Place a #2 tone under the chin and down the neck area. Apply shading (#3) to the jawline and under the nose and the lower lip. Add more to the front of the forehead, the cheek and neck.

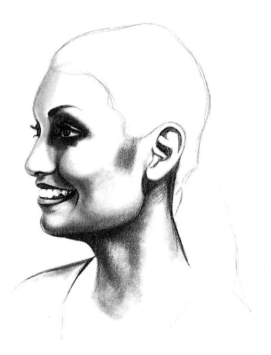

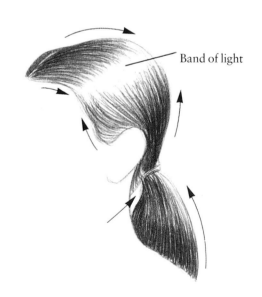

Band of light

Step 5: Add the Hair

Now for the hair. See the hair as one big shape. Apply the darkness of the hair. Draw following the hair's direction. Take your strokes dark into light, leaving the band of light. Keep filling until you achieve the right amount of darkness to give the illusion of dark brown hair. This is between a #1 and a #2 on the value scale.

Step 4: Blend the Tones With Your Tortillion

Blend from dark to light with your tortillion to give the illusion of smooth skin. Be sure your blending is smooth and even. This is the time to look for reflected light, which is very subtle but extremely important. Reflected light is what makes things look rounded.

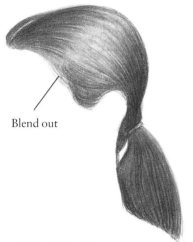

Blend out

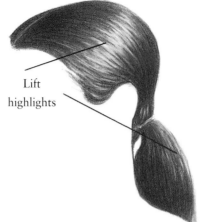

Lift
highlights

#1	#2	#3	#4	#5

Step 6: Blend the Hair

Blend the whole thing out to make it appear smooth.

Step 7: Lift the Highlights

Lift the highlights out with your kneaded eraser. Be sure to keep a sharp edge on the eraser. Add and subtract lights and darks until you get the look you want.

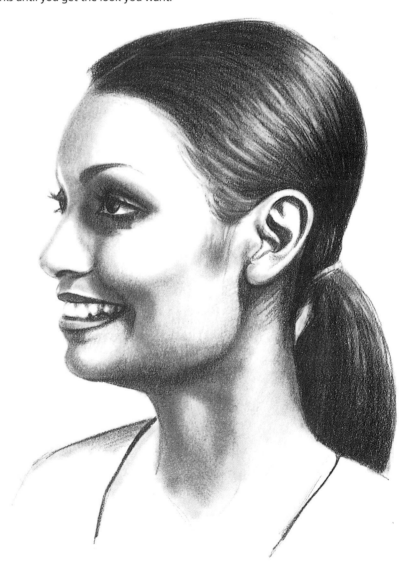

Step 8: Put It All Together

This is what the finished drawing looks like.

Draw George Washington

Take your 1-inch (3cm) graph and develop an accurate line drawing. When you are satisfied with its accuracy, remove the graph and continue on to the next steps.

PENCILS USED

Use either an Ebony pencil or a graphite pencil.

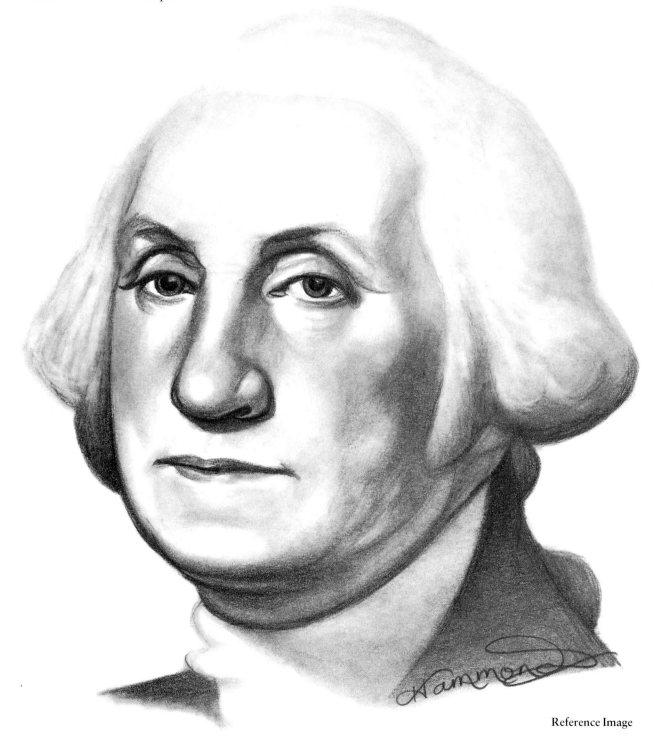

Reference Image

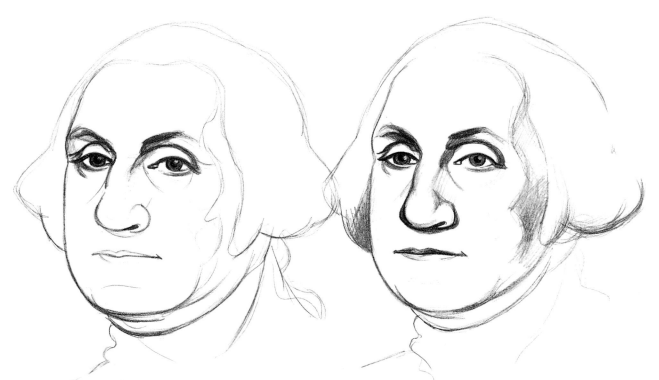

Step 1: Begin With the Eyes

Fill in the pupil, but don't forget to leave the highlight.

Step 2: Place the Shadow Areas

Use the image above as a reference when you place your shadow areas.

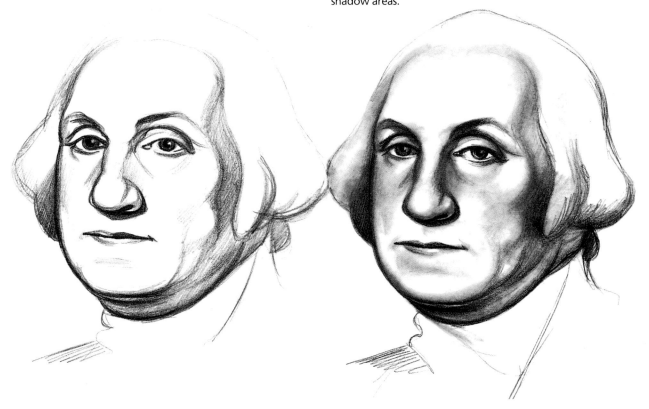

Step 3: Continue Adding the Shadow Areas

Add the shadows on the neck and jaw.

Step 4: Blend the Skin Tones Out

Look for areas of light and don't let them fill in too much. Refer to the original drawing on the previous page to finish the clothing and continue on to complete the hair.

Draw Abraham Lincoln

This drawing is fun to do, and it will give you an opportunity to draw a beard. Do a line drawing, follow the directions and make it look real!

PENCILS USED

Use either an Ebony pencil or a graphite pencil.

#1	#2	#3	#4	#5

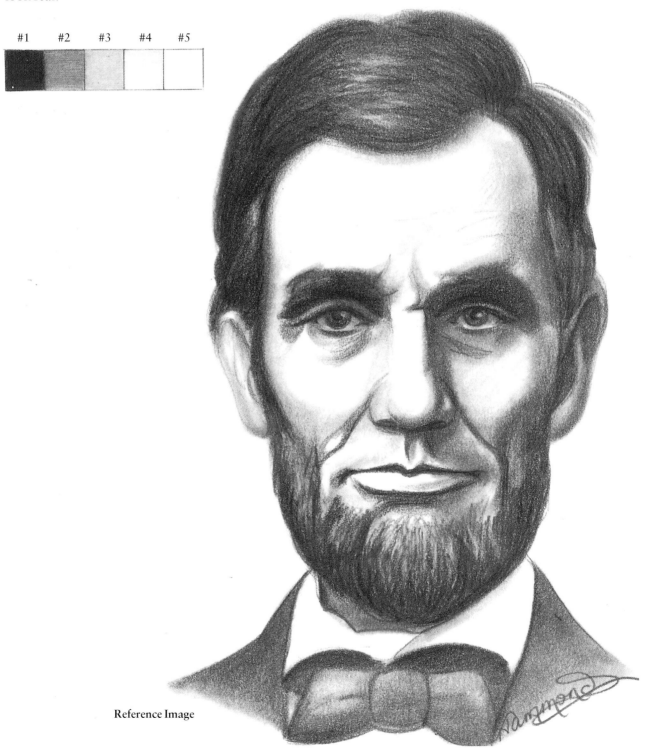

Reference Image

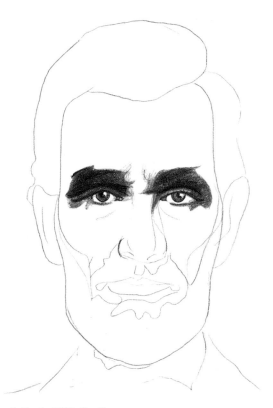

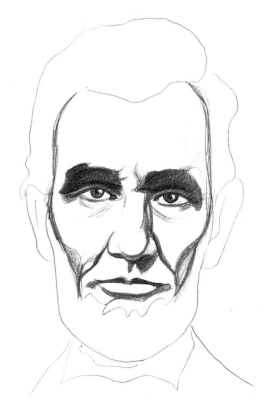

Step 1: Begin With the Eyes

Notice how dark and shadowed the eyes are. These are #1 and #2 on your value scale.

Step 2: Continue Placing the Dark Areas

Use values #2 and #3 on the scale along the cheek areas, the side of the nose, under the nose, on the upper lip and below the bottom lip. Place some light shading (#3) along the right side of the forehead and under the eyes.

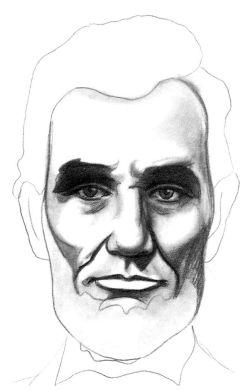

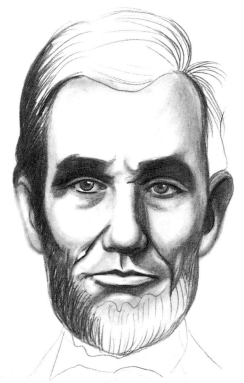

Step 3: Blend the Skin Tones Until Smooth

Take a dirty tortillion into the beard area and blend out to a halftone. This will give you a foundation to build the beard on.

Step 4: Draw the Beard

Drawing a beard is very much like drawing the hair on the head, only a beard is shorter. Use quick strokes to start filling in the beard. Finish the clothing and hair.

DEFINE THE INDIVIDUAL

Every person has his or her own special look. That is why portrait drawing can be so rewarding. But every race of human being has its own characteristics, too.

The bone structure and face shape is different in each one of these examples. Also, the nose and lips change from one to another. Look at the eyes. Can you see how they vary not only in their shape but also in their color? And each one of these men has a different type of hair.

Have fun looking through books and magazines and really study the differences in the appearances of people. It can be fascinating. Use your graphs to practice drawing them. Practice every day and you will become a wonderful portrait artist!

CAPTURE EXCITING EXPRESSIONS

Drawing portraits doesn't mean you have to draw only a serious or smiling expression. Have fun finding photos with strange and funny expressions. Although drawing expressions may seem more difficult at first, if you approach it the same way as you dealt with other features—shapes, darks and lights—you will be able to do it! If you draw the shapes correctly, you can draw the face correctly.

Take your graphs and try to draw the following expressions. Do your best to make them look real!

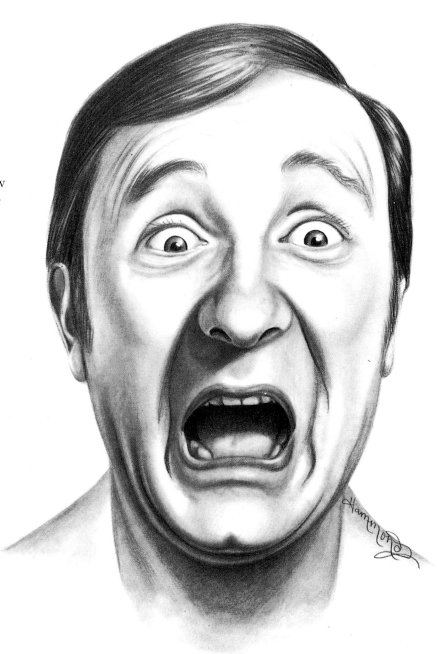

Scared Look
Notice how the face pulls up when one is scared? The eyes are open wide with shock. The forehead creases as the eyebrows pull up. The man's cheeks are deeply creased as he opens his mouth in a scream or gasp.

ONE FACE, TWO EXPRESSIONS

This is an example of how different faces look depending on mood and expression. It almost looks like two different people. The expression actually changes the shape of the face because of the way the muscles are being used.

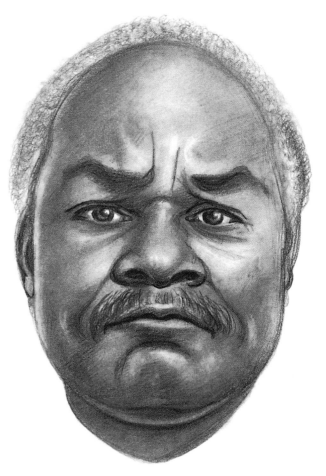

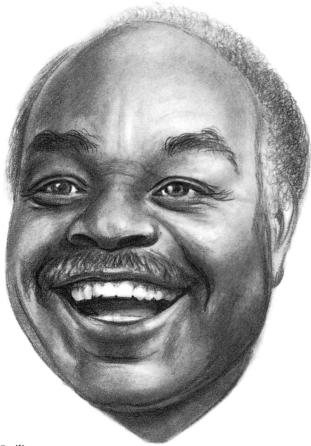

Sad or Grumpy Face
Notice how the area of skin between his eyebrows creases and folds as his face pulls downward. The lips are set tight, and the chin juts forward.

Sad Face
Here, the lines of the face take on a downward direction.

Smiling
Smiling causes the entire face to change. Creases appear around the man's eyes as his cheeks push up against them. The flesh around his mouth creases as his mouth stretches wide in a smile.

Smiley Face
On a smiling, happy face, all of the lines of the face take on an upward direction.

FIND THE UNDERLYING SHAPES OF THE HAND

Look at the obvious underlying shapes in these examples. It is easy to see the rectangular nature of the hand's structure. To keep the palm and fingers from appearing too flat or rounded, always remember to look for the underlying shapes.

Look for the Underlying Shapes
Fingers are really just a series of rectangles and angles.

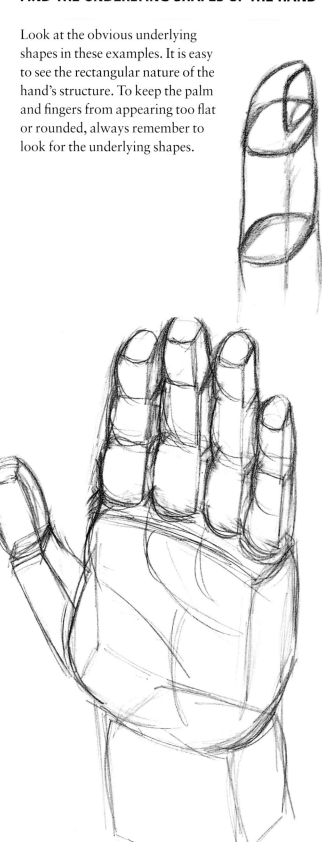

The Hand Is Not Thin and Flat
Look for the dimension created by the rectangular shape. This is most obvious along the side of the hand. Notice the "block" created by the wrist.

CORRECT ANATOMY IS KEY

It is also important to understand the anatomy of the hand before you attempt to draw it. After all, it is the bones and muscles inside the hand that give the outside its shape.

If you were a doctor, it would be important for you to learn and memorize the name of every bone, tendon and muscle of the hand, wrist and arm. However, as an artist, it is more important to know them as shapes. The bone's name or its Latin origin is not important, but the shape of the bone and how it connects to another shape is important. For that reason, I've chosen not to include all of the proper names of the bones and muscles. That is something you can look up later if you so choose. For now, just concentrate on what you're seeing, how it looks as a shape and how to draw that shape correctly.

The bones within the fingers give them most of their shape. Because the fingers are not filled in with much flesh and fat, the bony structure is easy to see. The fingers are divided into four segments connected by joints or knuckles. Look at this skeletal illustration. Can you see why the fingers must not be drawn as one continuous tubular shape? The finger varies in its shape, being thick in some areas and thin in others.

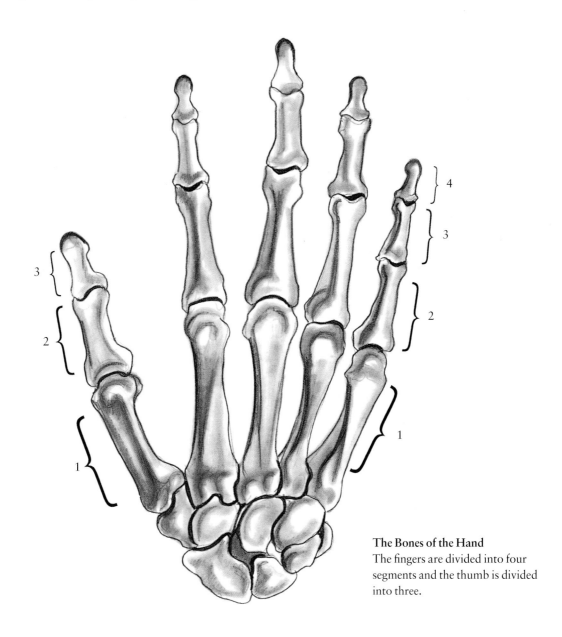

The Bones of the Hand
The fingers are divided into four segments and the thumb is divided into three.

PRACTICE DRAWING HANDS

For additional practice, I have given you these examples to work from. Each photo shows you a different pose to study with the graphed example next to it. Also, a line drawing has been completed within a graph for you to replicate. Try to be as accurate as possible, so that your line drawing looks like mine. Review the procedures for blending and shading, and try to render these drawings on your own.

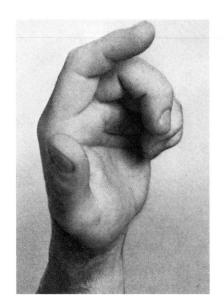
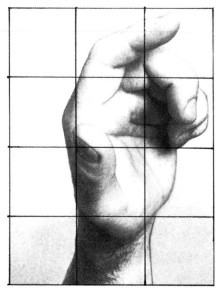

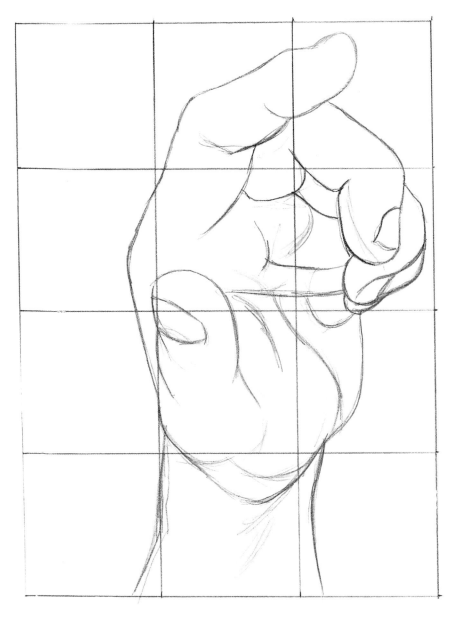

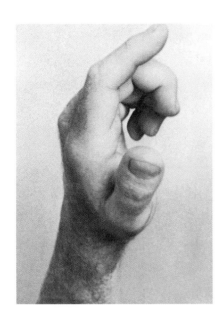

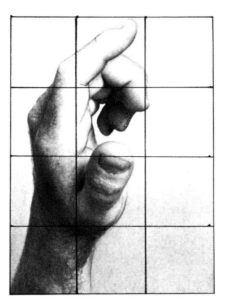

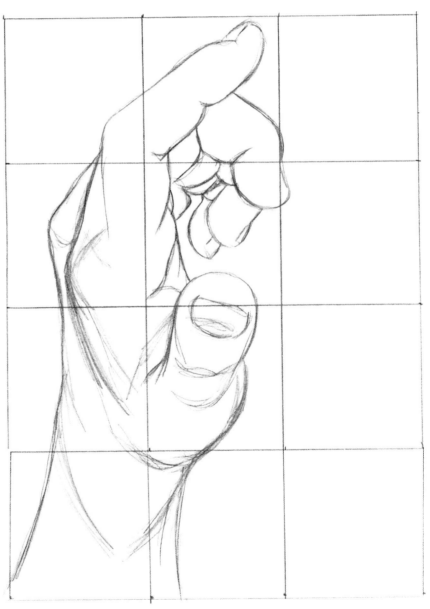

Draw a Simple Gesture

Here is a simple pose to practice from. Pay special attention to the foreshortening above the wrist where the hand projects to you.

Reference Photo

PENCILS USED

Use either an Ebony pencil or a graphite pencil.

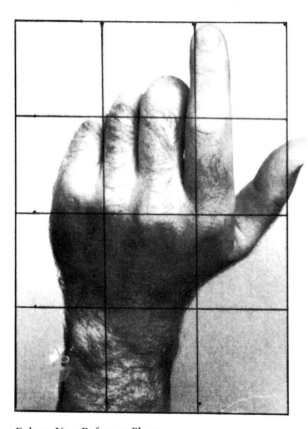

Enlarge Your Reference Photo
When drawing from photographs, I often have an enlargement made. This helps me to see the shapes more clearly. However, the details of the shading are easier to see in the original photo.

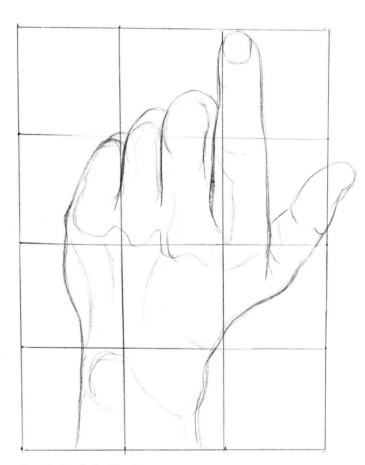

Step 1: Graph the Hand

Draw the shapes within each of the boxes of the graph paper. When drawing the graph on your paper, be sure that you use extremely light pencil lines. Once you are sure that your line drawing is accurate, remove the graph lines with your kneaded eraser.

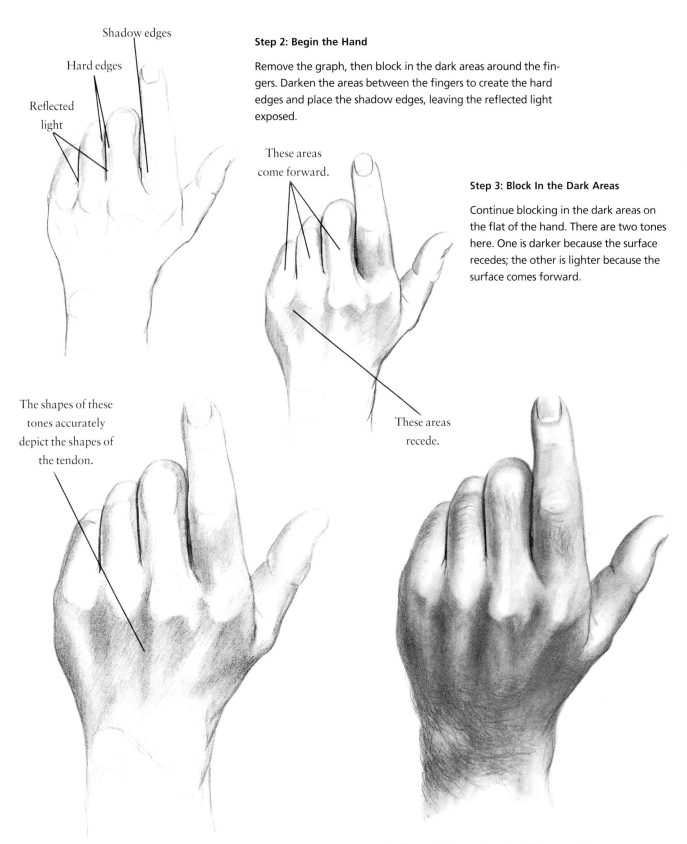

Shadow edges

Hard edges

Reflected light

These areas come forward.

Step 2: Begin the Hand

Remove the graph, then block in the dark areas around the fingers. Darken the areas between the fingers to create the hard edges and place the shadow edges, leaving the reflected light exposed.

Step 3: Block In the Dark Areas

Continue blocking in the dark areas on the flat of the hand. There are two tones here. One is darker because the surface recedes; the other is lighter because the surface comes forward.

These areas recede.

The shapes of these tones accurately depict the shapes of the tendon.

Step 4: Finish Adding Tones and Shading

Finish adding values until all of the tones are filled in. I paid particular attention to the shapes that the tones were creating, being sure that they were accurately illustrating the anatomy being represented.

Step 5: Blend the Tones Together With a Tortillion

Make sure that the tones are smooth and gradual. As a final touch, add the body hair with quick, tapered pencil strokes, being sure to follow the hair's growth pattern.

Draw a More Complicated Pose

An accurate line drawing is essential to a good finished drawing. Learning the placement and size of all the body parts will help. It is especially difficult to achieve an accurate line drawing when you are drawing from life. But when drawing from photo references, you can use the grid system to obtain accurate shapes.

By enlarging this photo and placing a grid on it, I can see the pose, not just as the girl sitting down but more as a group of shapes. It breaks the picture down into puzzle pieces, simplifying it and making it much easier to draw.

This particular picture is seven boxes across by nine boxes high. To make your drawing the same size as the photo, make your boxes the same size. To make your drawing smaller, make the squares smaller on your paper. It doesn't matter as long as the boxes are perfect squares. You can also use this method to enlarge by making the squares on your paper larger than the ones on the photo.

To achieve the line drawing, you draw what you see, from box to box. It is important to see where each shape lines up within the box, watching for placement and accuracy. Draw using simple lines, and draw lightly so you can make corrections as you go.

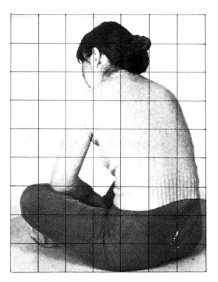

Reference Photo
A photocopy of the reference picture with a grid drawn on top.

NOTE

Always start with the darkest areas and blend into the light areas. This creates the roundness and form of your subject.

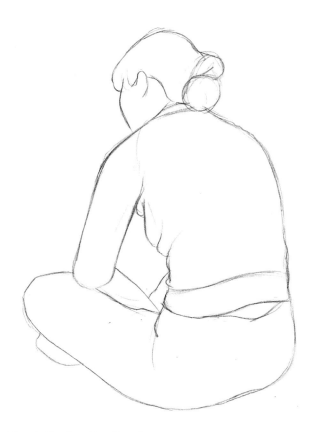

Step 1: Create a Line Drawing

Use the graphed reference photo above to help you break down the pose into a series of simple shapes. Once you are sure that your drawing is accurate in its shapes, gently remove your graph lines with a kneaded eraser.

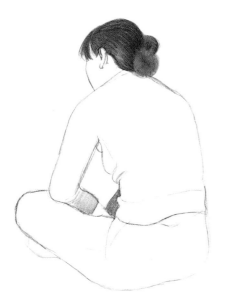

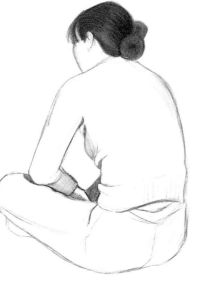

PENCILS USED

Use either an Ebony pencil or a graphite pencil.

Step 2: Begin With the Darkest Tones

Start this drawing by first filling in the darkness of the hair. Then place some tone into the dark areas of the arms.

Step 3: Shade Her Upper Half

The upper portion of the drawing is light, so be very careful not to apply too much tone with your pencil at first. Blending with a tortillion will make it darker in the following steps. Apply a little light tone to the front of her chest and to the edge of the back. I came down to the jeans and added some more line detail to the seams, as well as some ribbing to the waist of the sweater.

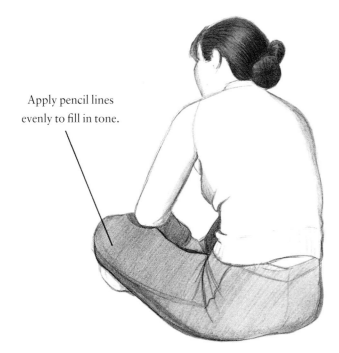

Apply pencil lines evenly to fill in tone.

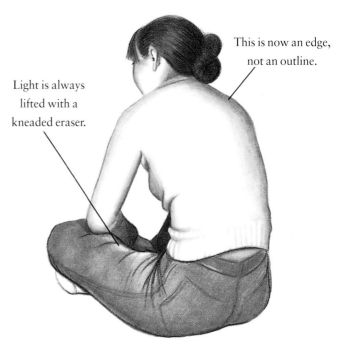

Light is always lifted with a kneaded eraser.

This is now an edge, not an outline.

Step 4: Evenly Apply the Tone of the Jeans

Since the jeans are the darkest area, place an even application of tone to the entire area. To make sure that this will blend nicely, be very careful to apply your pencil lines evenly and smoothly, with no scribbles. Notice how I placed a "shadow edge" along the underside of her leg, helping to make it look rounded.

Step 5: Blend the Drawing

With a tortillion, blend the tones of the drawing, being sure to keep the tones smooth. Where the drawing once looked outlined, now the tones are creating edges instead of outlines. This is one of the keys to realism.

PRACTICE POSES

Here are some additional exercises for you to draw. Starting with the photo, study the subject for the basic shapes and angles. I have drawn an illustration of the photo, reducing the figure into shapes and angles for you. The second drawing shows what an accurate line drawing, graphed from the photo, looks like.

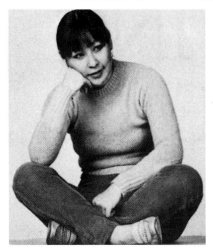

Reference Photo
Study the photo for the basic shapes.

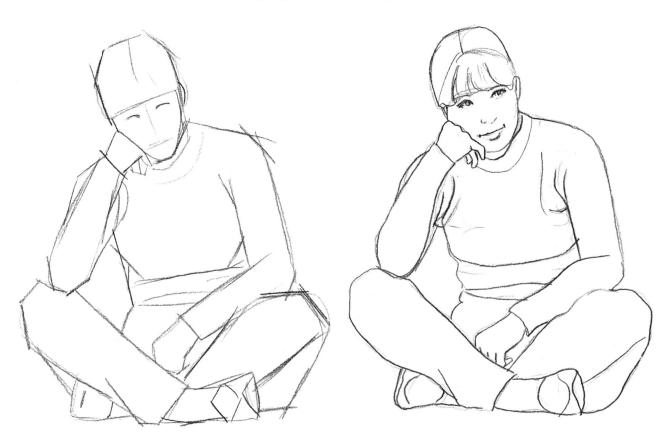

Look for the Angles
Always try to see the angles being created by the form.

Try Your Hand at the Pose
Sometimes sketching from a drawing is easier than sketching from a photo. Place a graph over my line drawings for practice. See if you can fully render the drawings on your own.

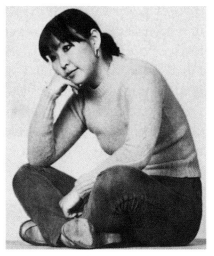

Reference Photo
Study the photo for the basic shapes.

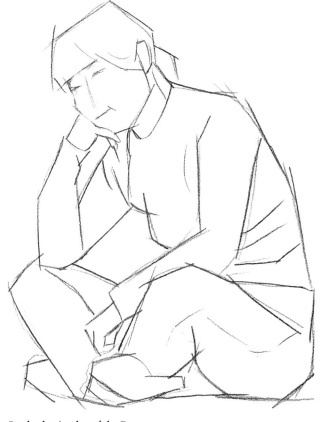

Study the Angles of the Pose
Again, it is important to look for the angles of this pose. Your finished drawing will look distorted and odd if you don't have the angles correct.

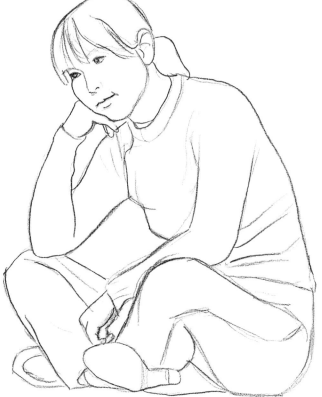

Create a Line Drawing, Then Blend and Shade
With your graph placed over my line drawing, practice your shapes. When you are finished, you can then refer to the photo and try your hand at the blending and shading.

CHAPTER THREE

Drawing Animals in Black & White

So what do you think makes a good animal drawing? It goes beyond just what the animal looks like. This example shows what can be done with my technique. See how full and hairy this dog looks? Good contrasts (the balance of light areas against dark areas) are very important. The trick is using the darks and lights together to create shape and blending to create realism.

As you go through the book, look at all of the illustrations carefully. See the pictures as shapes first, then ask yourself, where are the dark areas? Where are the light areas?

Since you will be working from photographs, remember that your artwork can be only as good as the picture you are working from. A tiny, blurred photo will not give you the information you'll need to do a good piece of artwork. Make sure you can see all of the details clearly. You can't draw what you can't see! For this reason, the picture should be fairly large (at least a 3" × 4" print [8cm × 10cm]).

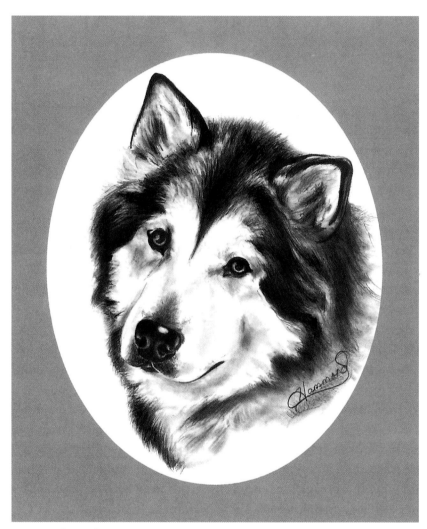

Portrait of a Husky
Lee Hammond
9" × 12" (23cm × 30cm)

NOTE

This drawing is more than just a "sketch;" it is an actual portrait of this particular animal. See how the oval mat around it creates a professional look? You will be doing drawings like this in no time!

LOOK FOR BASIC SHAPES

When you draw, try to see the basic shapes that make up the form. The following are a few of the basic shapes you'll see when drawing animals. Draw these shapes for practice. Apply the blending technique to each of them, remembering the five elements of shading as you go. It will make drawing the horse (below) easier.

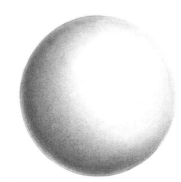

Sphere
This shape can be found in any rounded area.

Cone
Look for this shape in beaks and legs.

Cube
This can be found in areas such as the rump and belly.

Heavy Cylinder
This can be used for the trunk and the neck shape.

Elongated Cylinder
This is what makes up the shape of the legs.

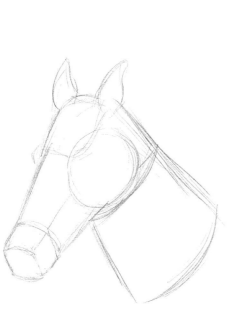

The Basic Shapes of a Horse Head
This horse head and neck are made up of a cone and cylinder. By seeing it in basic terms, you can see how angular the shapes really are and avoid drawing things too round.

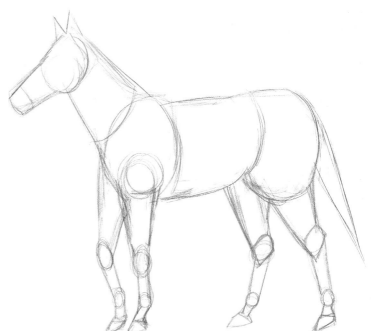

The Basic Shapes of a Horse
Look at all of the cylinders in this example. Again, be sure to look carefully for the many angles that make up the shapes. Notice how the legs are extremely angular due to the joints.

Compare the two drawings on the top half of this page. Can you see how the application of basic shapes can help you see the angles in the form of the horse? Even some of the rounded shapes have slight angles to them.

Look at the area of the stomach and the rump. Can you see that it is really more angular and cube shaped than circular? The same is true for the knee and ankle joints. By adding a hint of angle to them, they will not appear too round.

The rear view of the horse, on the bottom half of this page, shows the squared appearance of the rump. This is often drawn too round, giving the horse an unnatural curviness. The rump is more of a cube shape than a sphere. Try seeing the angular shapes in everything you draw. It will give your drawings more realism.

Draw the Basic Shapes
By drawing in the basic shapes, the overall shape of the horse is easier to see.

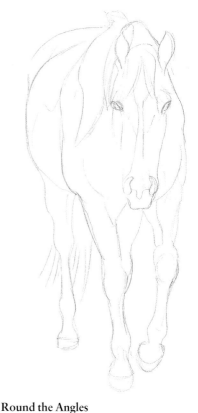

Round the Angles
By gently rounding out some of the angles, the horse takes on a realistic, natural shape.

Rear View of the Horse
This view of the rear shows how squared off the rump really is. Don't draw this area too round.

Round the Angles
The rump gently curves but still maintains the look of a cube rather than a sphere.

Learn to Shade a Seal

This seal is a fun one to draw and a great lesson in blending.

#1 #2 #3 #4 #5

PENCILS USED

Use either an Ebony pencil or a graphite pencil.

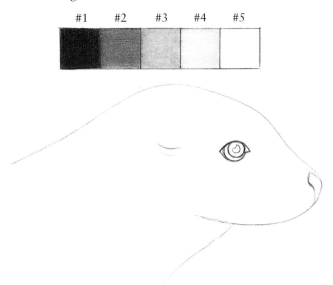

Step 1: Complete the Line Drawing

Place a graph over this line drawing and lightly draw a corresponding graph on your paper. Complete your line drawing, keeping the basic shapes in mind as you draw. The graph will help you place the eye and other features. When the line drawing is finished, erase the graph lines.

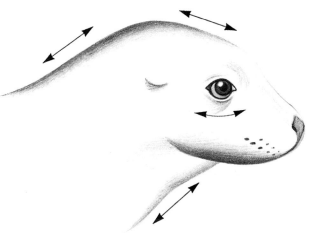

Step 2: Begin to Shade

Gently apply shading, following the arrows until you achieve the right tone. Complete the eye with a series of circles, one inside the other, each a different tone. Leave the catchlight; it helps make the eye look shiny.

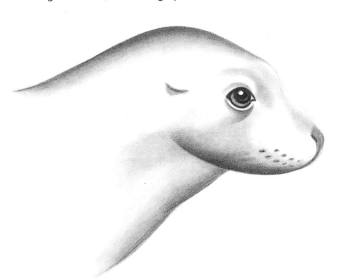

Step 3: Blend the Tones

Blend with a tortillion from dark to light, following the same direction as your pencil strokes. Add more tone if it becomes too light, then blend again. Look closely at the seal's eye. Get the dark parts of the eye as dark as you possibly can. This is a #1 on the value scale.

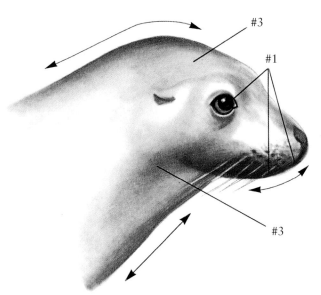

Step 4: Add the Finishing Touches

See how the whiskers are light against the seal and dark against the background? To get the light parts, squish the kneaded eraser into a "razor edge" and draw it across the shaded area of your drawing. Where the whiskers are dark against the background, use your pencil.

Draw and Shade a Flamingo

Now you're ready to advance to even more complex cylinder/egg-shaped animals. Let's begin with this flamingo. Look closely at the textures of the feathers. Can you see how the light has been "lifted" off of the dark (just like the whiskers of the seal on page 73)?

Begin by using a graph to draw the outline onto your drawing paper. When you are happy with the overall shape, remove the graph lines from your paper with the kneaded eraser. I will show you how to add the blending, shading and details to make it look real!

PENCILS USED

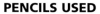

Use either an Ebony pencil or a graphite pencil.

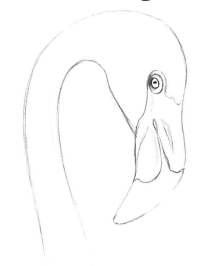

Step 1: Complete the Line Drawing

Place a graph over this drawing and lightly draw a corresponding 1-inch (3cm) graph on your paper. Lightly draw the line drawing, then erase the graph lines.

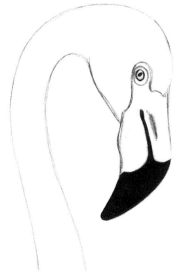

Step 2: Begin the Beak

Apply your #1 darks to the beak. Make sure that your tone is very smooth.

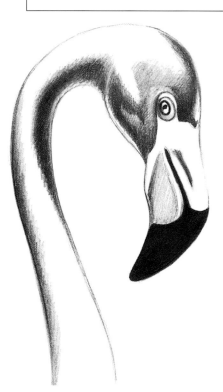

Step 3: Shade the Dark Areas

Apply shading, paying attention to the value scale (see page 75).

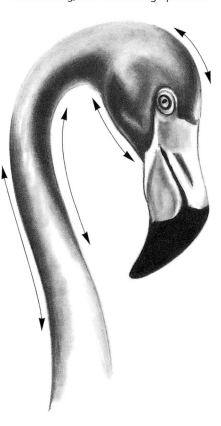

Step 4: Blend Until Smooth

Blend everything out to a smooth tone, following the arrows.

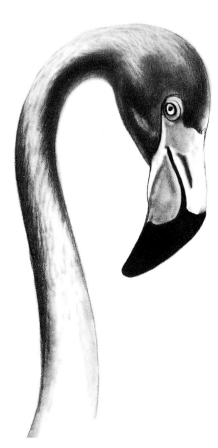

Step 5: Create the Feathers

Lift the feathers out with the kneaded eraser. With quick strokes, begin to add (or subtract) details. Use quick flicks of the wrist and some overlap in your strokes. If you take away too much, just put it back with your pencil or tortillion.

Lift the Lights on a Dark Bird

In this exercise you'll create dark tones then lift out the highlights with a kneaded eraser. It's important to create a fresh edge on the kneaded eraser after every two or three strokes. This keeps the eraser clean and the edge sharp. To clean your eraser, just play with it. Keep squishing!

PENCILS USED

Use either an Ebony pencil or a graphite pencil.

Step 1: Darken the Eye and Beak

Use a graph to obtain this outline, and then apply a #1 dark to the eye and beak.

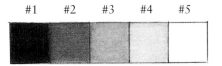

#1	#2	#3	#4	#5

Use your eraser to put "lights" on top of the darks.

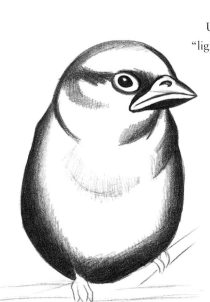

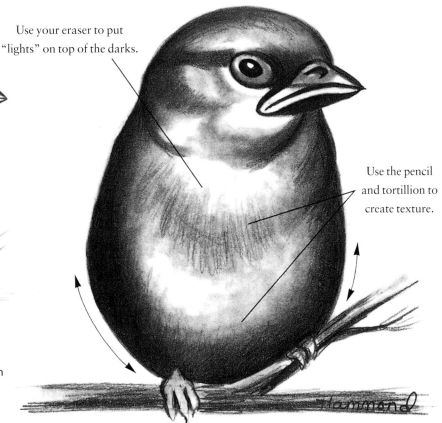

Use the pencil and tortillion to create texture.

Step 2: Add the Darker Values

Follow the arrows and apply your tone for shading. This ranges from #1 to #3 on your value scale.

Step 3: Blend and Lift Out the Highlights

Blend until smooth. With your pencil and tortillion, create a little texture. Use the lifting method to make those light areas look like they are on top of the dark areas.

Draw a Labrador Retriever

Now that you understand the principles of drawing something light, let's do the same for something dark. Just as white is not really white, black isn't just black either!

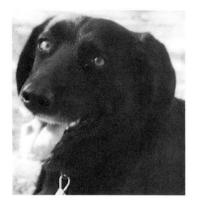

Reference Photo
In this photo of my dog, Tippy, you can see that she is about as black as an animal can get. But because of the lighting, she has highlights in her fur. Study the photo and the drawing. You can see the light area where the sunshine is hitting her. My most used comment in my drawing class is: Get it darker!

Step 1: Make an Accurate Line Drawing

Look carefully to see how every tone created by the lighting has been assigned a shape. I like to think of this as a "puzzle-piece theory" with each shape connecting to another. The more complex your subject or lighting, the more pieces you will have to draw in. This is where a graph is mighty handy.

Step 2: Begin to Fill In the Darks

Apply your #1 darks as shown. Be sure that these areas are as dark as you can get them! This drawing will take more time than drawing something that is white.

Step 3: Layer the Darks

Continue placing #1 darks. Again, be sure to get them nice and dark. Go over them as many times as necessary until your pencil lines no longer show.

Step 4: Fill In the Shading

Now, apply the #2 darks as indicated. Try to keep your pencil lines smooth. Apply #3 dark to the tongue area.

#1 #2 #3 #4 #5

NOTE

See how you can use the photos out of your family album for inspiration? You don't have to draw the whole picture; just a select part of it can make a nice drawing.

Step 5: Blend the Tones Until Smooth

Start to blend the tones together so the drawing has a smooth, even finish. If blending starts to make it look too light, just reapply the darks and blend again. There is no limit to the number of times you can go back and forth.

Facial features are very similar from person to person. Not so with animals! They are all different, and you must carefully study details that you normally would overlook. Each animal species has its own set of characteristics and differences. Look at the eyes on this page. Each of them belongs to a different animal group.

The procedure for drawing the eyes is the same regardless of the species. Follow the directions on the next page for drawing the eye of a deer. When you have completed it, take the line drawings of the other species and render them yourself. Use the same guidelines. Since everything should be seen as just shapes first, I've drawn the puzzle piece version of the eyes to help you get started.

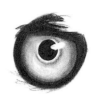

Owl Eye
This is the eye of an owl. See how round the eye is? Use a circle template to draw this eye.

Cat Eye
This is the eye of a cat. It has a slit for the pupil, which changes from very round to very thin depending on the light.

Reptile Eye
This is the eye of a reptile. See the pupil (the black spot in the middle of the eye)? It is more of a slit than a circle. Of course, the size of the pupil depends on how much light is hitting it.

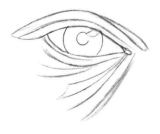
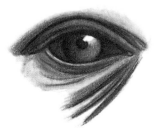

Gorilla Eye
Nope, this isn't the eye of a person, although it sure looks like it! This is the eye of a gorilla. One of the biggest differences is that the white of the eye is dark instead of white, like ours. Also the eyelashes aren't as noticeable.

Draw a Deer's Eye

Practice drawing this deer's eye.
Pay particular attention to the
catchlight, the little white spot that
is partially in the pupil. It is where
the moisture of the eye is reflecting
light. Without this, the eyes would
not look wet and wouldn't sparkle.

PENCILS USED

Use either an Ebony pencil or a
graphite pencil.

**Step 1: Graph the Eye for the Line
Drawing**

This is the eye of a deer. A deer's eyes are
on the sides of its head, and the pupils
are wide and oval. Start with the basic
outline or accurate line drawing. Look
at the many ovals in this eye.

Step 2: Fill In the Darks

Fill in your #1 and #2 darks.

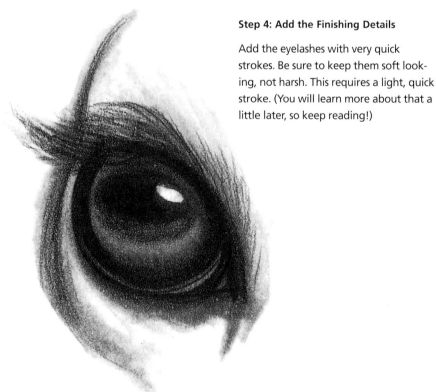

Step 4: Add the Finishing Details

Add the eyelashes with very quick
strokes. Be sure to keep them soft look-
ing, not harsh. This requires a light, quick
stroke. (You will learn more about that a
little later, so keep reading!)

Step 3: Blend the Gray Tones

Blend out the gray tones until they are
smooth. Blend around the outside of
the eye.

CAPTURE THE PERSONALITY

Animals have the same life essence as people. Each creature has its own personality, and it is through the eyes that it expresses its feelings. Horses have beautiful eyes. I love drawing their deep color and soulful expressions.

For me, the eyes are the most critical element to any portrait. It doesn't matter if the portrait is of a person or an animal. The eyes hold all of the personality and soul of the subject. I want my drawing to communicate with viewers, making them feel like they are beholding a living thing. I use eyes as a way of connecting with my audience.

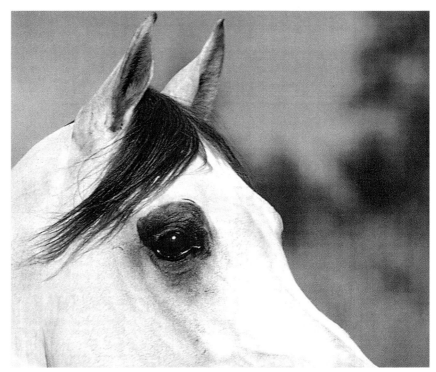

Reference Photo
This close-up of a horse's eye shows all of the details necessary to make your drawing of a horse come to life. Study it well, and look at all of the small areas of creases, highlights and shadows. Use this photo for the exercise on the opposite page.

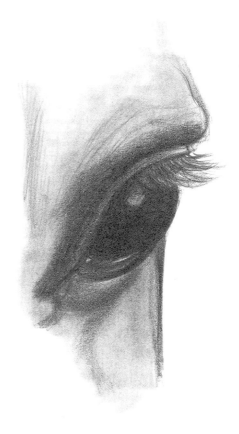

Showcase the Eyelashes
This front view shows what beautiful eyelashes horses have. This characteristic gives the horse a human quality that we can identify with. The lashes are only visible from this view. The side view above makes them hard to see.

Draw a Horse's Eye

Horses' eyes are so soulful and beautiful. Once you complete the side view of the horse's eye, try applying these lessons to other views.

PENCILS USED

Use either an Ebony pencil or a graphite pencil.

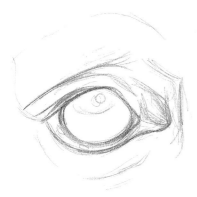

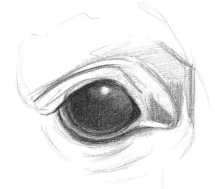

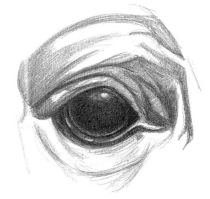

Step 1: Create a Line Drawing

You can use a graph overlay or freehand your shapes.

Step 2: Darken Inside the Eye

Make the pupil darker in the the center of the eye, but don't cover up the catch-light. Resist the urge to fill in the whole eye; this will make it look flat. The pupil is not as noticeable or defined as in a human eye. Start to place some tone in the shapes around the eye. The area around the eye isn't as dark as the eye-ball area.

Step 3: Add Tone

Continue adding tone around the eye, paying attention to the creases and shadows.

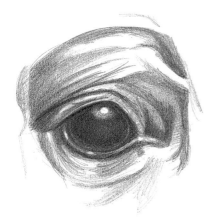

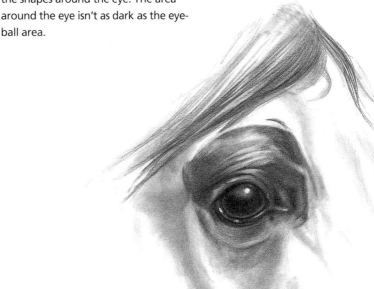

Step 4: Blend the Eye and Lift the Catchlight

With your tortillion, begin blending the tones to soften them. Blend the eyeball, and add more graphite to deepen the tones. Lift the catchlight out with the kneaded eraser. This is what will make the eye look shiny.

Step 5: Detail the Surrounding Areas

By adding some of the details of the face surrounding the eye, the drawing looks much more realistic. Blend the facial tones with a dirty tortillion for softness. Draw the forelock.

GET TO KNOW THE NOSE

When I teach the facial features for drawing portraits of people, I have students practice each feature separately. This gives them the experience they need before putting all of the features together. This is hard to do with animals. Although the eyes are separate, the nose and mouth are closely related. It is impossible to draw one without the other.

It is important to examine and study how different the features look when viewed from different angles. The shapes of the nostrils look entirely different from the front than they do from the side.

When looking at the nostrils of a horse from the front, the shape appears to be a teardrop. But like any living thing, this will vary from individual to individual and breed to breed. Study your photos carefully before you begin drawing any animal.

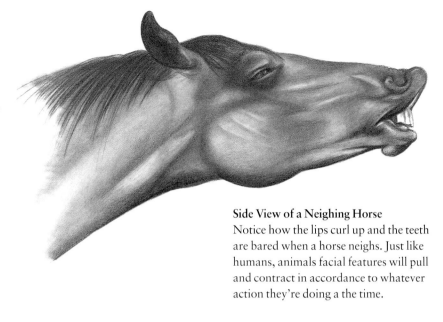

Side View of a Neighing Horse
Notice how the lips curl up and the teeth are bared when a horse neighs. Just like humans, animals facial features will pull and contract in accordance to whatever action they're doing a the time.

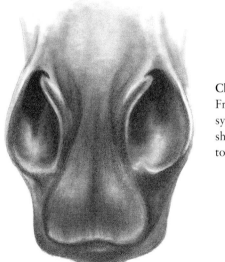

Close-Up, Front View of a Horse's Nose
From the front view, the nostrils appear symmetrical. They will be the same shape. The shape of the nostril connects to the mouth.

Look for a Variety of Shapes
The nostril is a shape that has many other shapes within it. Each horse's nostril area will be different.

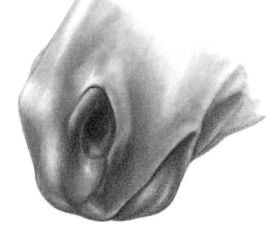

Draw a Horse's Nose

Complete this exercise of a horse's nose. Don't forget that the nostrils are basically a teardrop shape, but they also contain many smaller shapes within.

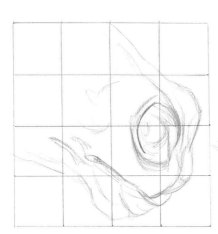

Step 1: Graph the Image

Use eight boxes for your grid. When your line drawing looks like mine, remove the graph lines.

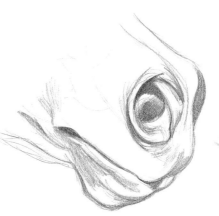

Step 2: Begin the Darkest Areas

Begin placing in the darkest areas first. Look at the tones as patterns of light and dark, assigning each shape its own tone. At this stage the drawing resembles a puzzle.

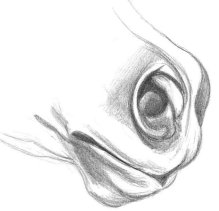

Step 3: Add the Halftones

Continue adding the tones. These create the halftone areas.

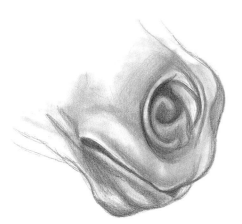

Step 4: Blend the Tones

Blend the tones out with your tortillion. This will smooth out the tones, making them appear softer.

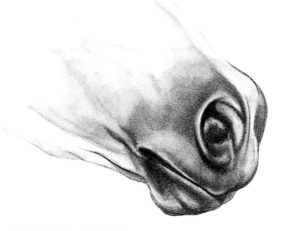

Step 5: Lift Out the Highlights

Gently lift out some of the lighter areas with the kneaded eraser. This should be done to the rim of the nostril, the edge of the upper lip and the chin area. If any of the dark tones were lightened during the blending phase, deepen them once again and blend.

Draw Two Very Different Noses

Animal features can really vary between species. The rabbit's nose looks much softer than the wet, shiny nose a dog. One of the keys to making any animal look real is to pay attention to its defining characteristics.

PENCILS USED

Use either an Ebony pencil or a graphite pencil.

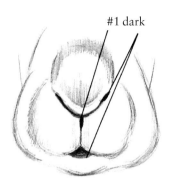

#1 dark

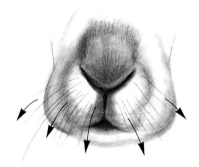

Step 1: Begin With a Line Drawing

This rabbit nose has a very distinctive shape and is easy to capture in a line drawing.

Step 2: Begin to Shade

Apply medium tone (#3). Notice how the pencil lines are going in the direction that the fur is growing.

Step 3: Create the Soft Appearance

Blend to make it look soft and rounded. Apply the whiskers with your pencil using very light, quick strokes.

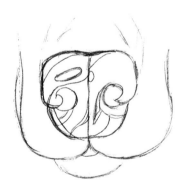

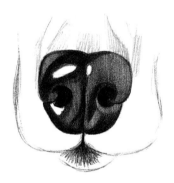

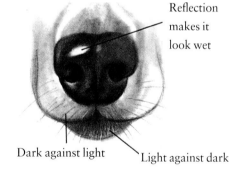

Reflection makes it look wet

Dark against light Light against dark

Step 1: Map Out the Individual Tones

This dog nose is also easy to draw in line form, but the shading is more complex than that for the rabbit nose. Use a graph to help you break down the individual tones as shapes. This is called "mapping." This nose is wet, so it's important to show the glare of light reflecting off the wet surface, like the catchlight seen in the eyes.

Step 2: Begin to Shade the Nose

Fill in shading accordingly. You will be using mostly #1 and #2 values.

#1 #2 #3 #4 #5

Step 3: Blend and Apply the Whiskers

Blend out the nose and mouth with your tortillion. Apply the whiskers with your pencil. There are some light whiskers on the chin area. Lift these out with your kneaded eraser.

STEP-BY-STEP DEMONSTRATION
Draw a Tiger's Nose

Tigers share many of the same basic features and shapes as other domestic cats. After you have completed this demonstration, try applying the lessons you learned and draw a domestic cat's nose.

PENCILS USED

Use either an Ebony pencil or a graphite pencil.

Step 1: Line Drawing of a Tiger's Nose

Use a graph to draw the "puzzle pieces" as accurate shapes.

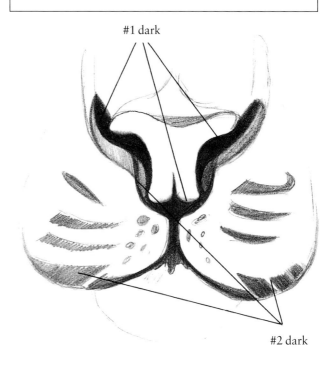

#1 dark

#2 dark

Step 2: Make the Stripes and Begin to Shade

Apply dark tones accordingly (#1 and #2). Due to the stripes, this nose has areas of extreme light and dark.

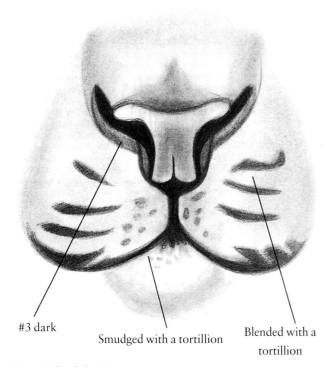

#3 dark

Smudged with a tortillion

Blended with a tortillion

Step 3: Blend the Tones

Use your tortillion to help you blend and smudge the tones until your drawing resembles the one above.

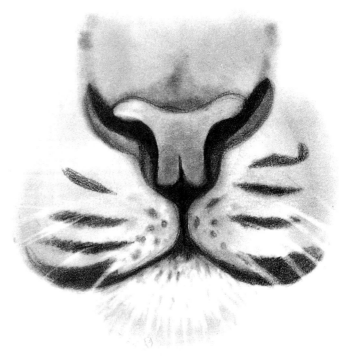

Step 4: Lift Out the Whiskers

Lift out the whiskers and small hairs in the chin with a kneaded eraser.

ANIMAL HAIR AND FUR

When drawing animal hair and fur, you can make it look real by using your shading and blending, so the formula will be very much the same as before. The difference will be the addition of pencil strokes to mimic the look of hair and fur.

NOTE

When the hair or fur doesn't look right, it's usually because the artist gave up before really being finished. Devote the proper time to the rendering of hair—it must be built up in layers!

An Example of What Not to Do
These lines are too hard and too straight. To draw hair or fur, you must use a quick stroke, one that will become lighter and tapered on the end.

Tapered Lines
By flicking your wrist as you draw, the lines will soften at the end. Also, there is a slight curve to them, which makes them look softer.

Use Long, Tapered Strokes for Long Hair
To draw long hair, apply quick strokes, always going in the same direction that the hair is growing. Keep applying until it "fills" and becomes the color you want. Overlap some of the hairs. Follow the direction of the hair growth and blend it all out. With a razor edge on your eraser, lift some lighter hairs out. This is what makes the hair look like it is in layers and has fullness.

Use Shorter Strokes for Short Hair
Short hair is done the same way, only with shorter strokes. A quick stroke with the pencil is essential!

Light, Smooth Fur
This type of hair, like a polar bear's, is drawn mostly with a dirty tortillion instead of a pencil. The look of individual hairs is not as visible. Again, lift the lighter hairs out with the kneaded eraser.

STEP-BY-STEP DEMONSTRATION
Short Hair

This cat is perfect to practice the technique for drawing short hair. Remember to use quick strokes and always taper your lines.

PENCILS USED

Use either an Ebony pencil or a graphite pencil.

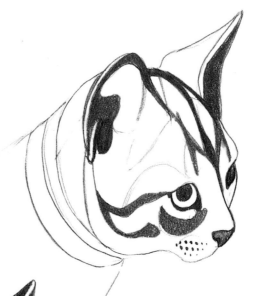

Step 2: Start to Shade

Apply the gray tones in the proper places. Look at these areas as shapes that all fit together.

Step 1: Use a Graph to Complete an Accurate Line Drawing

Look at the patterns the lights and darks are creating in the fur; draw them in as shapes. When you are happy with the outline, remove your graph lines. Apply the darkest darks as indicated.

Step 3: Blend Out the Grays Until Smooth

Leave the light areas light. Add some smooth gray to the eye with your tortillion.

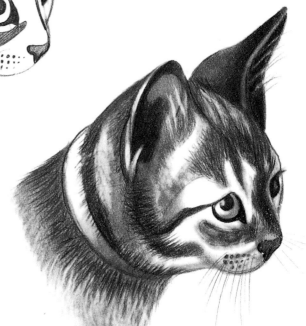

Step 4: Create the Look of Fur and Whiskers

Add quick strokes to imitate the look of fur, and add the whiskers with quick, tapered lines. Put your eraser to work, lifting out little white hairs. Experiment, using your pencil lines and eraser together to make the cat as furry as you want.

With your kneaded eraser in a point, gently lighten the color of the eye and pull out a highlight to make it look shiny.

Create a Hairy Tail

This squirrel's tail presents an unique opportunity to study long, textured hair.

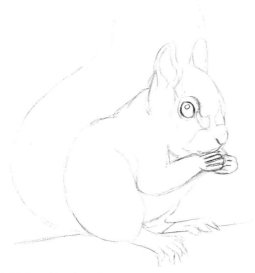

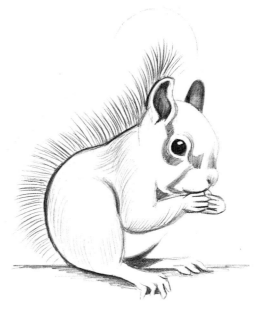

Step 1: Make a Line Drawing

Make sure that your line drawing is accurate before you begin. You've had a lot of practice since we first started, and you probably are better at drawing now! Check to see if there is anything you would like to change. When you are satisfied, move on to the next step.

Step 2: Begin to Shade and Indicate Hair Direction

Fill in the eyes, except for the catchlight. Apply tone to the ears and face. Begin the process of filling in the hair direction. Use quick strokes.

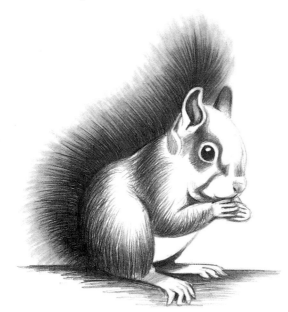

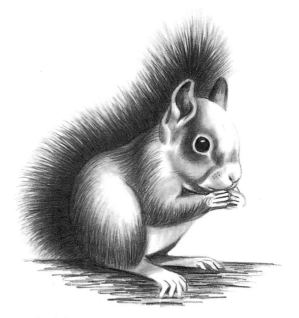

Step 3: Complete the Tail

Keep applying hairs to the tail until it fills in. When it seems fairly full, blend the whole thing out. Keep building up the tone in the body. Apply some dark under the squirrel; use rough pencil lines to create the look of wood.

Step 4: Blend the Tones

Blend out the squirrel's body, face and tummy. Use a razor edge on the kneaded eraser to soften the edges of the tail and create lighter hairs in it.

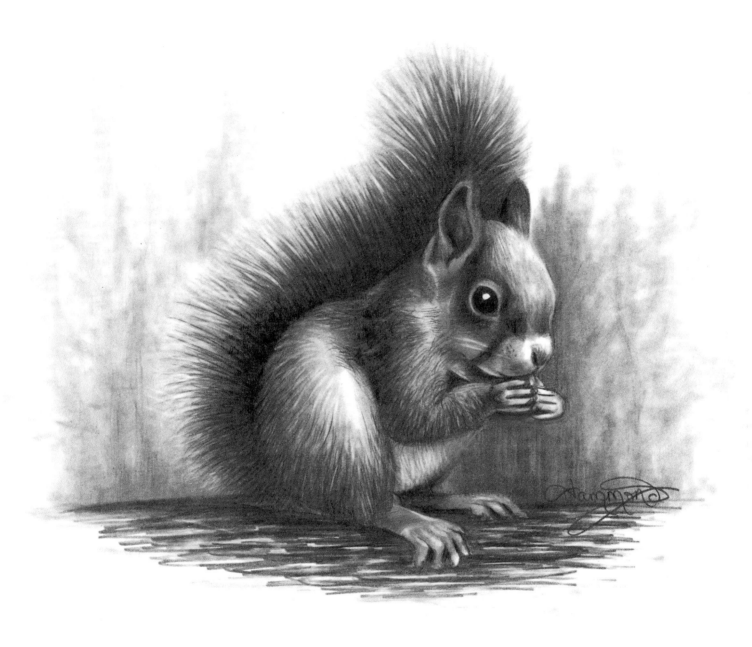

PENCILS USED

Use either an Ebony pencil or a graphite pencil.

Step 5: Add the Finishing Touches

Here's the finished drawing. Can you see how the background has been created by smudging with a dirty tortillion? By making the background soft and out of focus, it gives the illusion of trees far in the distance.

Draw Puppy Hair

Here is another photo to work from. Compare it to the drawing I did from it. Can you see the difference? I changed it a little bit by leaving out the back of the dog. Sometimes what looks good in a photo will not look good in a drawing. Good ole' artistic license!

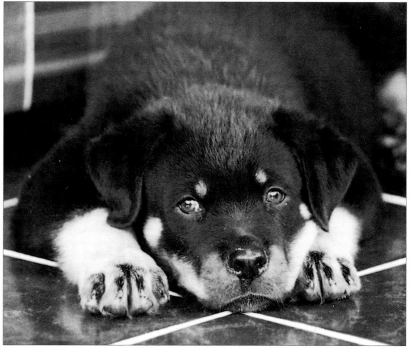

Reference Photo

PENCILS USED

Use either an Ebony pencil or a graphite pencil.

#1	#2	#3	#4	#5

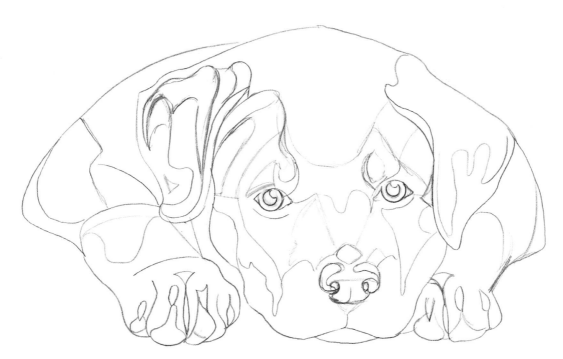

Step 1: Begin With a Line Drawing

Use your graph to achieve this line drawing. Graph from the drawing, not from the photo this time (since I changed the drawing a little). Notice all the different shapes created by the light reflecting off this black fur. This is a good example of black not being black!

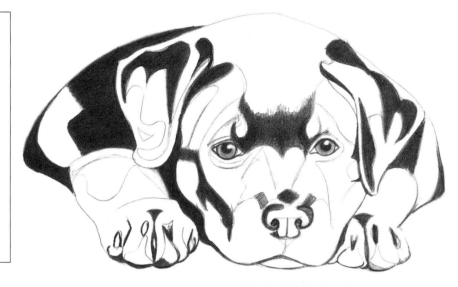

Step 2: Add the Dark Areas

Apply all the areas that appear to be
a #1 dark.

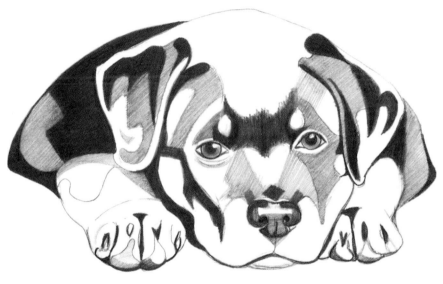

Step 3: Draw the Gray Tones

Apply your other gray areas, which are
#2 and #3.

Step 4: Blend the Hair and Smudge the Background

Blend everything out to give the illusion
of soft fur. Smudge some tone below and
beside the dog to make it look like he's
lying on something.

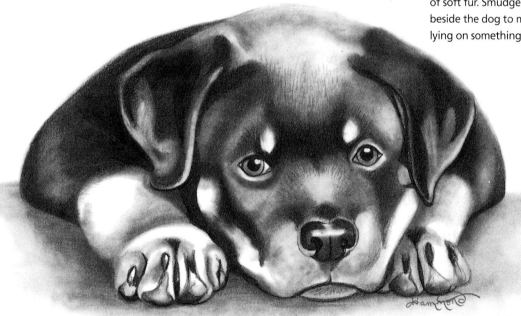

Draw Shaggy Hair

Many breeds of dogs have long, shaggy hair. Drawing this is not that much different than drawing a person's long hair. Just remember to follow the direction of the hair growth.

PENCILS USED

Use either an Ebony pencil or a graphite pencil.

#1	#2	#3	#4	#5

Step 1: Follow the Direction of the Hair

Start with an accurate line drawing. When drawing something this small, it will be helpful to use a graph. Then apply the pencil lines in the direction that the hair is going. Fill in the nose and eyes with #1 darks. Use quick, curved strokes to help create the form of the dog. Be sure to leave the catchlights white!

Step 2: Blend Until Smooth

Blend everything out to a smooth gray tone. Blend in the same direction as the pencil lines.

Step 3: Lift Out Long Hairs

With your kneaded eraser in a razor edge, use quick strokes to lift out the long hair. Use the back-and-forth process of lifting lights and reapplying darks until the hair looks shaggy and full. Be sure not to stop too soon!

Create Very Long Hair

Now try some really long hair and some curly hair. Ask yourself these important questions as you draw.

1. What direction is the hair going?
2. Where does the hair start?
3. Where does the hair end?
4. Where is it blended?
5. Where is it dark?
6. Where is it light over dark?
7. Is it smooth, or should obvious pencil lines show?
8. Where are the dark areas and the highlight areas?

Step 1: Lay In the Base Strokes

Apply quick pencil strokes following the hair's natural curve.

Step 2: Blend With a Tortillion

Blend out with the tortillion. Create curls and wisps.

Very Long Hair Examples

On the lion, the hair direction is easy to follow, but the dog has curly hair on top. The curly hair was done with circular blending with the tortillion and circular marks with the eraser. The highlights are found anywhere the hair is curved and rounded.

Step 3: Lift Out the Highlights

Lift curly layers out with the eraser.

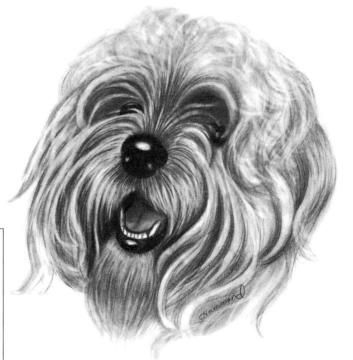

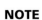

NOTE

By now you are probably thinking that this is all very repetitious, right? That's good! It proves that the same process is used for everything you draw. Now that you know the process, there's no end to what you can draw! Have fun!

SMOOTH SKIN

The smooth skin of some animals provides a great lesson on the proper use of lights and darks. The interplay of highlights and shaded areas can make or break your drawing.

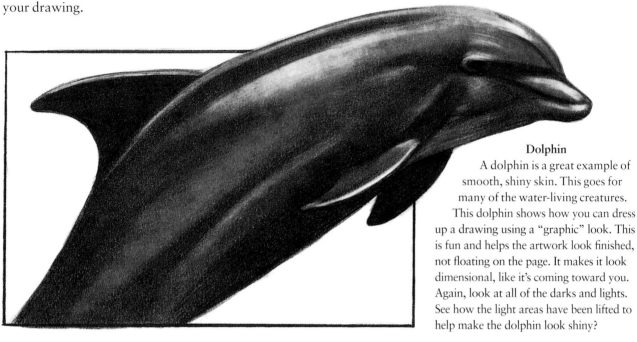

Dolphin
A dolphin is a great example of smooth, shiny skin. This goes for many of the water-living creatures. This dolphin shows how you can dress up a drawing using a "graphic" look. This is fun and helps the artwork look finished, not floating on the page. It makes it look dimensional, like it's coming toward you. Again, look at all of the darks and lights. See how the light areas have been lifted to help make the dolphin look shiny?

Shark
Study the shark and the effects of the light on it. Can you see that the light is mostly coming from the bottom and the extreme dark areas are found along the top? Pay close attention to how the fin on the right side overlaps the side of the shark and appears to be coming forward. Be sure to keep your blending extremely smooth!

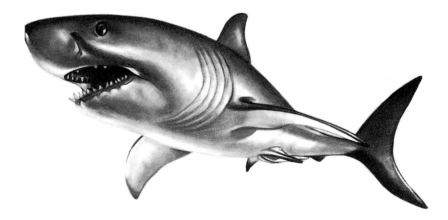

A Whale of a Tail
You do not have to draw everything in full form, as is evident from this drawing. Even though it is just part of a whale, it is still a fun drawing.

Highlight the Muscles

Besides dogs and cats, horses are popular animals to draw. Horses have very muscular faces and bodies, as you can see in this photo of my friend's horse, "Reward." Since you are already familiar with the procedure you need to follow to make it look real, try something different with this one. Put a 1½-inch (4cm) graph on your drawing paper and make this real big (10½-inches [27cm]) high. Think you can do it?

#1	#2	#3	#4	#5

PENCILS USED

Use either an Ebony pencil or a graphite pencil.

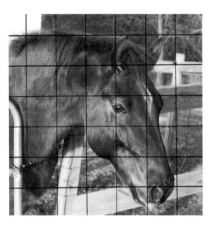

Reference Photo
I have placed a graph over this reference photo to help you easily identify the shapes.

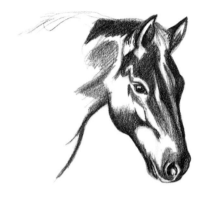

Step 1: Begin With the Dark Areas

Create an accurate line drawing from the graphed reference photo. Place the dark areas (#1). Continue with medium dark areas (#1) and (#2).

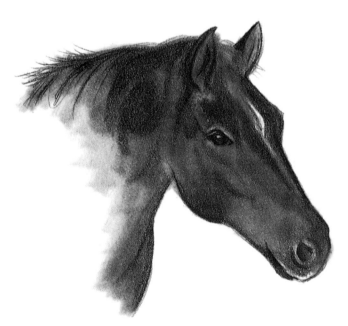

Step 2: Blend Until Smooth

Using your tortillion, blend the tones until you create the smooth appearance of shiny hair.

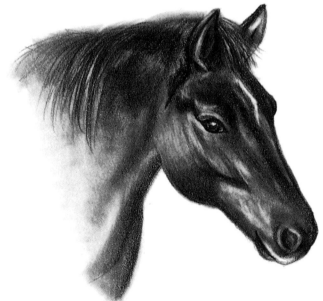

Step 3: Balance the Lights and Darks

Lift lighter areas and highlights with a kneaded eraser. Add more details, such as the hair in the mane. Keep balancing lights and darks until you like the results.

Practice Patterns

Drawing animals with patterns is easier than it looks. Do you know why? It's because their markings are nothing more than shapes, and anytime you can break something down into shapes, it's easier to draw.

Look at the zebra and leopard. By placing your graph over them, you have created exercises much like the graph of the tiger's nose (see page 85). The patterns that are created are very similar. Try graphing these animals upside down and concentrate on just drawing the little shapes. When you have completed the line drawing, continue on and make them look real.

PENCILS USED

Use either an Ebony pencil or a graphite pencil.

Step 1: Accurate Line Drawing of a Zebra

Try turning this drawing upside down and graphing the individual shapes.

Step 2: Fill In the Stripes

Use a solid black with a #1 dark tone to create the black stripes.

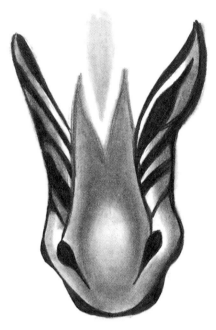

Step 3: Blend the Shapes

Blend to create the shadows and shapes. If the stripes become too light, fill them in again.

Step 1: Accurate Line Drawing of a Leopard

Draw the markings as small shapes that make up the whole pattern.

Step 2: Fill In the Patterns

Draw in the dark markings, following the pattern.

Step 3: Blend the Dark Patterns

Blend the dark areas with your tortillion to create a shadow over the spots.

ZEBRA MARKINGS

The zebra's markings are so spectacular that I thought they deserved a better look. Study these two examples and see if you can draw them.

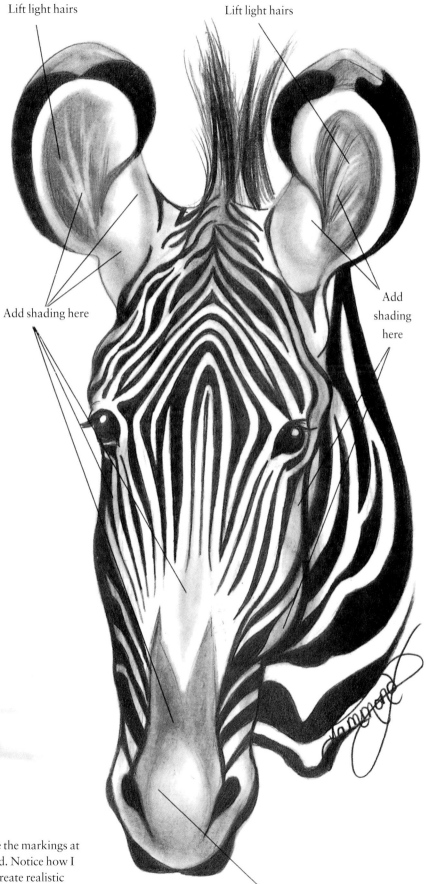

Lift light hairs

Lift light hairs

Add shading here

Add shading here

Gently blend the nose

Try a Rear View
Because of its markings, a zebra is so beautiful, even from behind.

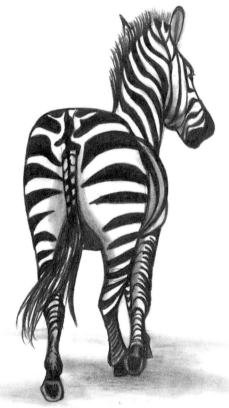

A Zebra's Full Head
Here you can clearly see the markings at work in this zebra's head. Notice how I blended some areas to create realistic dark and light areas.

TIGER PATTERNS

The cat family is another good example of animals with beautiful markings. Take a look at this example. The overall shape of the tiger's head gets you started, the designs and patterns take you halfway there, but the shading is the trick to make it look real. The tiger would look very flat without the addition of some blending to the drawing.

Place your graph over this and have fun!

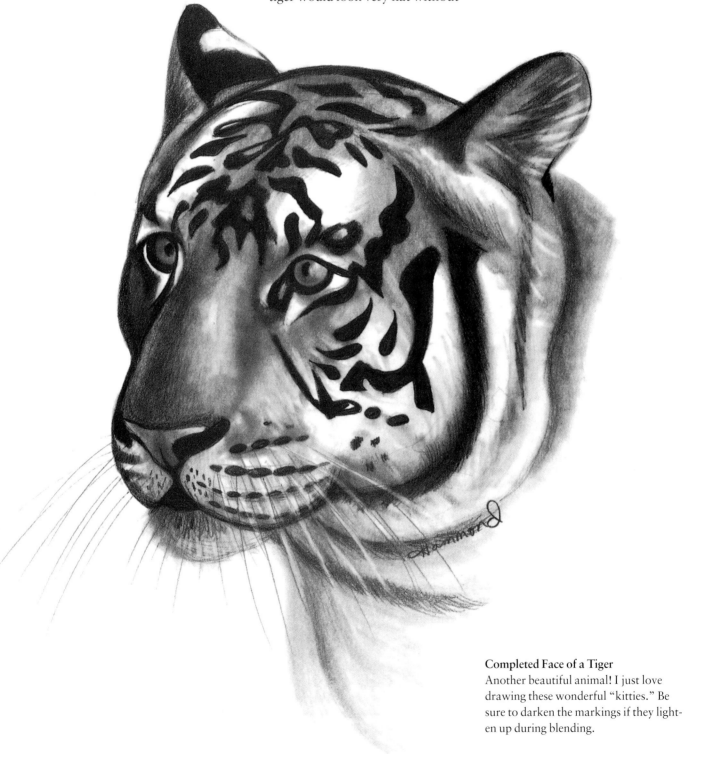

Completed Face of a Tiger
Another beautiful animal! I just love drawing these wonderful "kitties." Be sure to darken the markings if they lighten up during blending.

GIRAFFE PATTERNS

How many other animals can you think of that have unusual patterns and markings? My favorite is the giraffe. Not only are the markings very striking, the overall basic shape of a giraffe is unique. To me, a giraffe looks like it shouldn't even be real!

The Amazing Giraffe
See what you can do with this guy. Keep in mind that this giraffe is built with shape first, patterns second and blending third. His markings are not black like the animals before—his are more of a gray tone—and he has a lot less white in between the markings. Look at the shadows that are cast on the legs and the shadow on the ground below him. These are the things that will make the giraffe look real, so include them in your work.

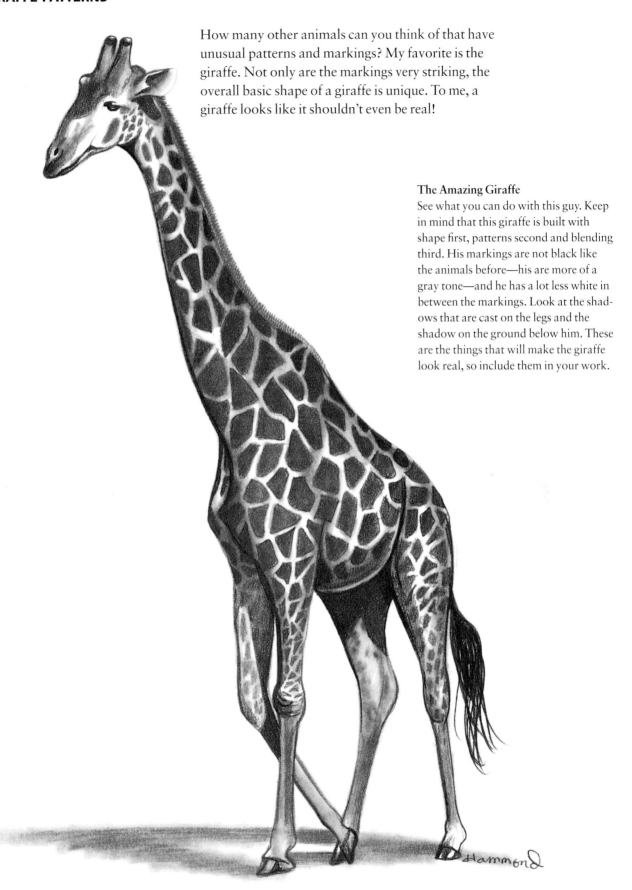

Bird Markings

Just like other animals, birds have markings too. But with the individual feathers, they are somewhat more complex and challenging to draw. Again, being able to see the small shapes that make up the patterns will help you draw them.

Look at this falcon. Each feather is a separate challenge to deal with, but by taking it one feather at a time, it is easier.

PENCILS USED

Use either an Ebony pencil or a graphite pencil.

Step 1: Use a Graph to Help You Make a Line Drawing

Look at all the many shapes created in the feathers.

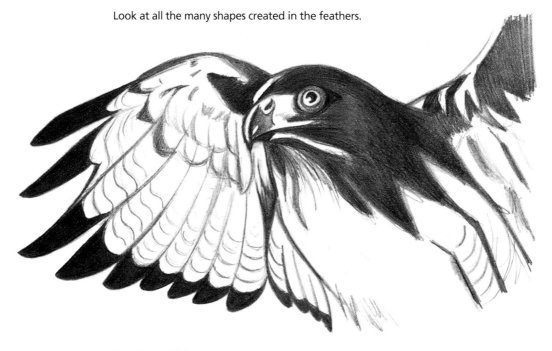

Step 2: Establish the Dark Areas

Place the #1 darks in the feathers and head of the falcon.

NOTE

Instead of boxing in this bird, use your tortillion to create the look of it flying out of a cloud. Or, find out how the rest of the bird looks and draw it landing on a branch or catching a fish.

Step 3: Blend the Darks

Blend the dark and light areas to make it look real!

Step 4: Complete the Drawing

Continue to blend and lift out light areas. Just as you did while creating fur, watch the direction of the feathers and blend accordingly.

COMPOSITION IS KEY TO DYNAMIC DRAWINGS

When creating a "finished" drawing, it is important to take into consideration the way you place your drawing on the page. This is called "composition." Look at the drawing of the koala holding its tree. You can see how the drawing creates a diamond shape. This is called a diamond composition. Circles, ovals, triangles, diamonds, rectangles or squares can also be used for placing your subjects on the page.

Another important note about composition: *Always* place your subject closer to the top of the page than the bottom and *s* in the middle. There should always be more empty space at the bottom of the page than at the top.

Helpful Clues to a Better Composition
See how the darks and lights work together, especially where the dark areas of the tree help the light side of the koala's face show up? The tree is created by using some dark lines straight up and down in a rough fashion, blending it out and pulling the highlights out on top.

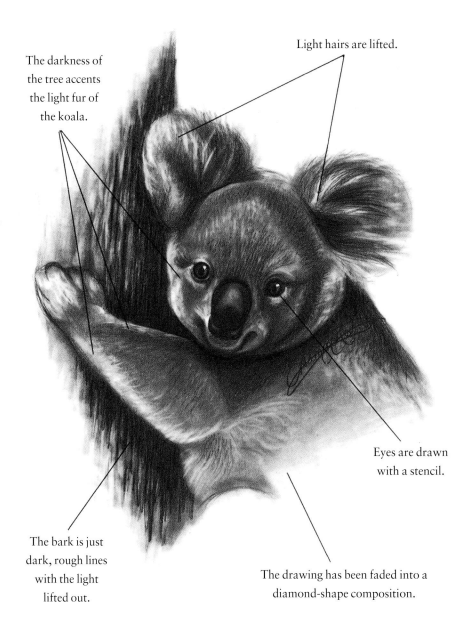

The darkness of the tree accents the light fur of the koala.

Light hairs are lifted.

Eyes are drawn with a stencil.

The bark is just dark, rough lines with the light lifted out.

The drawing has been faded into a diamond-shape composition.

These are examples of triangular compositions. They are beautiful animals to draw. Each of these would make a nice frameable piece of art if done a little larger. Refresh your memory on how to enlarge animals (see page 10). Place them closer to the top than to the bottom of your drawing paper.

Look at the effects of light on the ram horns and the deer antlers—light gives them the illusion of roundness. When drawing them, draw the shapes first and then apply all the darks. Study to see where it's light against dark and where it's dark against light. Pull out the lights with the eraser.

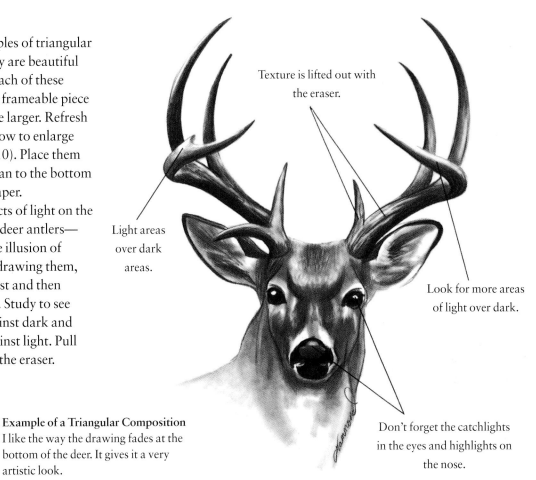

Texture is lifted out with the eraser.

Light areas over dark areas.

Look for more areas of light over dark.

Don't forget the catchlights in the eyes and highlights on the nose.

Example of a Triangular Composition
I like the way the drawing fades at the bottom of the deer. It gives it a very artistic look.

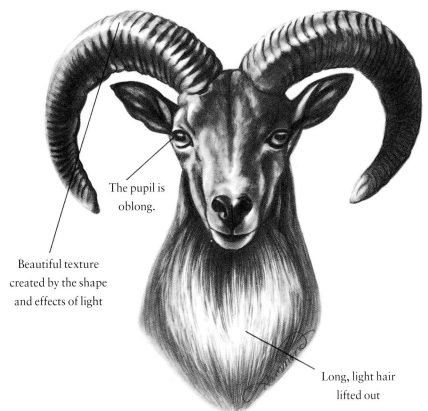

The pupil is oblong.

Beautiful texture created by the shape and effects of light

More Composition Clues
The ram was given a more solid, sturdy edge at the bottom, which helps give it a bold look. Experiment with different approaches when finishing your work.

Long, light hair lifted out

Draw a Grazing Horse (Front View)

This photo will give you practice drawing a lighter-colored horse. I love the soft gray color. It almost appears like suede. I love the way the long, light eyelashes of the horse show up against its dark eyes. I also really like the contrast of the dark mane against the light-colored face and neck. Because of the close-up shot, the vein of its face is also clearly seen. This is an important feature that can usually be seen in the horse's face. It should always be included to aid in the realism.

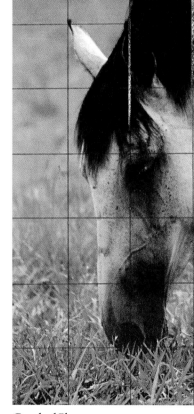

Reference Photo
This photo will give you practice drawing a light-colored horse. I like the relaxed pose, typical of a horse in the field.

Graphed Photo
I copied and enlarged the photo then placed the graph over it. Use it as a guide for drawing this pose.

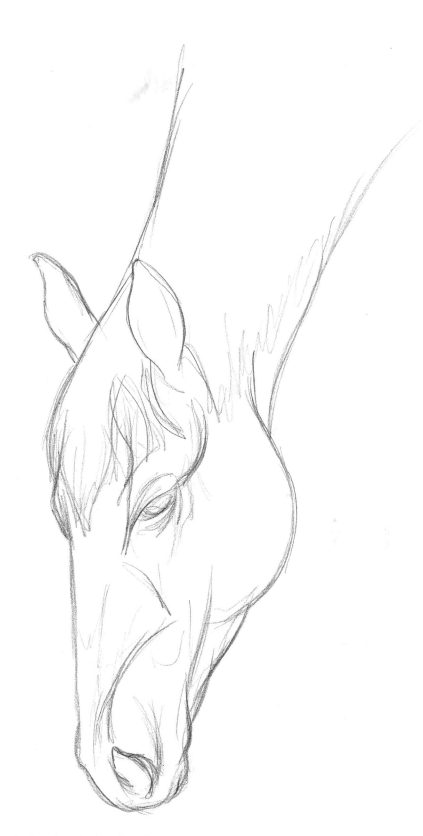

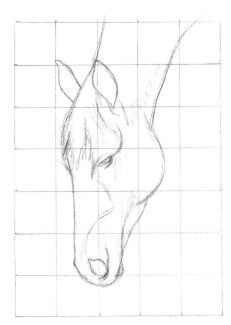

Step 1: Draw the Graphed Image

This is what your line drawing should
look like in your graph.

Step 2: Complete the Line Drawing

When you are sure of the accuracy of your shapes, remove your graph lines with your
kneaded eraser.

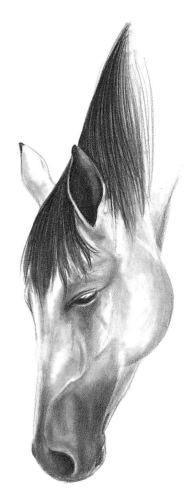

Step 3: Start With the Darkest Tones

Begin by placing in the darkest tones. These are found in the ear, the nostril and the eye. Leave the light area for the eyelashes. Add some quick strokes to begin the mane.

Step 4: Fill In the Mane and Add Gray Tones

Continue adding dark pencil strokes to the mane to fill it in. Add some medium gray tones to the face to create the facial contours.

Step 5: Blend the Tones

With the tortillion, blend the tones out until smooth. Blend the mane also. Look at how the values create the shape of the face. The vein running down the face, below the eye, is a very important feature. Keep it light there. Don't let it fill in.

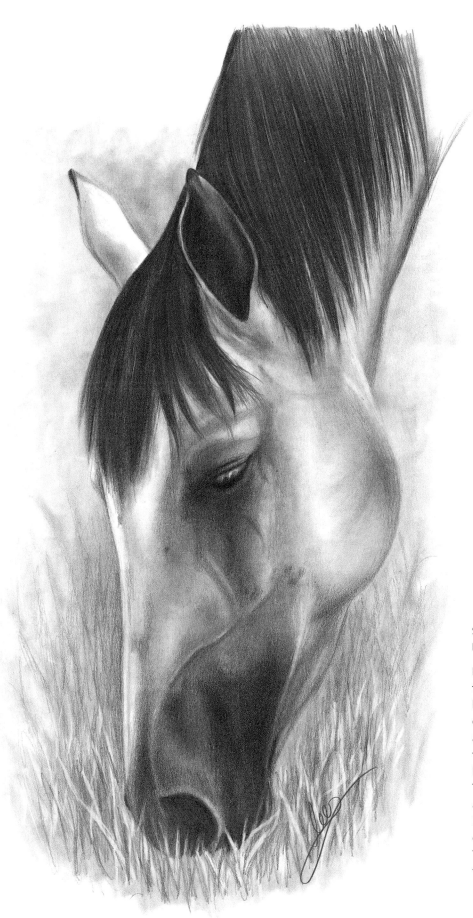

Step 6: Finish the Drawing and Background

Finish the drawing by lifting out all of the reflected light areas. Place some tone behind the horse's face to make the light edges stand out. This will make the cheek and jaw area resemble a sphere. Create the illusion of grass by blending tone out horizontally, to give the shadow effect. Then apply quick strokes with the pencil and the kneaded eraser to replicate the look of dark and light grass blades. The closer it is, the more detail you'll need. The background is mostly just blending, to make it recede.

Draw a Grazing Horse (Back View)

This back view of the same horse gives you a unique opportunity to see how the head appears from behind. It clearly depicts the bone structure of the jaws and muzzle. Drawing this view may be more difficult than the poses from the previous exercises., because you may not be used to looking at it. The shapes are not recognizable, so your brain will pump your head full of descriptions of what a horse is supposed to look like. When drawing, just concentrate on one box at a time. See everything as inanimate shapes, and let the shapes connect like a puzzle to create the horse.

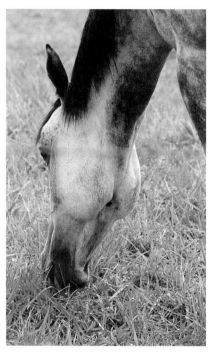

Reference Photo
This back view of the horse's head gives you a unique pose to practice. The bone structure of the jaw and muzzle are clearly seen.

Step 1: Draw the Graphed Shapes

This is what your line drawing should look like.

Step 2: Remove the Graph

When you are sure of the accuracy of your shapes, remove your graph with your kneaded eraser.

Step 3: Shade the Darkest Areas

Begin by placing in the darkest tones. These are found on the ear, in the eye, in the mouth and in the crease where the jawbones meet.

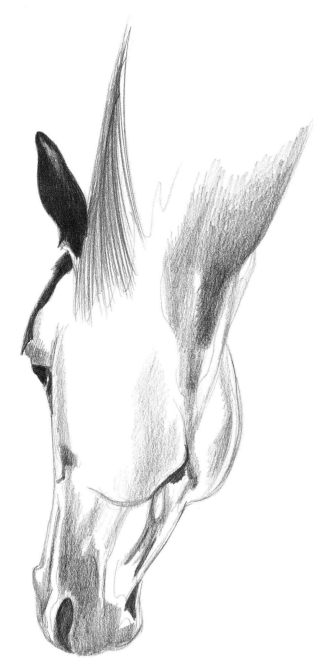

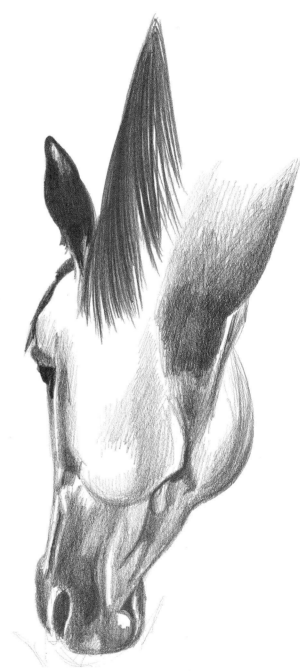

Step 4: Add the Medium Gray Tones and Shadow Edges

Place medium gray tones in the neck and mouth areas and down the front of the face. (Leave a space for the reflected light here.) Apply the shadow edges on the jaws, again leaving room for the reflected light. Apply quick strokes to begin the mane.

Step 5: Continue Building the Depth of Tone

The whole right side is in shadow here. Even though this is a light horse, the tones appear dark. Continue filling the mane with layers of dark, quick strokes.

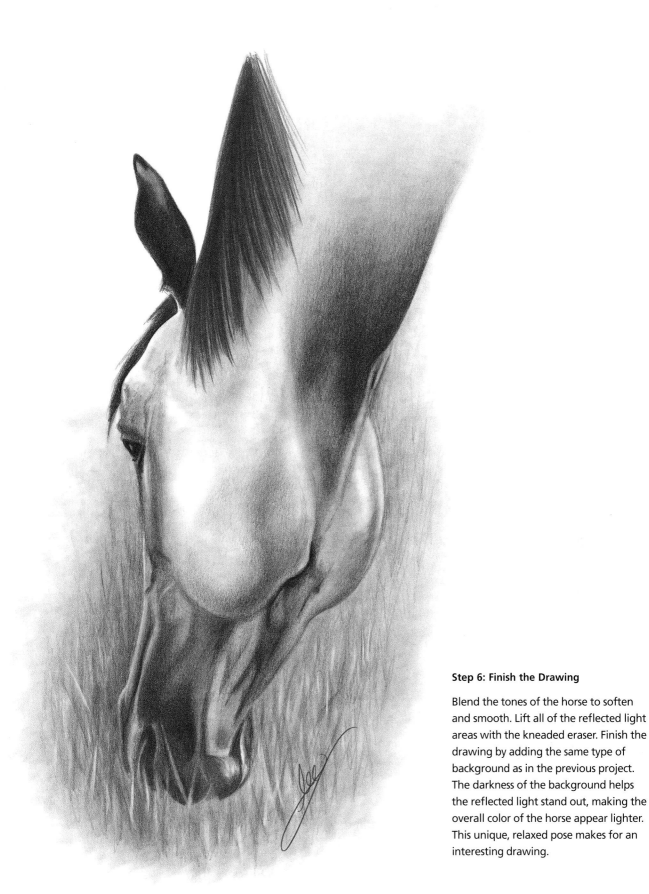

Step 6: Finish the Drawing

Blend the tones of the horse to soften and smooth. Lift all of the reflected light areas with the kneaded eraser. Finish the drawing by adding the same type of background as in the previous project. The darkness of the background helps the reflected light stand out, making the overall color of the horse appear lighter. This unique, relaxed pose makes for an interesting drawing.

Draw a Horse's Hoof

Drawing a hoof is much like drawing any other animal feature; you start by breaking it down into shapes, then move on to shading and highlighting. These shiny nails are basically spheres, so reference the shaded sphere exercise on page 15 if necessary.

> **PENCILS USED**
>
> Use either an Ebony pencil or a graphite pencil.

Step 1: Begin With a Line Drawing and Dark Tones

Start with an accurate line drawing. Be careful to draw in the angles of the ankle joint and the hoof. Place in the darker tones around the ankle joint. Develop the recessed area on the leg where the tendon shows.

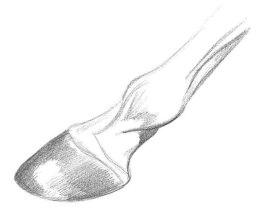

Step 2: Deepen the Shading

Apply dark tones to the hoof area. Leave the highlighted area lighter.

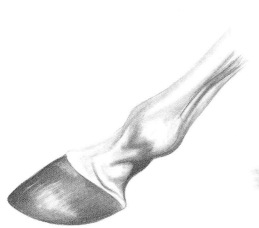

Step 3: Blend and Lift the Tones

Blend the tones to soften and smooth. Make the highlighted area of the hoof look shiny by lifting highlights with your kneaded eraser.

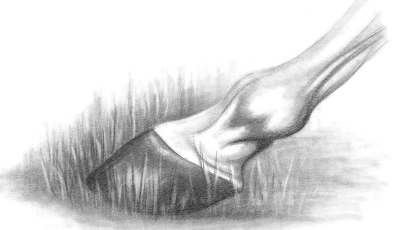

Step 4: Add the Background

Continue to layer pencil lines and lift highlight to create the illusion of ground and grass. This makes the horse hoof look like it is stepping on firm ground.

TRY SOMETHING DIFFERENT

When drawing horses, it is also fun to draw the more unusual poses. This pose is a cute example. The curled up position of this colt makes his body seem very rounded.

If you look closely, the sphere exercise and the five elements of shading can be seen in the rounded shape of the belly. Look for the reflected light along the belly and the edge of the leg, where these two surfaces touch the ground and the shadow area. Without the reflected light, these areas would run together.

By breaking this pose into basic shapes, you can see how to simplify the shapes, making it easier to draw. Place a graph over this drawing and practice your skills.

Break the Pose Down Into Basic Shapes
You can see the shape of an egg in this pose.

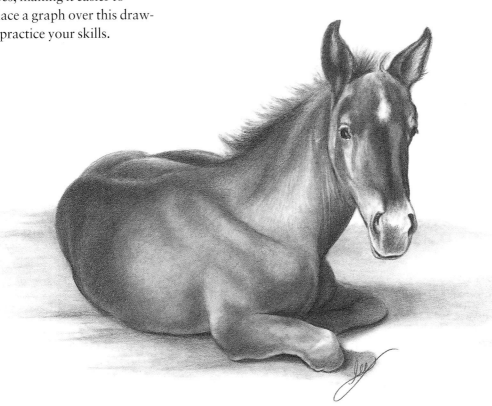

Look for the Rounded Edges
This position of the body in this drawing gives the colt a much rounder contour. The five elements of shading are clearly visible in the belly and in the front legs.

Materials & Techniques for Working in Colored Pencils

Each brand of colored pencil has a different appearance when used. Each pencil is made differently to create a unique effect. I can't easily answer which pencil is the best or which one I like the most. It really depends on the final outcome and the look I want my work to have.

Rarely will I use just one brand of pencil to complete a project. Any one brand alone is somewhat limited. I have found that by using a combination of pencils I can create more variety in my techniques. This enables me to achieve the look I'm trying to accomplish. The following is an overview of the six types of pencils I like the most.

Prismacolor Pencils

Prismacolor pencils have a thick, soft, wax-based lead that provides a heavy application of color. They are opaque and will completely cover the paper surface. They are excellent for achieving smooth, shiny surfaces and brilliant colors. The colors can be easily blended to produce an almost painted appearance in your work. They come in a huge selection of colors: 120 or more.

Verithin Pencils

Verithins also have wax-based lead, but they have a harder, thinner lead than the Prismacolors. Because of their less waxy consistency, they can be sharpened to a very fine point. They are compatible with Prismacolors but are more limited in their color range, which is thirty-six. I use Verithins whenever I want the paper to show through because they cannot build up to a heavy coverage. They can give you very sharp, crisp lines. They are good for layering colors without the colors mixing together. The Prismacolors can give your work a painted appearance; the Verithins give your work more of a "drawn" look.

Prismacolor Pencils

Verithin Pencils

Col-erase Pencils

Unlike Prismacolor and Verithin, Col-erase pencils can be easily erased. They can also be blended with a stump or tortillion, giving them the look of pastels. Although these pencils have a limited palette of colors (only twenty-four), the ability to blend colors makes them quite versatile. They also can be sharpened into a fine point, but due to their powdery consistency, it is hard to achieve extreme darks. Left unsealed (without a fixative), they look like pastels. Spray them with fixative, and they can resemble watercolors.

Studio Pencils

Studio pencils, by Derwent, are somewhat like a composite of the other brands. They are clay-based pencils with a range of seventy-two colors. Applied heavily, they can create deep, dark hues. Applied lightly, they can be blended with a tortillion. They also have a sister pencil called the Artists line, which has the same formulation and a bigger lead diameter. I use the Studio line because I prefer a sharper point. Also, because it is clay based, it will not build up color as well as Prismacolor and will give more of a matte (nonglossy) finish.

Col-erase Pencils

Studio Pencils

Nero Pencils

Using this clay-based black pencil is an excellent way to achieve deep, rich black in your work without a hazy wax buildup. This is the blackest pigment I've ever found in a colored pencil. It comes in five degrees of hardness, ranging from soft (1) to hard (5).

Watercolor Pencils

Watercolor pencils are unique artistic tools that can be used to combine the techniques of drawing and painting. They contain actual watercolor pigment put into a pencil form. You can draw with them or apply a little water and the pigment dissolves into paint. These are a fun break from traditional colored pencils.

Nero Pencils

Watercolor Pencils

OTHER TOOLS OF THE TRADE

As with anything you do, the quality of your colored-pencil artwork is determined by the quality of the tools you employ for the job. The following is a list of supplies you will need to succeed.

Paper

The paper you use with colored pencils is critical to your success. There are many fine papers on the market today. You have hundreds of options of sizes, colors and textures. You will undoubtedly develop your personal favorites as you try various types.

Before I will even try a paper for colored pencil, I always check the weight. Although there are many beautiful papers available, I feel many of them are just too thin to work with. I learned this the hard way, after doing a beautiful drawing of my daughter only to have the paper buckle when I picked it up. The crease formed was permanent, and no amount of framing kept my eye from focusing on it first. From that point on, I have never used a paper that could easily bend when picked up. The more rigid the better! Strathmore has many papers that I use often. The following is a list of the ones I personally like to use the most and recommend to my students.

Paper Types
Strathmore Renewal paper has soft colors with the look of tiny fibers in it.

Strathmore Artagain has a speckled appearance and deeper colors. Both of these papers have a smooth surface.

Artagain

Artagain is a recycled paper by Strathmore that has somewhat of a flannel appearance to it. This 60-lb. (130gsm) cover-weight paper comes in a good variety of colors, dusty as well as black and white. Although it has a speckled appearance, its surface has no noticeable texture. It is available in both pads and single sheets for larger projects.

Renewal

Renewal, another Strathmore paper, is very similar to Artagain, but it has the look of fibers in it instead of speckles. I like it for its soft earth tones.

Crescent Mat Board

My personal favorite is Crescent because of the firmness of the board. It is already rigid and doesn't have to be taped down to a drawing board. This makes it very easy to transport in a portfolio. Its wide range of colors and textures is extremely attractive. Not only do I match the color to the subject I am drawing, but I will often use the same color of mat board when framing the piece to make it color coordinated.

Crescent Suede Board

Crescent Suede Board is another one of my favorites. It has a surface like suede or velveteen. I've developed a technique using Prismacolor that makes it look like pastel when applied to this fuzzy surface (see pages 164 and 189).

Pencil Sharpeners

Pencil sharpeners are very important with colored pencils. Later in the book, you will see how many of the techniques require a very sharp point at all times. I prefer an electric sharpener, or a battery-operated one when traveling. A handheld sharpener requires a twisting motion of the arm. This is usually what breaks off the pencil points. The motor-driven sharpeners allow you to insert the pencil straight on, reducing breakage. If you still prefer a handheld sharpener, spend the extra money for a good metal one with replacement blades.

Erasers

I suggest that you have three different erasers to use with colored pencil: a kneaded eraser, a Pink Pearl eraser and a typewriter eraser. Although colored pencil (except for Col-erase) is very difficult—if not impossible—to completely

Prismacolor Pencils on Mat Board

Prismacolor Pencils on Suede Board

erase, the erasers can be used to soften colors as you draw.

The kneaded eraser is like a squishy piece of rubber, good for removing your initial line drawing as you work. It is also good for lifting highlight areas when using the Col-erase pencils. (I'll show you later.) Because of its soft, pliable feel, it will not damage or rough up your paper surface.

The Pink Pearl eraser is a good eraser for general cleaning. I use it the most when I am cleaning large areas, such as backgrounds. It, too, is fairly easy on the paper surface.

The typewriter eraser looks like a pencil with a little brush on the end of it. It is a highly abrasive eraser, good for removing stubborn marks from the paper. It can also be used to get into tight places or to create clean edges. However, great care must be taken when using this eraser, because it can easily damage the paper and leave a hole.

Mechanical Pencils

I always use a mechanical pencil for my initial line drawing. Because the lines are so light—unlike those from ordinary drawing pencils—they are easily removed with the kneaded eraser. As you work, replace the graphite lines with color.

Tortillions

Tortillions are cones of spiral-wound paper. They are used to blend after you have applied the colored pencil to the paper. I use them only with Col-erase and Studio pencils. Prismacolor is too

waxy for this technique. Verithins work somewhat but don't blend as evenly as the clay-based pencils.

Acetate Graphs

Acetate graphs are overlays to place over your photo reference. They have grid patterns on them that divide your picture into even increments, making it easier to draw accurately. I use them in both 1-inch (3cm) and ½-inch (1cm) grid squares. They are easy to make: Use a permanent marker on a report cover. You can also draw one on paper and have it copied to a transparency on a copy machine.

Templates

Templates are stencils that are used to obtain perfect circles in your drawing. I always use one when drawing eyes to get the pupils and irises accurate.

Magazines

The best source for drawing material is magazines. I tear out pictures of every subject and categorize them into different bins for easy reference. When you are learning to draw, magazines can provide a wealth of subject matter. Don't copy the image exactly, because that is copyright infringement.

Craft Knives

Craft knives are not just for cutting things; they can actually be used as drawing tools. When using Prismacolor, I use the edge of a knife to gently scrape away color to create texture such as hair or fur. A knife can also be used to remove unwanted specks that may appear in your work. As you can probably imagine, it is important to take care with this approach to avoid damaging the paper surface.

Fixatives

The type of spray that you use to fix your drawing depends on the look you want your piece to ultimately have. I use two different types of finishing sprays, each one with its own characteristics.

Workable Fixative

The most common of the sprays, the workable fixative is undetectable when applied. The term "workable" means that you can continue drawing after you have applied the spray. Experience has taught me that this is more true for graphite and charcoal than it is for colored pencil. I have found fixative to actually behave as a resist. I use it whenever I don't want the appearance of my work to change. When using Prismacolor, the wax of the pencil will rise to the surface, making the colors appear cloudy and dull. Workable fixative will stop this "blooming" effect and make the colors true again.

Damar Varnish

I use this spray when I want a high-gloss shine applied to my Prismacolor drawings. It gives the drawing the look of an oil painting and makes the colors seem shiny and vivid. (Its primary use is to seal oil paintings.) I often use this when drawing fruit and flowers, but it will make a portrait beautiful also.

Horsehair Drafting Brush

This is an essential tool when you are drawing and even more so when using colored pencil. Colored pencil, particularly Prismacolor, will leave specks of debris as you work. Left on the paper, they can create nasty smudges that are hard to erase later. Brushing them with your hand can make it worse, and blowing them off will create moisture on your paper, which will leave spots. A drafting brush gently cleans your work area without smudging your art.

> **NOTE**
>
> When a fixative is used on colored pencils that have been blended with a tortillion, the pigment can seem to melt into a watercolor appearance. The colors will appear much brighter and darker. Leave these areas unsprayed.

VARIOUS BRANDS OF COLORED PENCILS

The type of pencil you use can largely determine the look of your art. Study the examples below to see how the various colored pencils appear.

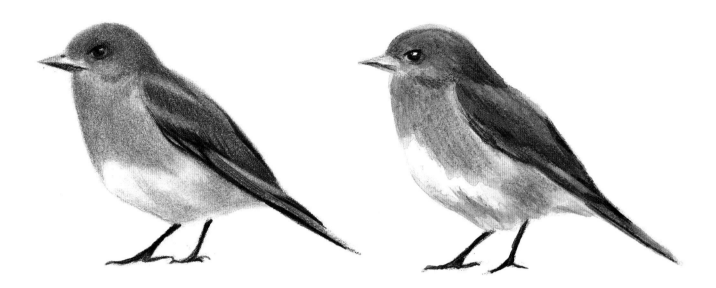

Studio
This bluebird was drawn with Studio pencils. Because the tones were blended with a tortillion, it has a softer look to it than the Studio and watercolor pencil drawings.

Watercolor
This bluebird was done with Watercolor pencils. It looks much more like a painting than a drawing.

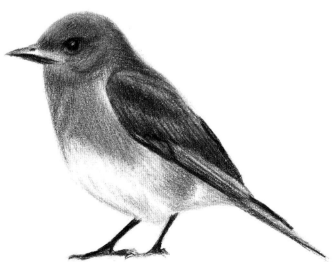

Verithin
This bluebird was drawn with Verithin pencils. The thin, hard lead of this pencil gives the drawing a grainier look than the one completed with Prismacolors.

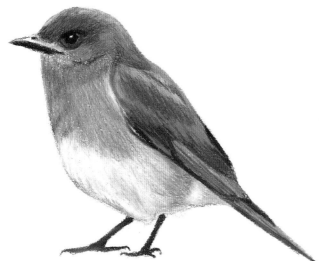

Prismacolor
This bluebird was drawn with Prismacolor pencils. The thick, waxy lead of this pencil completely covers the surface of the paper. It gives the drawing a smooth look.

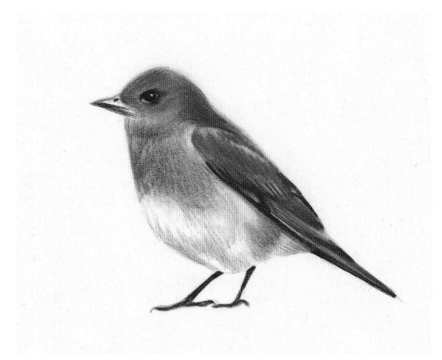

Prismacolor on Suede Board
This bluebird was drawn with Prismacolor pencils, but this time on suede board. The look is very soft, much like a pastel drawing. It doesn't even resemble the look of the drawing done with the same pencils!

A QUICK GUIDE TO COLOR

As with any technique, there is a right way and a wrong way to proceed. The most common complaint I hear about colored-pencil drawings is that they can look like crayon drawings instead of nice pieces of art. This is just a misunderstanding of how the medium should be used. It is very important to learn how to apply the pencils properly.

The first example on the opposite page looks very much like crayon. The rough, uncontrolled fashion in which it has been applied appears childish.

The second example looks much better. The pencil lines have been applied smoothly, so the distinct lines are not evident. The result is a smooth gradation of tone from

dark to light with no choppiness. This type of control in application leads to good artwork.

Color

A good understanding of colors and how they work is essential to drawing. It all begins with the color wheel, which illustrates how colors relate to one another.

The basic groups of colors are primary and secondary colors. Another categorization is warm and cool colors. A third is complementary colors. Within these classifications, you will encounter shades and tints.

There are three primary colors: red, yellow and blue. They are pure colors. Mixing these colors in dif-

ferent combinations creates all the other colors. Mixing two primary colors makes a secondary color; for instance, red mixed with yellow makes orange. Secondary colors can be found in between the primary colors on the color wheel.

Complementary colors are opposites on the color wheel; for example, red is opposite green. Opposite colors can be used in many ways. Mixed, complements become gray. For shadows it is always better to mix a color with its complement rather than add black.

An opposite color can also be used to "complement" a color, or make it stand out; for instance, to make the color red stand out, place green next to it. This is the most frequent color theory found when working with flowers and nature. Because almost all stems and leaves are green and many flowers are red or pink, the flowers have a very natural way of standing out.

The warm colors consist of yellow, yellow-orange, orange, red-orange, red and red-violet. The cool colors are violet, blue-violet, blue, blue-green, green and yellow-green.

Shades and tints are also important. A shade is a darker version of a color. A tint, on the other hand, is a lighter version. Shades and tints are the result of light and shadow.

Intensity is the brightness of color. Unlike shades and tints, intensity applies to the overall concentration of color.

Experimenting with color is fascinating. As you proceed through this book, you will see many examples of using color creatively.

The Color Wheel

Color Pencil Applied the Wrong Way
A scribbled approach when applying colored pencil will produce a look similar to that of a crayon.

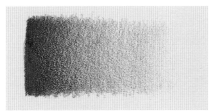

Colored Pencil Applied the Right Way
Applying color using controlled pencil lines produces an even gradation of tone.

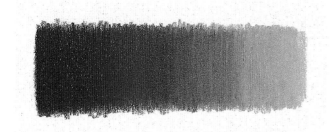

Cool Colors
A value scale made with cool colors (violet, blue and green).

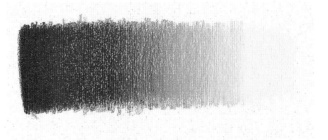

Warm Colors
A value scale made with warm colors (red, orange and yellow).

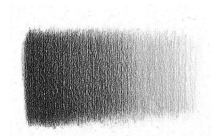

Complementary Colors
A value scale made with the complementary (opposite) colors blue and orange.

Shades and Tints
Shades and tints of red, as seen on a value scale. The middle section is the true color. Everything on the left is a shade; everything on the right is a tint.

Intensity
Greater intensity is achieved by increasing the hue.

THE FIVE ELEMENTS OF SHADING IN COLOR

It is important to fully understand what it takes to create depth and realism in your work. The five elements of shading can be found in every three-dimensional shape. Can you see all of these elements in the sphere below? The five elements of shading are as follows (listed in order from darkest to lightest):

1. Cast Shadow
This is the darkest part of your drawing. It is underneath the sphere, where no light can reach.

It gradually gets lighter as it moves away from the sphere.

2. Shadow Edge
This is where a sphere curves and the rounded surface moves away from the light. It is not the edge of the sphere, but is inside, parallel to the edge.

3. Halftone Area
This is the true color of the sphere unaffected by either shadows or

strong light. It is found between the shadow edge and the full light.

4. Reflected Light
This is the light edge seen along the rim of the sphere. This is the most important element to include in your drawing to illustrate the roundness of a surface.

5. Full Light
This is where the light is hitting the sphere at its strongest point.

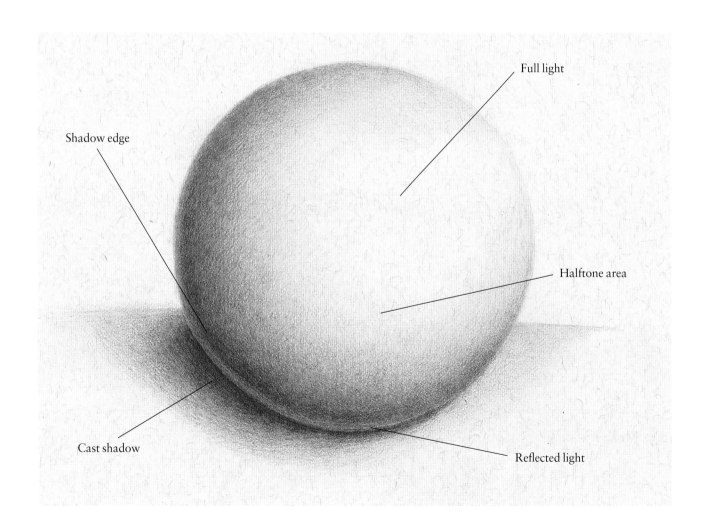

Shadow edge

Full light

Cast shadow

Halftone area

Reflected light

Draw a Sphere in Color

Using this step-by-step example, practice drawing a sphere. I have used the Verithin pencils for this exercise. After drawing a sphere, practice drawing the egg on the next page. Apply the five elements of shading as well. The more of this you do now, the better your drawings will be later.

COLORS USED

Verithin Pencils: Dark Brown, Poppy Red and Canary Yellow.

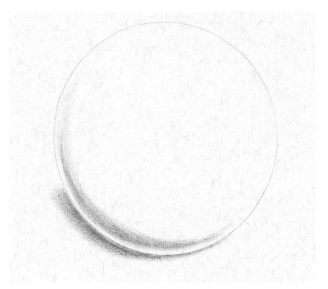

Step 1: Begin With the Cast Shadow and Shadow Edge

Trace around a circular object, or use a template, to give yourself a round outline. With Dark Brown, add the cast shadow below the sphere. Also add the shadow edge. Remember, this does not go to the edge of the sphere; it is inside, parallel to the edge. The space between will become the reflected light area.

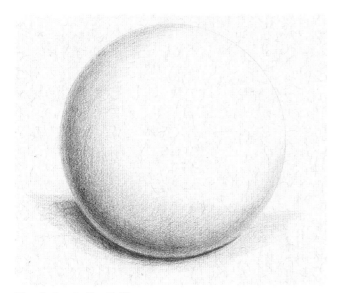

Step 2: Create the Halftone

Add Poppy Red, overlapping the Dark Brown. You are now creating the halftone area. Work up gradually to the light area. Place some Poppy Red below the sphere, over the cast shadow and around to the other side. This gives you the illusion of a tabletop.

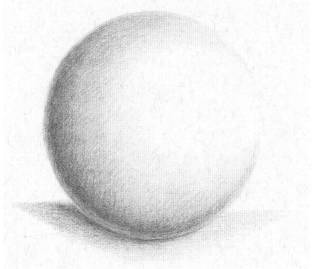

Step 3: Finish Filling In the Sphere

With Canary Yellow, lightly overlap all of the colors already there. Lighten your touch, and gradually fade into the color of the paper in the full light area.

Draw an Egg

For additional practice, use this example of an egg step by step. It's drawn with the Studio pencils and blended with a tortillion. It has a smoother look to it than the sphere exercise before, doesn't it?

<table>
<tr><td>COLORS USED</td></tr>
<tr><td>Studio Pencils: Chocolate Brown</td></tr>
</table>

Step 1: Sketch the Outline and Begin the Shadow Areas

Lightly sketch an outline of an egg with your mechanical pencil. Go over it lightly with Chocolate Brown. Place the cast shadow below the egg. Lightly apply the shadow edge, leaving room for the reflected light. The light is coming from the front on this example, so the shadow areas are off to the sides.

Step 2: Build the Halftone Area

Build your tone with the Chocolate Brown until it looks like mine. This area is the halftone. Lighten your touch as you move toward the full light area.

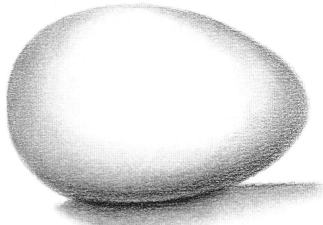

Step 3: Blend the Tones Until They Are Smooth

With a tortillion, smooth the tones. Begin in the dark areas and work toward the lighter ones, lightening your touch as you go. Can you see how the color changes when blended? It takes on a warmer appearance.

THE SIMPLE EGG

So what comes first, the chicken or the egg? It is an age-old question, but, for us artists, the answer is easy: the egg! It is the overall shape most obviously seen within the form of a bird, for example, and shape is everything. The simple-looking egg contains every element necessary for creating a realistic drawing of a bird.

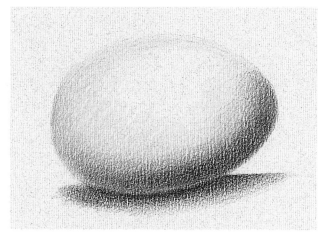

The Most Common Shape
The egg is the most common basic shape seen within the form of a bird.

Look for the Basic Shapes
Look for the egg shapes within the form of this chick.

Line Drawing
This line drawing shows how the simple egg shape is repeated four times to create a small chick. Notice how the body of the chick is thick and appears divided down the middle. For this reason, it is better to use four egg shapes rather than two when creating it.

Drawing People in Color

Drawing portraits with colored pencils can be similar to drawing them with graphite pencils, but colored pencils can dramatically change the look and feel of any subject matter. Practicing in black and white first allows you to concentrate on the feel of the pencil and how to apply it without having to switch pencils and colors. It will also give you practice creating tone, which is the gradual blend from dark to light.

Always Look for the Basic Shape

Of all the aspects of your work, the most important element is shape. If your shapes aren't accurate, no amount of technique or color theory will make your drawing look like the person you are rendering. To help my students begin to train their eyes to see shapes properly, I have them use a graph, or grid, method. By placing a graph on top of their photo reference, the subject being drawn is reduced to simple shapes.

Drawing Shapes

By drawing what I saw in each square, being careful to watch for placement within the box, I was able to achieve an accurate line drawing of the model. Sometimes it is helpful to turn your reference

photo upside down when drawing it. This is a way of seeing it more as just shapes and less than as the person you recognize.

For a challenge, and to really isolate the shapes, you could also cut a square out of a piece of paper and cover everything but the box you are drawing. The more graphing you do, the better your eye will be trained to see shapes, so you can accurately draw them.

Using Graphs

The following exercises are designed to help you get used to the graphing process. It will be very important for you to draw the graph lines on your drawing paper very lightly: These lines will need to be erased after the line drawing is completed. If you draw the lines too dark, it will be hard to remove them later. For this reason I use a mechanical pencil for preliminary sketches. These pencils make lighter, more delicate lines than other graphite drawing pencils.

As I said, it is more important right now to learn to draw the shapes accurately. Later, I will show you how to apply various types of colored pencil to turn your graphed images into realistic portraits.

Let's begin with this photo of my son, Christopher. I have combined both 1-inch (3cm) and ½-inch (1cm) grids for the graph. To achieve more accurate facial features, I divided the 1-inch (3cm) squares into ½-inch (1cm) squares around the eyes, nose and mouth. Notice how I placed a diagonal line under the eyes? This helps me get the angle of the head tilt right. The rest of the shapes were easier, so I left them 1-inch (3cm) squares.

Also, I enlarged the drawing a bit by making my squares on my drawing paper bigger than that of the photo. As long as your boxes are perfectly square, the shapes are relative. This is a good way to enlarge. It's all about the shapes and their placement within the box. You can reduce a large photo this way, too, by making the squares on your paper smaller than those in the grid over the photo.

Later on in the chapter, you will be drawing this picture in full color with Verithin pencils. Practice this on inexpensive white drawing paper first and then do it again later on mat board.

GRAPHING EXERCISES

Practice using a graph, and create a
line drawing like the one provided.
Remember to draw lightly and be
as accurate as possible.

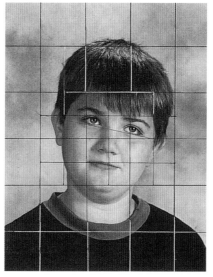

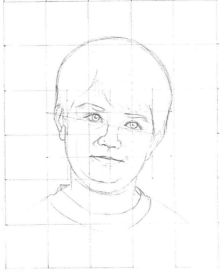

Reference Photo
I placed a combination of 1-inch (3cm)
and ½-inch (1cm) squares over the photo
to help me better break down the shapes.

Graphed Drawing
Here you can see how the smaller squares
really helped me place the features.

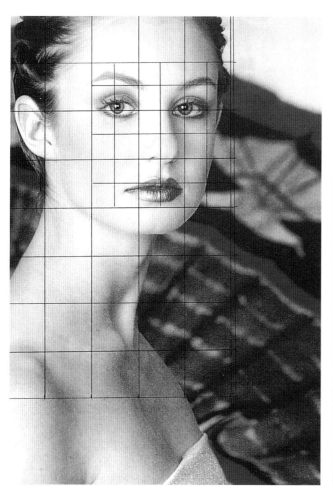

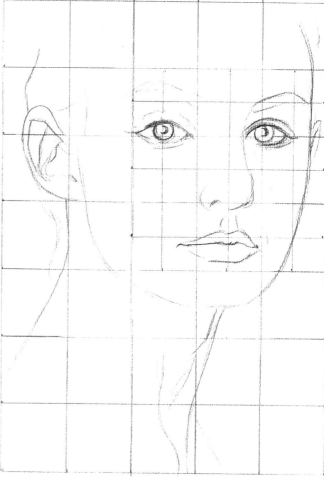

Reference Photo
A graphed photo with both 1-inch (3cm) and ½-inch (1cm)
squares.

An Accurate Line Drawing
Use the reference photo at left to create a line drawing like the
one shown here.

COMPARE THE VARIOUS TECHNIQUES

Look at how the appearance of an eye can vary in each of these examples. Each one has been drawn with a different technique and has taken on its own special quality. Although they all look quite realistic, the various approaches make them all unique.

If you compare the color versions against the gray tones, you can see how much life color can add to a drawing. The color versions seem warmer and happier. The eyes drawn in black and white seem more serious and cold. Below is an eye rendered with watercolor pencils. It has more of a "painted" appearance.

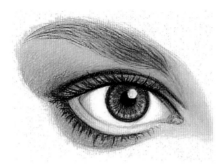

Full-Color Burnished Prismacolor

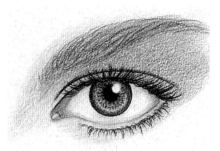

Full-Color Layered Verithin

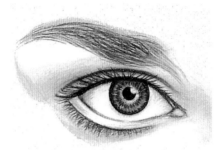

Black-and-White Burnished Prismacolor

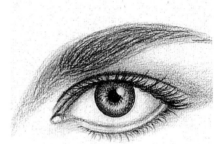

Black Layered Verithin

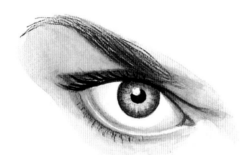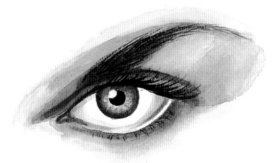

Full-Color Eye in Watercolor Pencils
This example shows how a colored pencil drawing can also look like a painting. This technique will be covered in more detail later.

Draw the Eye

Let's start small with the heart of the portrait: the eyes. Practice drawing the eye in black and white to help you get the feel of using colored pencils. Once you feel confident in your abilities, move on to a full-color demonstration.

To draw lashes and brows, it is important to have the shapes of the eye drawn accurately first. Give the eyebrows some light shading within the shape first. The hairs of the brows are then applied on top of the shaded area with quick, tapered strokes. Layer the hair strokes on top of one another to build up the thickness.

Apply the eyelashes with very quick, tapered strokes. The lines originate off of the lash line, along the eyelid. They should not be drawn in single rows, but should be placed in clumps that taper at the ends.

It will be important to use a template to obtain the perfect circles of the iris and the pupil. The catchlight, or highlight, of the eye should always be placed half in the iris and half in the pupil no matter how the highlights look in the photo you are working from. If the photo you are working from has more than one highlight in the eye, reduce it to just one. Place the highlight in the same spot in each eye. Remember: The eyes are the most important part of any portrait. It is there that you will find the personality, the mood and the essence of your subject.

COLORS USED

Prismacolor Pencils: Black and White.
Verithin Pencils: Black

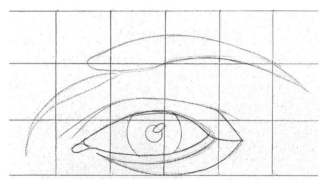

Step 1: Graph the Eye

Using the graph method and a template for the circles, draw this accurate line drawing of the eye.

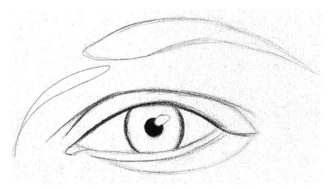

Step 2: Begin the Pupil

With Black Prismacolor, blacken in the pupil. It is always centered inside the iris! Place the catchlight half in the pupil and half in the iris, regardless of what your photograph may have. Change it if you have to. Darken the lash line and the area around the edge of the iris.

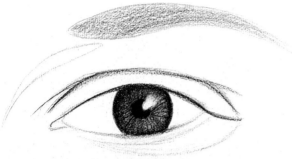

Lower Lid
Thickness

Step 3: Fill In the Iris

Fill the eyebrow area and the iris with Black Verithin. Using a starburst design, create some pattern in the iris. Do not cover up the catchlight.

Step 4: Place the Tone

Begin placing tone on the eyelid, on the brow bone and below the eye. Look for the lower lid thickness. This makes the eye look three-dimensional and realistic. Begin adding a small amount of shading to the eyeball.

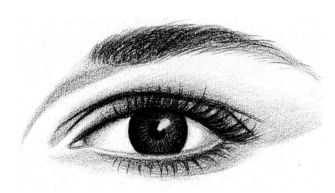

Step 5: Apply the Eyebrows and Eyelashes

Use quick strokes with Black Prismacolor to make the eyebrows and eyelashes. Apply White Prismacolor to the catchlight. This drawing could be called finished if you want only the layered technique.

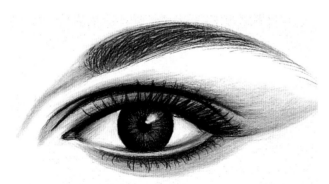

Step 6: Create the Burnished Look

Apply White Prismacolor over the entire drawing. Reinforce the dark tones with Black Prismacolor, and blend the tones together with White again. Can you see how different this makes the eye appear? It takes on a much shinier appearance.

PRACTICE DRAWING THE EYES IN PAIRS

It is important to practice drawing eyes in pairs. These angle lines show you how much the tilt of the face affects the angles of the eyes. Our minds have a tendency to make us draw everything straight across, leveling out everything for us. By giving yourself some guides like this as you draw, you can overcome this common problem.

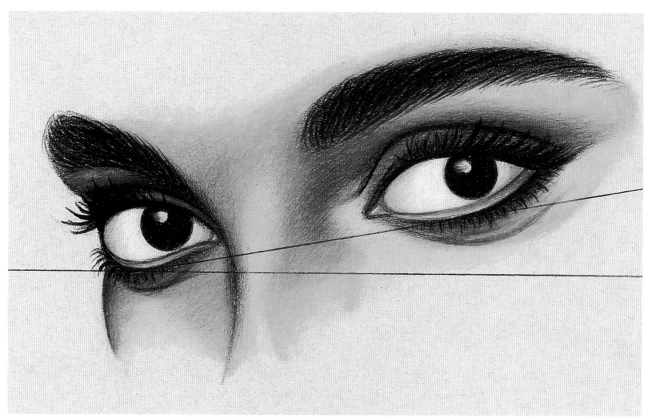

Use a Line to Help You See the Angle of the Eye
When drawing two eyes together, a horizontal line can help you see the tilt of the head. The eye on the right in this illustration is almost an entire eye higher. These irises are perfect circles. Even though the eyes are turned to the side, the eyeballs are turned to look at you straight on.

When drawing eyes at an angle, the perfect circles of the irises and pupils turn into ellipses instead (circles in perspective). Templates can be purchased for these.

Draw the Nose

Using the same approach we used for the eyes, begin the practice work for noses. Pay particular attention to the fact that the nose is a rounded form and is gradually protruding from the face. Because of that, you should be careful not to outline the nose as if it were a separate object. The shadow side of the nose does have a hard edge, but be sure to soften it into the face.

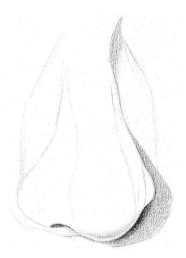

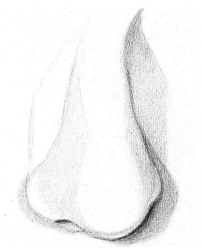

COLORS USED
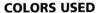

Verithin Pencils: Black
Prismacolor Pencils: White

Step 1: Graph a Line Drawing

Use a graph to help you complete a line drawing. Once the drawing is complete, remove the lines and begin placing tone on the shadow side of the nose with a Black Verithin pencil. Try to keep this tone smooth, with no pencil lines showing. Keep your pencil very sharp!

Step 2: Shape and Contour the Nose

Continue adding tone to develop the shape and contour of the nose. Lighten your touch for a gradual transition of tone.

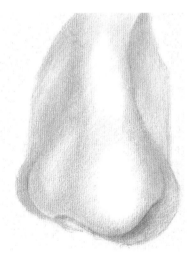

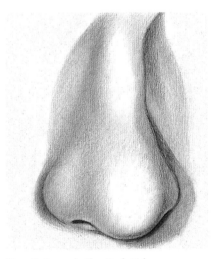

Step 3: Finish Shading the Nose

This nose is finished at this stage if you are just using a layered approach.

Step 4: Burnish the Drawing

To burnish this drawing, apply a layer of White Prismacolor over it. Use firm pressure to cover the paper. It will look a bit milky at this stage.

Step 5: Reapply the Dark Values

Reapply the values and soften them back in with the White. This drawing now looks entirely different from the previous one.

Draw a Full-Color Nose

Take your drawing knowledge one step further and add some color to the nose this time. You'll use the same process as in the last demonstration. Isn't it amazing how much difference a little color can make?

<div>

COLORS USED

Studio Pencils: Burnt Carmine, Terra Cotta, Pale Vermilion and Burnt Yellow Ochre.

</div>

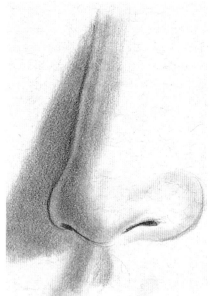

Step 1: Make a Line Drawing

To draw the full-color nose with Studio pencils, start with Burnt Carmine for the line drawing. Lightly fill in the shadow on the left with Burnt Carmine also.

Step 2: Begin the Skin Tone

Place a light layer of Terra Cotta over the Burnt Carmine and onto the skin on the right side. Darken the nostrils with Burnt Carmine.

Step 3: Blend the Colors

Blend the colors together with a tortillion. The colors will warm as they smooth out.

Step 4: Add the Finishing Touches

Add some Pale Vermilion and Burnt Yellow Ochre for a more golden glow to the skin and blend them in. Use a typewriter eraser to lift the highlights on the tip of the nose.

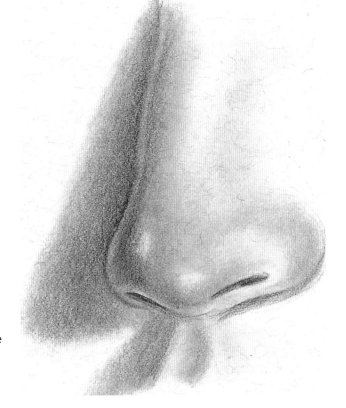

Draw the Mouth

The mouth is another important feature as far as capturing your subject's personality. It's very important that the mouth be drawn correctly, especially when it is an open-mouth smile. Each tooth must be drawn exactly in size, shape and placement.

This is where practice plays an important role. When I was learning to draw faces, I spent hours and hours with magazines, drawing every face I could find. It is the repetition that makes us learn the most.

Follow the exercise here and practice your techniques with colored pencils. Again, be aware of the differences between drawing a subject with graphite pencils versus colored pencils.

COLORS USED
Verithin Pencils: Black
Prismacolor Pencils: White

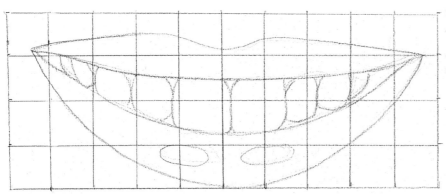

Step 1: Use a Graph to Help You Accurately Draw the Mouth

A ½-inch (1cm) graph helped me get the shape of every tooth accurate.

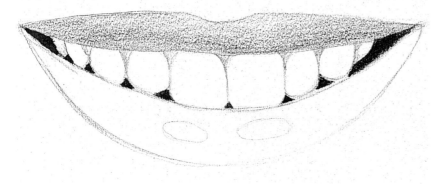

Step 2: Darken the Upper Lip

The upper lip always appears darker than the bottom one. Begin placing your tones here with a sharp Black Verithin.

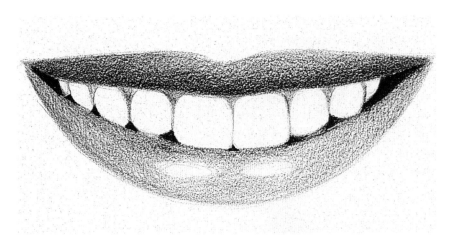

Step 3: Add Some Tone to the Bottom Lip

Keep it lighter than the top one. Leave some areas of the paper visible for highlights.

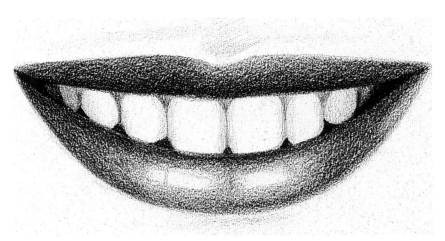

Step 4: Deepen Your Tones

Deepen your tones until you achieve the right color. Add a hint of shadowing to the teeth, especially the ones that are farthest back. Leave the drawing like this if you want to emphasize the layered technique.

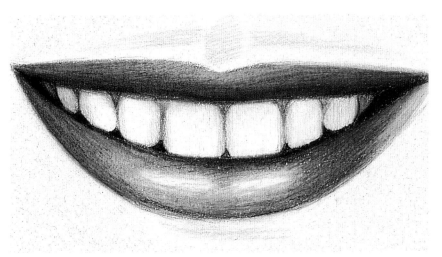

Step 5: Give the Teeth a Burnished Look

For the burnished look, cover the drawing with a coating of White Prismacolor. Reapply the darks and blend again with White until the transition appears smooth and gradual.

Draw the Nose and Mouth

Let's practice drawing the nose and mouth together in the following step-by-step exercise.

COLORS USED

Studio Pencils: Burnt Carmine and Pale Vermilion.

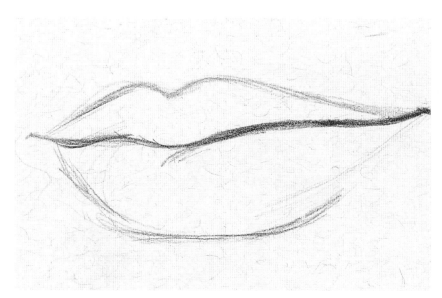

Step 1: Begin the Line Drawing

For full color with Studio pencils, begin this drawing with Burnt Carmine on the lower lip and Pale Vermilion on the upper lip.

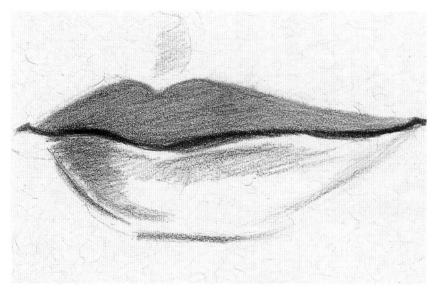

Step 2: Fill In the Upper and Lower Lips

Fill in the upper lip with Pale Vermilion and begin applying the shadow area of the lower lip with Burnt Carmine. Add some of the Pale Vermilion to the lower lip here also.

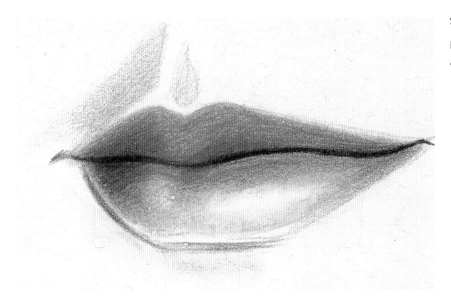

Step 3: Blend the Tones With a Tortillion

Reapply color and blend until you achieve the tone you want.

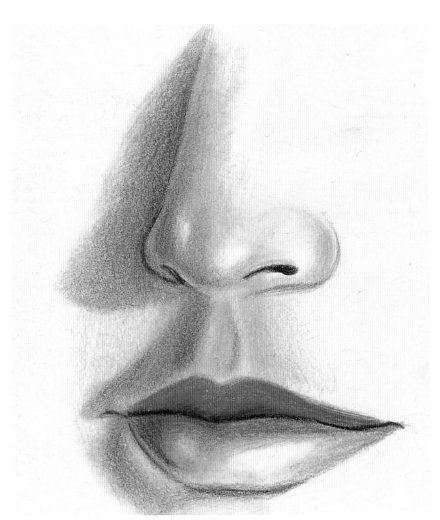

Step 4: Complete the Mouth and Add the Nose

Add and blend the colors around the mouth. Add the nose to complete the drawing (refer to pages 134-135 for complete instructions on creating the nose).

Draw the Ears in Color

The following studies of ears will give you some practice with the Verithin and Prismacolor pencils. Use a graph to create the line drawing. Be careful because the ear is a grouping of shapes within other shapes, which can be very confusing to draw.

The examples that follow the demonstration are common views of the ears as seen in portraits. As you can see, the hair plays an important part in the way they look. Since most of the time you will not see the ear from a side view, but more from the front, it is necessary to practice all angles and viewpoints. Often, very little of the ear—mainly its outside edge—will show.

<div style="border:1px solid black">

COLORS USED

Verithin Pencils: Dark Brown and Terra Cotta.
Prismacolor Pencils: Light Peach and White.

</div>

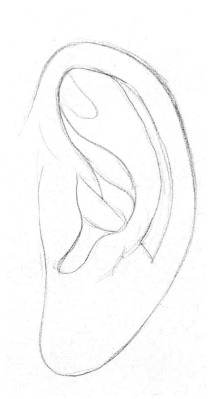

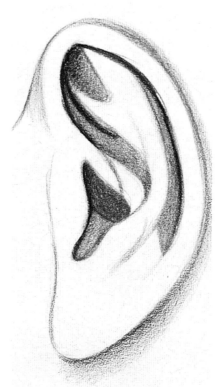

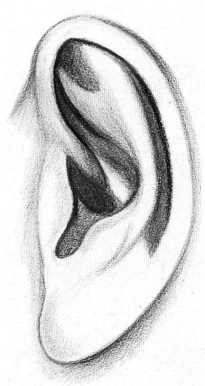

Step 1: Complete the Line Drawing

Use my graphing technique to help you complete an accurate line drawing on Shell Artagain paper.

Step 2: Apply the Shadow Areas

Replace graphite lines with a Dark Brown Verithin and begin to apply the shadow areas of the ear. This ear has a shadow behind it, making the edge of the ear appear light. Can you see reflected light around the earlobe? This would not stand out without the dark tone in the background.

Step 3: Contour the Ear

Continue adding tone to all of the contours of the ear. Look for where one surface overlaps another, creating hard edges.

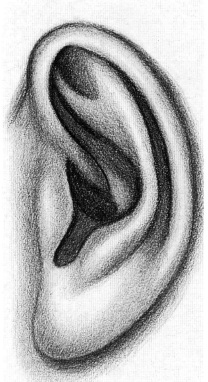

Step 5: Burnish the Ear

This drawing was burnished with Light Peach Prismacolor. Using the same colors in Prismacolor as you used before, reapply color and soften it with Light Peach. White Prismacolor has been added for the highlights.

Step 4: Create the Skin Tone

Add Terra Cotta Verithin to the drawing. This color will soften the brown into the peachy color of the paper and create the skin tone. This drawing is now complete if you are doing only the layered technique.

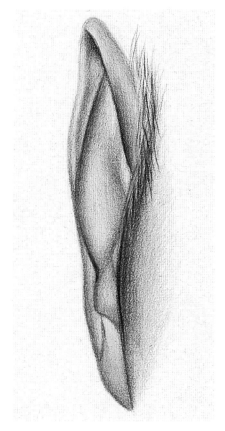

Typical View of the Ear
This ear looks very different than the side view of the ear you just completed in the demonstration. The head-on view gives you a condensed perspective, with many of the details hidden.

Side View With Hair
Hair often hides much of the ear.

Draw the Hand in Color

Knowing how to draw hands is very important if you are drawing people. However, hands are very complex. To learn them in their entirety, I suggest referring to my book *Draw Real Hands*. For now, I will give you a condensed version of what to look for when drawing them.

Again, shape is crucial to the overall look. Most people draw a hand that looks way too rounded. Instead, look for the many angles and straight edges found on a hand. This graphed example will help you practice. Use a graphite pencil to help you create a line drawing and practice drawing these shapes with a graph.

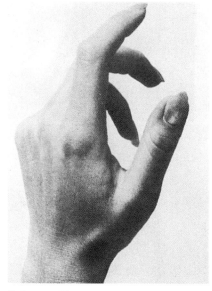

Reference Photo

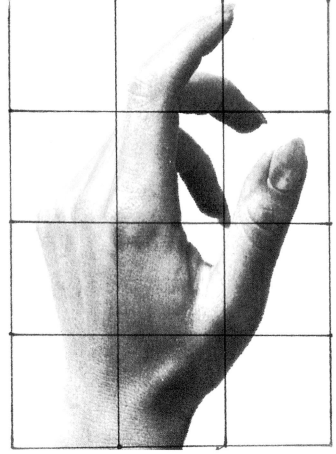

Step 1: Graph the Photo

Use this to obtain your shapes.

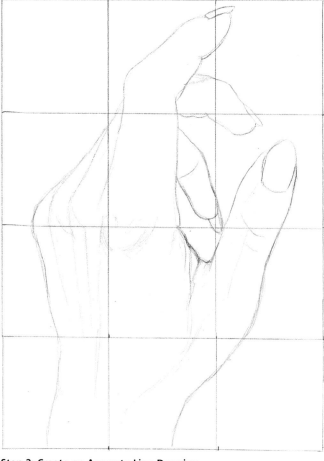

Step 2: Create an Accurate Line Drawing

Use a graphite pencil and the graphed photo at left to help you.

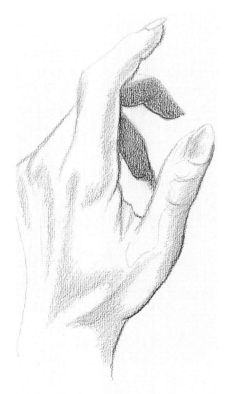

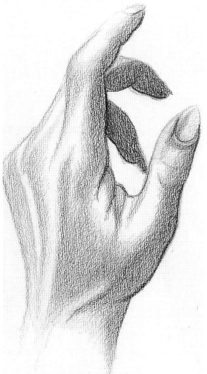

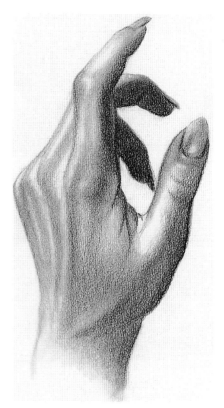

Step 3: Add the Shadow Areas

Begin adding the shadow areas with Dark Brown. Be sure to keep a sharp point on your pencil to create even tones.

Step 4: Create the Midtones

Add Terra Cotta to create the midtones of the drawing. Overlap the Dark Brown, which has already been applied. The colors will layer together.

Step 5: Finishing Deepening the Tones

Continue adding Terra Cotta until the depth of tone is achieved.

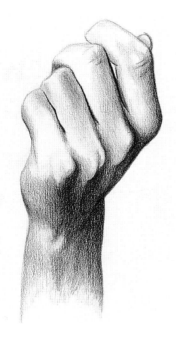

Hand Drawn in Brown Tones

Study this example of the hand drawn only in brown tones. Now compare it to the final step in the demonstration above. By adding a small amount of Terra Cotta to the brown, the final drawing has the look of realistic skin tones.

COLORS USED

Verithin Pencils: Dark Brown and Terra Cotta.

HAIR COLOR COMBINATIONS

Drawing hair seems to be a real trouble spot for many artists. There are two key factors to watch for: First, look for the direction of the hair and the way it is growing. Second, look for the dark shadows and highlights. Pencil lines should always be drawn going with the direction of the hair to represent hair strands. A quick stroke will taper the ends of your lines, making them appear more realistic. Hair must also be built up with many pencil layers to mimic the fullness of real hair.

When working with pencils, there are certain colors you can use effectively. The following hair examples will give you an idea of which colors to use. Remember, and this is just a basic formula. Every picture is different, and you will have to modify it to match the photo reference you are using.

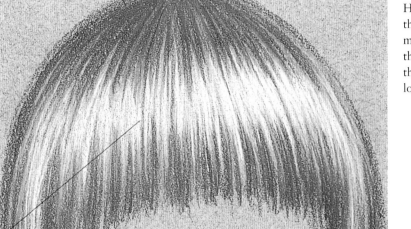

Band
of
light

Band of Light Indicates a Rounded Form
Here you can see a band of light across the head. This protruding area is the most rounded part of the head and, therefore, reflects the most light. Without this highlighted section, the head would look odd and flat.

Color Combinations
Listed below are color combinations for most of the common hair types. Experiment with your own combinations to match the hair color of the person you are drawing.

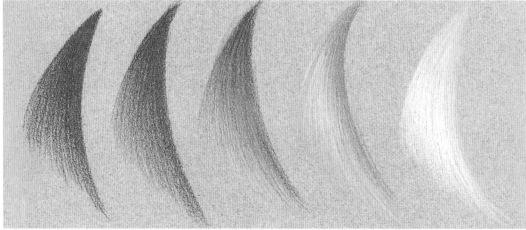

Dark brown hair: Black, Burnt Umber and Dark Brown

Medium brown hair: Burnt Umber, Dark Brown and Terra Cotta

Light brown hair: Dark Brown, Terra Cotta, Goldenrod and Cream

Dark blonde hair: Terra Cotta, Goldenrod, Cream and White

Blonde hair: Goldenrod, Cream and White

CLOTHING CLUES

I colorized these graphite illustra-
tions with Verithin pencils. They
are good to study whenever you
are drawing clothing. Realistic
depictions of fabric are essential
to good portrait drawing. To fully
understand how to draw dynamic
folds, look back at the beginning
chapters and study the five elements
of shading. All of these elements are
seen in clothing and will make your
clothing look believable. For more
in-depth coverage of drawing
clothing, refer to my book *Draw
Fashion Models*.

Study the Layers and Folds
This example shows how fabric hangs
and drapes. When this happens, folds
and layers are created. Each layer and
surface will show the effects of light and
dark. Always look for reflected light
along the edges of overlapping material.
This is what gives the fabric form, keep-
ing it from looking flat.

Create the Appearance of Realistic
Material with Shading and Highlights
Look at how the fabric is draping off of
this body. To create the smooth look of
silky material, I used Col-erase pencils. I
used Magenta with a hint of Gray for the
shadows. I blended the color out with a
tortillion and lifted highlight areas out
with a kneaded eraser. Can you see all of
the reflected light along the edges of the
fabric creases? Notice how this draping
effect is similar to the other examples.

TAILOR YOUR WORK WITH CLOTHING DETAILS

The different colored pencil brands will provide you with a variety of ways to draw fabric and clothing.

As you can see in the following examples, patterns are very important.

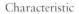

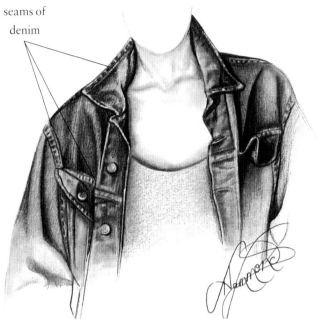

Characteristic seams of denim

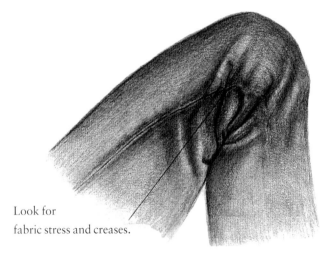

Look for fabric stress and creases.

Watch the Fabric Folds
Look for the way fabric creases when stressed or bent. The color tinting helps make the wave of the fabric stand out.

Denim Jackets
The seams are what make this drawing look like denim. The areas of light and dark are always seen in denim. The Indigo Blue makes this fabric look very realistic.

Heavy Layering

Blended texture

Stripes follow fabric folds

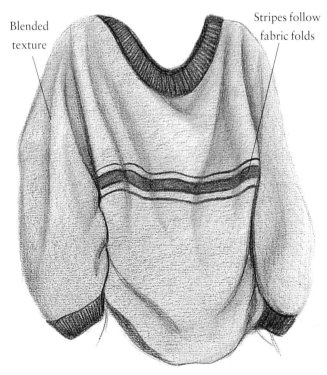

Create Textures in Fabric
This sweater was done in Prismacolors. To make the fabric seem rough and textured, I used the side of the pencil and a light touch, allowing the texture of the mat board to come through. The heather color was created with Lavender and Cool Gray 50%.

Pay Attention to the Details
This sweater is much smoother than the other one, but it is still textured—I didn't want it to appear too smooth. To achieve this effect, I used Studio pencils and blended them lightly with a tortillion. The light areas of the sweater were then lifted and softened with a kneaded eraser. I used Light Blue and Gray. Pay particular attention to the way the stripe of the sweater is rolling with the bend of the fabric. This is very important to the realistic representation of the material. Draw the stripe straight across and everything will look flat.

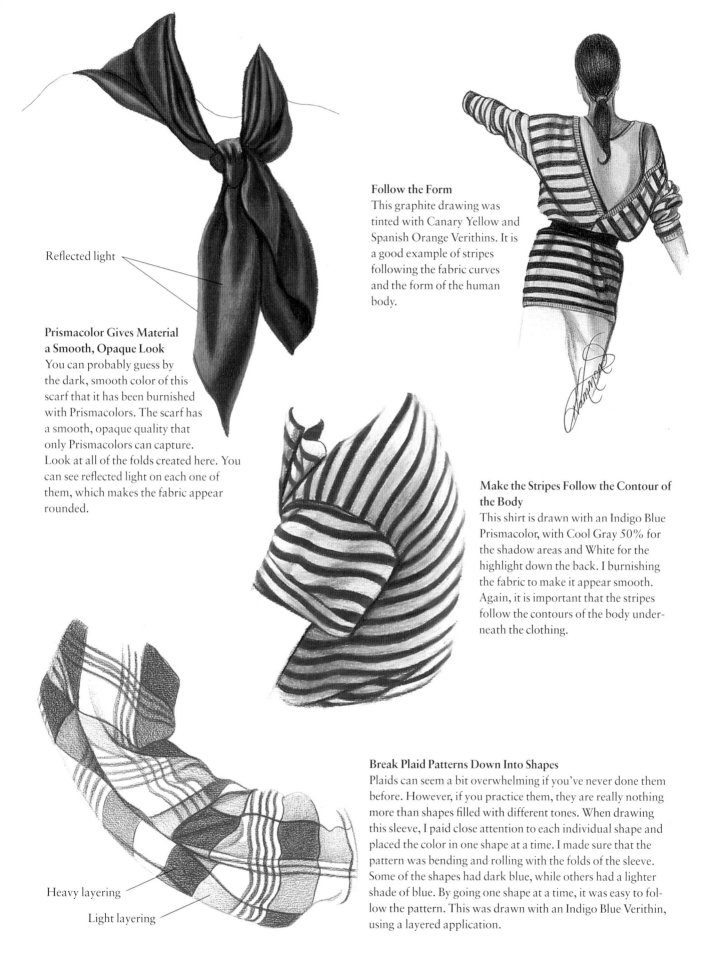

Reflected light

Prismacolor Gives Material a Smooth, Opaque Look
You can probably guess by the dark, smooth color of this scarf that it has been burnished with Prismacolors. The scarf has a smooth, opaque quality that only Prismacolors can capture. Look at all of the folds created here. You can see reflected light on each one of them, which makes the fabric appear rounded.

Follow the Form
This graphite drawing was tinted with Canary Yellow and Spanish Orange Verithins. It is a good example of stripes following the fabric curves and the form of the human body.

Make the Stripes Follow the Contour of the Body
This shirt is drawn with an Indigo Blue Prismacolor, with Cool Gray 50% for the shadow areas and White for the highlight down the back. I burnishing the fabric to make it appear smooth. Again, it is important that the stripes follow the contours of the body underneath the clothing.

Heavy layering

Light layering

Break Plaid Patterns Down Into Shapes
Plaids can seem a bit overwhelming if you've never done them before. However, if you practice them, they are really nothing more than shapes filled with different tones. When drawing this sleeve, I paid close attention to each individual shape and placed the color in one shape at a time. I made sure that the pattern was bending and rolling with the folds of the sleeve. Some of the shapes had dark blue, while others had a lighter shade of blue. By going one shape at a time, it was easy to follow the pattern. This was drawn with an Indigo Blue Verithin, using a layered application.

Draw a Dark Outfit

Clothing is an important factor in any portrait. To draw it well is essential. Even in a dark outfit, such as this one on the baby, the folds and creases of the fabric can make or break your drawing. Without realistic depiction of this dress, the drawing would not be nearly as cute. Also, the outfit is a large portion of the composition. Without dimension and form, that large dark area would appear flat and compositionally heavy.

To help you practice clothing, let's draw this portrait of Caitlynn.

I've used a white outline in the photograph to help separate her from the dark background (see the edge of the hat). Create an accurate line drawing using the grid. For this drawing I used no. 1008 Ivory mat board. The final drawing was done in Studio pencils.

As you draw, look for the creases and folds in the outfit. Look for the hard, overlapping edges as you map it out box by box. If you need more help with the shapes of the facial features, you can divide those boxes into smaller squares.

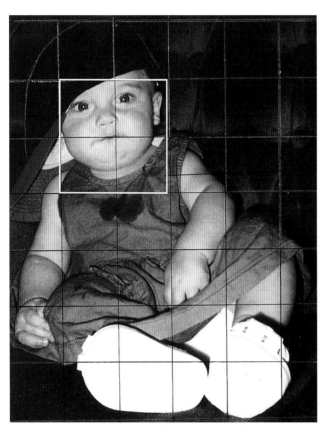

Reference Photo
Divide this photo into ½-inch (1cm) squares for more accuracy.

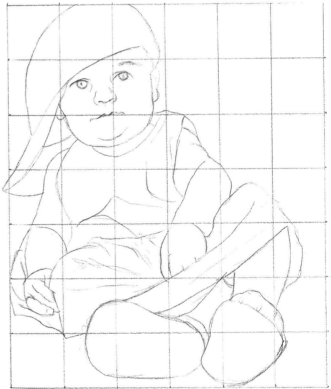

Step 1: Make a Line Drawing

Use a graph to achieve an accurate line drawing. Use ½-inch (1cm) squares in the area of the facial features if necessary.

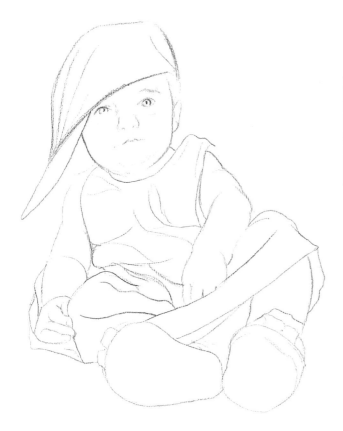

Studio Pencils: Terra Cotta, Indigo Blue, Geranium Lake, Mineral Green, Burnt Carmine, Red, Chocolate Brown and Delft Blue.

Step 2: Remove the Graph Lines

When you are satisfied with your line drawing, remove the graph lines with a kneaded eraser.

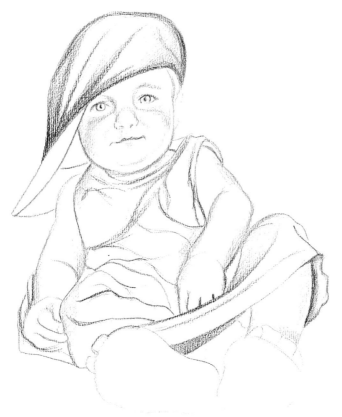

Step 3: Replace the Graphite Lines

Use Terra Cotta for the skin and Indigo Blue for the dress and hat. Outline the bill of the hat with Geranium Lake.

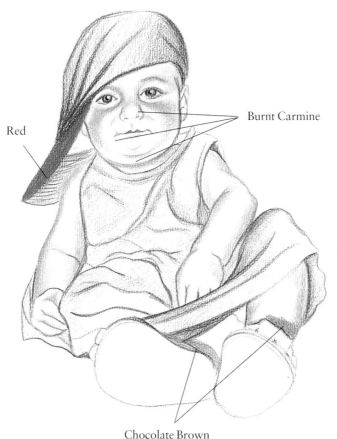

Red

Burnt Carmine

Chocolate Brown

Step 4: Build the Color

Continue adding more color to the drawing with your sharp pencil points.

Step 5: Add the Finishing Touches

Blend the skin tones, adding some Burnt Carmine for the deeper areas. Fill in the bill of the hat with Geranium Lake, and use Mineral Green for the inside of the bill.

Add a layer of Indigo Blue to the hat and dress. Create the shadow above the shoes using Chocolate Brown.

Gently blend the Terra Cotta color in the arms and legs, allowing the color of the paper to come through for the lightest areas.

To finish the drawing, add more color to the skin tones, using a hint of Geranium Lake for more redness. Blend everything at this point with the tortillion. Look at how smooth the dress and hat become. If any areas get too dark, or if you need more highlight areas, you can lift out some color with a kneaded eraser. Leave the background light, instead of dark like the photograph. Give her a surface to sit on using Delft Blue to create a shadow underneath (some of it is bounced up into the bottom of the shoe).

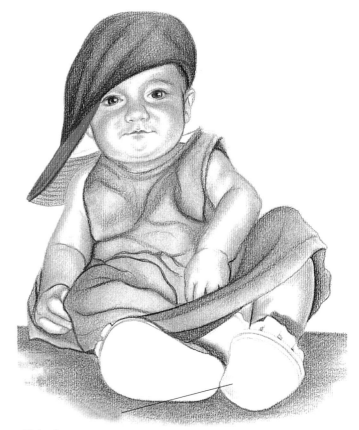

Color bounces up
from below.

PORTRAIT POINTERS WITH COL-ERASE PENCILS

We are now ready to begin a complete portrait concentrating on one particular brand of pencil. Moving from my graphite technique to Col-erase pencils may seem like a smooth transition. Much of the same approach is used for both because they both are blended with a tortillion.

Col-erase pencils are clay-based with a very powdery consistency. The colors are not very rich and give a much softer impression when used. Because of this, the Black pencil is very weak and will not produce a deep black. When working with them, I supplement the black with a Nero pencil. It's clay based, but it has a much richer pigment that can produce a deep, dark black tone without the wax buildup that Prismacolor produces.

This illustration is a good example of what Col-erase pencils can achieve. This study in brown and black has a very smooth look. To enhance the brown tones, I chose a mat board with a hint of brown. It is called no. 908 Candlelight.

Can you see how the hair has been created by the direction of pencil strokes? Because both Col-erase and Nero pencils are erasable, I used a combination of erasers to lift the highlight areas. A kneaded eraser will produce subtle highlights; a typewriter eraser will create bright light areas.

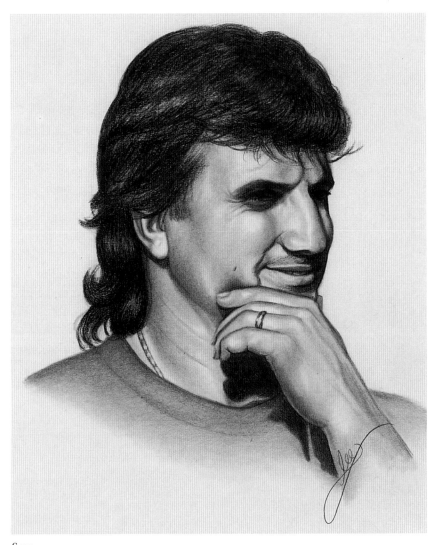

Sam
Brown Col-erase and no. 1 Nero pencils on no. 908 Candlelight mat board
14" × 11" (36cm × 28cm)

CREATE REALISTIC SKIN TONES

The following illustrations show how versatile Col-erase pencils can be. I began with a monochrome study in brown. I used Moonstone Artagain paper. Look closely at how the Brown is blended gently into the color of the paper. See how it fades gradually? This will help you create smooth skin tones.

The color drawing of the girl, at right, has been done on no. 1026 Rose Gray mat board. I tried to keep the drawing simple, not overdetailed. I chose to leave the hair somewhat unfinished for a bit of a graphic look. The suggestion of line gives the hair its direction. Again, notice how smoothly the color has been blended into the paper color. I rendered her skin with the basic skin colors: Brown, Tuscan Red and Terra Cotta. I added Crimson Red into the face to create an appearance of blush.

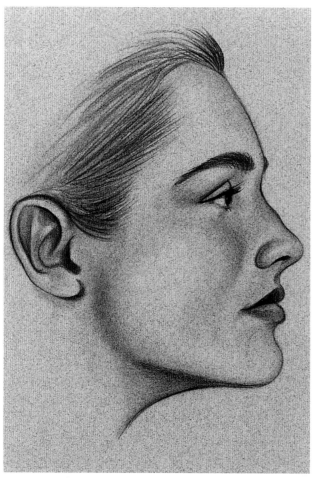

Profile in Brown Tones
Col-erase pencils on Moonstone Artagain paper
14" × 11" (36cm × 28cm)

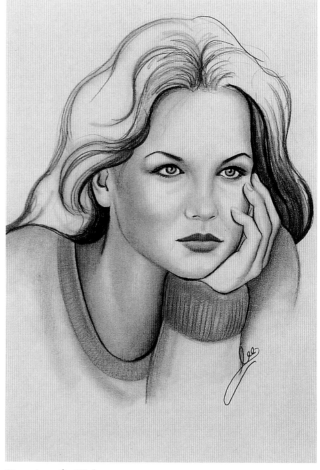

Drawing of a Girl
Col-erase pencils on no. 1026 Rose Gray mat board
14" × 11" (36cm × 28cm)

Draw a Face Using Col-Erase

Now, let's try a full-color example. I chose no. 1008 Ivory mat board for this drawing to help create the subtle tones of the skin. Using the line drawing and the graphed photo example from page 129, let's draw Kayce. When you are working with color, you should replace the graphite lines of your graph drawing with a Brown Col-erase pencil, or draw the graph drawing in Brown to begin with. Sometimes graphite lines can blend into your colored pencil and muddy it.

COLORS USED

Col-erase Pencils: Black, Brown, Terra Cotta, Tuscan Red, Canary Yellow and Light Green.
Nero Pencils: Black

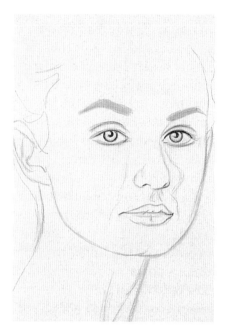

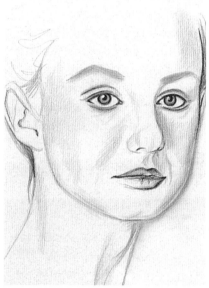

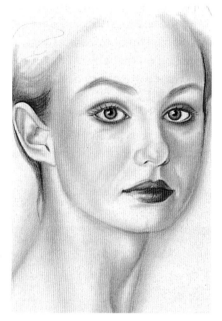

Step 1: Begin the Portrait

Always begin a portrait with the eyes using the circle template. Place the pupil in the center of the iris with Black, leaving a small area for the catchlight. Later, after you apply more color to the iris, intensify the Black with the Nero pencil. Softly apply some Brown to the eyebrows and blend it smooth. With some Brown, apply color to the eyelid crease. Then place Terra Cotta along the lash line and under the eyes.

Step 2: Add Color to the Face

To develop the shadow areas of the face along the right side, use a light application of Brown and gently blend it with a tortillion. Then add Terra Cotta and blend the two colors together. Add Tuscan Red to the outline of the lips and to the inner membrane of the eyes and below the eyes. Add Tuscan Red to the nostril area.

Step 3: Fill in the Eyes, Face and Background

To achieve the hazel color of her eyes, place Brown around the outside edge of the iris and then add some Canary Yellow and a small amount of Light Green. When blended together, the colors look wonderful!

This face has a beautiful edge of reflected light along the right side. To help describe the edge of the face, start adding the blue background color next to it. Can you see how the reflected light is now visible? Also place Brown into the hairline and behind the ear.

Verithin colored pencils are some of my favorites. Sometimes, depending on the subject I am drawing, I want my work to have more of a "drawn" look to it, as opposed to being softly blended. The Verithin line of pencils is perfect for this. Their hard, sharp lead gives my artwork a somewhat grainy appearance.

The Old Masters used to say, "Draw not just the subject…draw the effects of light on the subject." This drawing is a perfect example of this theory. One of my students brought a photo into my studio; I fell in love with it immediately, and not just because of the darling little boys. I was entranced by the poses and the color. Most of all, I love the lighting.

Look at the way the light plays off of the faces and hands. It gives the illusion of warm sunshine radiating in through a window. The band of light along the head of the boy on the left makes his hair look so soft and shiny. I added some Prismacolor White to the highlight areas to make them stand out.

The Verithin pencils allowed me to control the effects of light on the clothing by using layers of color as opposed to adding light. The light areas are just layered more lightly to allow the color of the paper to come through: No white was added. For the shadow areas in the clothing, I used Tuscan Red. The brown background color behind the subjects helps define the outside edges, allowing the reflected light to be seen.

This type of lighting situation will produce the best-looking artwork. Keep this in mind whenever you are searching for reference photos.

I use Verithins for a variety of looks. I usually reserve the blended techniques for light portrait work, such as babies and women. I use Prismacolors for bright colors and shiny surfaces. I find Verithins good when drawing situation poses, textures and rougher skin tones on porous surfaces.

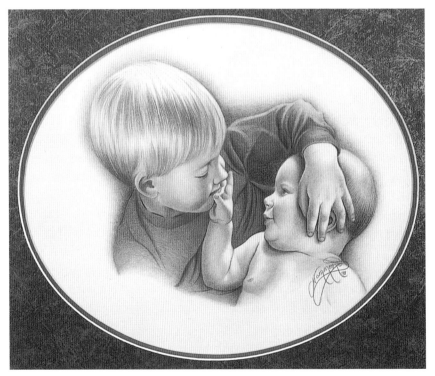

Be Creative With Your Framing
The matting around a piece is as important as the artwork itself. Always enhance your work, compositionally and with the color scheme, when selecting your mats and frames. Be as creative with this as you are with your art.

Rob and Ben
Verithin pencils on no. 1008 Ivory mat board
16" × 20" (41cm × 51cm)

Draw a Portrait Using Verithins

A full-color portrait is a challenge. Let's draw Christopher. Refer back to the line drawing we did on page 128 and follow along, step by step. This portrait was done on no. 1008 Ivory mat board. The line drawing is done with Verithin Dark Brown pencil.

<div style="border">

COLORS USED

Verithin Pencils: Dark Brown, Black, Terra Cotta, Indigo Blue, Light Peach and Tuscan Red.

</div>

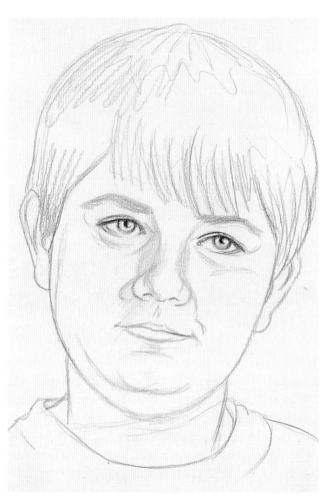

Step 1: Start the Portrait With the Eyes

Start the portrait by adding a touch of Black into the eye area. Gently apply some Black to the eyebrows and the lash line. Draw in the irises and pupils of the eyes with a template, leaving a spot for the catchlight. Also take the Dark Brown down the side of the nose to develop the shadow there.

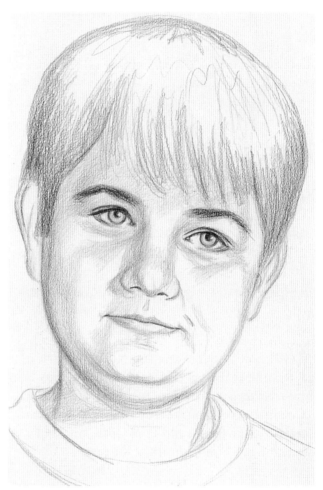

Step 2: Apply Tone to the Hair and Face

Continue to apply some tone to the hair with quick, sharp strokes of Dark Brown. He has two bands of light, so be careful not to fill it all in. For his skin tones, add a touch of Terra Cotta to the face and lips.

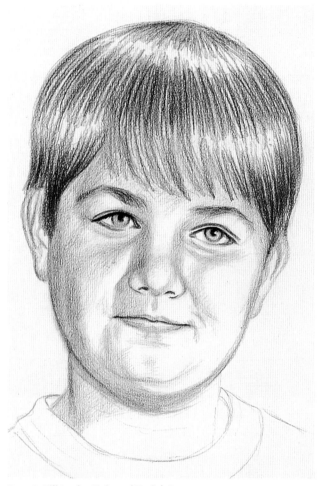

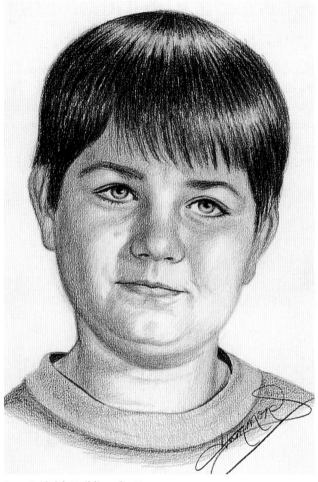

Step 3: Fill In the Hair and Facial Contours

Add more Dark Brown to the hair to help it fill in. Remember, you must build up the thickness of the hair with many, many layers of tone.

Continue developing the shadows of the facial contours with more Dark Brown and Terra Cotta. Also, add a touch of Indigo Blue to the irises.

Step 4: Finish Building the Tone

As you can see, the finished drawing is much deeper in tone. By applying Black, you are able to darken the eyes and deepen the hair color. To make the highlight areas of the hair appear more natural, use a kneaded eraser to lighten and soften the edges.

Deepen the skin tones with more Terra Cotta and a touch of Light Peach to help them fade into the paper color. Use Tuscan Red in the shadow areas along the side of the face and under the chin.

To complete the drawing, use Black and Dark Brown with a very light touch to create the neckline of the shirt. It is hard to believe that such a realistic drawing can be created with just a handful of colors.

Complete a Figure Drawing

Next, let's do a complete figure drawing. This project will give you practice drawing the entire figure. Look at everything as independent shapes within the grid boxes as you draw the picture accurately. Pay particular attention to the creases and folds of the clothing. These represent the body underneath and the stress placed on the fabric by the body's position. For this drawing, I used the Verithin pencils on no. 1008 Ivory mat board.

When you draw the face, refer to the previous exercises for information on the features. It will be harder to draw the face accurately when drawing small, so keep a sharp point on your pencil to keep the lines thin and easier to manage in small areas. It will also help you to draw lightly at first so you can alter and correct the features as you work. When you feel you have achieved a good likeness, then you can build up the color.

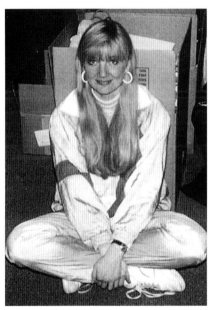

Reference Photo
This time you will be drawing a portrait of me.

COLORS USED

Verithin Pencils: Dark Brown, Rose, Tuscan Red, Black, Terra Cotta, Golden Brown, Process Red, Parma Violet, Deco Pink and Cool Gray 50%.

Prismacolor Pencils: White

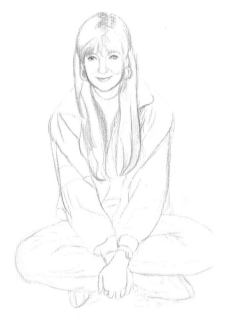

Step 1: Complete a Line Drawing

Once your graph lines have been removed, begin to replace the line drawing with your Verithin pencils. Use Dark Brown for the face and hair. Use Rose for the clothing. Keep the pencil lines light at this stage.

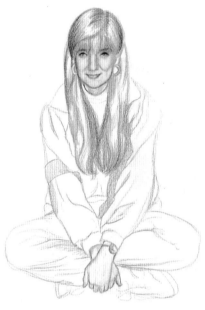

Step 2: Build Up the Color

Build up the color of the hair with Dark Brown. Look at the photo for the patterns of dark and light. Apply the pencil lines with quick strokes, following the direction of the hair.

Finish replacing the graphite lines of the clothing with Rose. Lightly fill in the stripes of the jacket.

Begin to add some color to the face and hands, starting with the outside edges. Use Tuscan Red for the dark edge, and then fade in from that with Terra Cotta. Use Tuscan Red for the lips, and define the eye with Black.

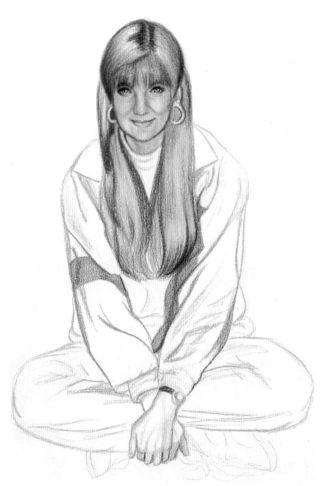

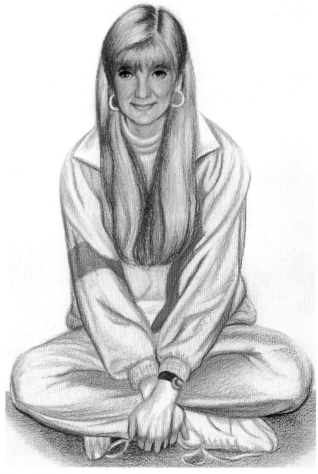

Step 3: Add Color to the Hair and Outfit

Continue building the color of the hair. Add some Terra Cotta to the brown for more of a reddish cast, and add Golden Brown for a blonde look. Again, put in the pencil lines following the direction of the hair.

Continue adding color to the outfit. For the stripes, use Process Red. Also place the red in the creases for more darkness. Under the elbow, place some Parma Violet (lavender). This creates the look of a shadow. Add some of the Process Red to the face so that the color of the outfit will reflect into the skin tones.

Add some Tuscan Red into the knuckle area of the hands and between the fingers. For the front of the hand, add a small amount of Terra Cotta for the skin tone.

Step 4: Complete the Drawing

To finish the hair, soften it by gently rubbing over it with a type-writer eraser. Add some highlights the same way. Look closely at the bangs. Lift a band of light for roundness.

Finish the clothing by filling in the fabric area with Deco Pink. Then lift the light areas out with a typewriter eraser. This gives the fabric the folds.

Add some of the Deco Pink into the face to complete the skin tone. To make the eyes stand out more, add White Prisma-color to the white of the eye.

Finish the hand by making the knuckle area darker with Tus-can Red and Terra Cotta. Draw the watch with Dark Brown; don't worry about adding too much detail.

Finish the shoes with Parma Violet and Cool Gray 50%. Again, don't add too much detail. Add just enough to create the illusion of shoes.

Finish off the drawing by adding the shadow underneath. For this, use Cool Gray 50% and Terra Cotta layered on top of one another. Adding this makes the drawing appear more solid. The shadow helps define the shape of the shoes and gives the impression of a floor underneath the figure.

SAVOR SITUATIONAL POSES

These drawings are more complex than what we have covered so far. They are situation poses, or character studies. They do more than just tell us what someone looks like, as in a posed portrait. They tell us what the subjects are doing.

This wedding picture of my nephew is an excellent example of a situation pose. It is designed to tell a story about the subjects. This is why they call it "illustration." The layered approach with the Verithin pencils allowed me to capture the texture of the suit and the wedding veil, but by applying color lightly, I was still able to make their skin look smooth.

Music on the Wharf is a great reason why I always have a camera ready. It is a wonderful example of a character study. This is another one of my favorite drawings because of the story it has to tell. I think the Verithin pencils capture the various textures of the drawing wonderfully. Look at the texture of his jeans. You can see the illusion of the fabric weave in the highlighted areas. The sun is shining off of the surface of his jacket, making it look smooth and leatherlike. The texture of his hair was created with the side of the pencil and tight, circular strokes.

I deliberately kept the background simple so it wouldn't take attention off of the main subject. With a touch of Indigo Blue horizontal lines, I was able to create the illusion of water. With some Brown and Black diagonal lines, I created the look of a wooden dock underneath him.

Bill and Christina
Verithin pencils on no.
1008 Ivory mat board
16" × 20" (41cm × 51cm)

COLORS USED

Skin: Terra Cotta, Dark Brown and Tuscan Red.

Jacket: Black, Indigo Blue and Dark Green.

Jeans: Indigo Blue and Peacock Blue.

Water: Indigo Blue

Music on the Wharf
Verithin pencils on Strathmore
Renewal paper
14" × 11" (36cm × 28cm)

PORTRAIT POINTERS WITH PRISMACOLOR PENCILS

When you want to make a bold statement of color with your work, Prismacolor is the way to go. Its waxy consistency and brilliant color range can give your drawings the look of oil paintings.

The drawing of the clown shows you just how bright the colors are. The creaminess into which they blend on the paper makes them quite easy to use for brightly colored subject matter. They are also excellent for creating bright highlights and sheen. Whenever I see shiny surfaces, I reach for my box of Prismacolor pencils.

You can employ a variety of applications and techniques when using Prismacolors. I burnished the drawing to get the bright hues seen in this clown. Burnishing is a process of building of thick layers of color. It can be quite time consuming, so be patient. All of the colors must be heavily applied to completely cover the paper's surface. Then every color added must be softly blended into the others. Generally, you will always use the lighter colors to blend into the darker ones. There is no limit to the number of colors you can add. It is a back-and-forth process of adding and blending until you have achieved the look you want.

Burnishing is not the only technique that can be used with Prismacolors. Look at the hair of the clown. I created this fuzzy texture using the side of the pencil with tight, circular strokes. I layered various colors together to give the hair contrasts of both light and dark. Can you see how each color blends into the next one?

Prismacolor Works Well for Very Bright Subject Matter
Prismacolor will completely cover the paper surface. Textures, such as this hair, can be achieved with the side of the pencil and a lighter touch.

The Clown
Prismacolor pencils on white illustration board
12" × 9" (30cm × 23cm)

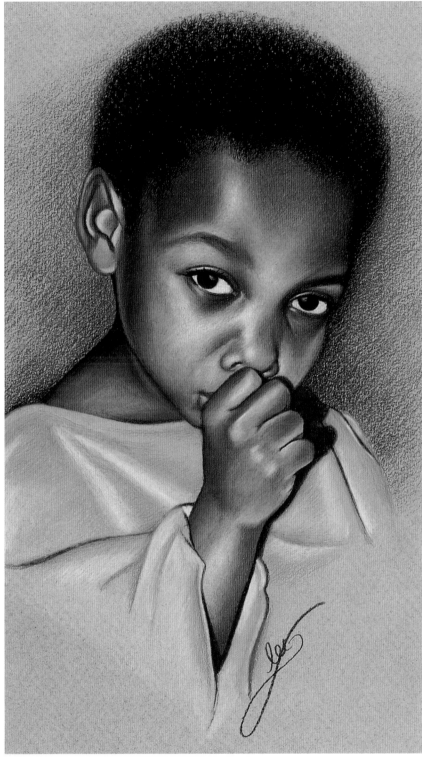

Little Boy Sucking His Thumb
Prismacolor pencils on no. 3305 English Stone mat board
20'' × 16'' (51cm × 41cm)

COLORS USED

Skin Tones: White, Cream, Peach, Deco Yellow, Terra Cotta, Mahogany, Dark Brown, Tuscan Red and Black. I started with the Peach, laying down an even coating of color, and then started working the dark shadow areas into it. Those colors were then softened together using the Peach. The lighter areas were built up slowly, gently softened into one another. Many layers were used, going back and forth until the right color was achieved. It is very important to have both the shadows and the highlights placed accurately to help create shape.

Eyes: Dark Brown for the iris; Black for the pupil. White for the sclera and catchlight. Black for the eyelashes; Dark Brown for the eyebrows. Always be sure to have the skin tones applied first, and then place the eyebrows and eyelashes on top of them.

Hair: Dark Brown and Black, using the side of the pencil for texture.

Clothing: True Blue combined with White. Cool Gray 90% was used for the creases and the shadow of the hand. Peacock Blue was used on the edges of the creases and shadows to soften them and make them appear less hard edged.

Background: Indigo Blue, combined with Cool Gray 90%, and softened on the outside edges with Peacock Blue. I used a light touch to create texture.

COMBINE PENCILS TO GET THE LOOK YOU WANT

Sometimes it's necessary to use a combination of pencils to achieve the look you want. The following two drawings are examples of that.

The drawing of LeAnne and Christopher reading is a combination of Verithin pencils and Prismacolors. If you look closely at the textures and colors of this drawing, you can see where each pencil has been used. As with many of my colored pencil drawings, I use Verithins to depict the skin tones and Prismacolor to render the bright colors of the clothing.

COLORS USED

Skin: Verithin Dark Brown, Tuscan Red and Terra Cotta.

Background: Verithin Indigo Blue

Hair: Verithin Dark Brown, Yellow Ochre, Terra Cotta and White.

Clothing: Prismacolor Ultramarine and Indigo Blue (Christopher), and White, Blue Slate and Cool Gray 50% (LeAnne).

Reading Together
Verithin and Prismacolor pencils on no. 1030 Pastel Pink mat board
16'' × 20'' (41cm × 51cm)

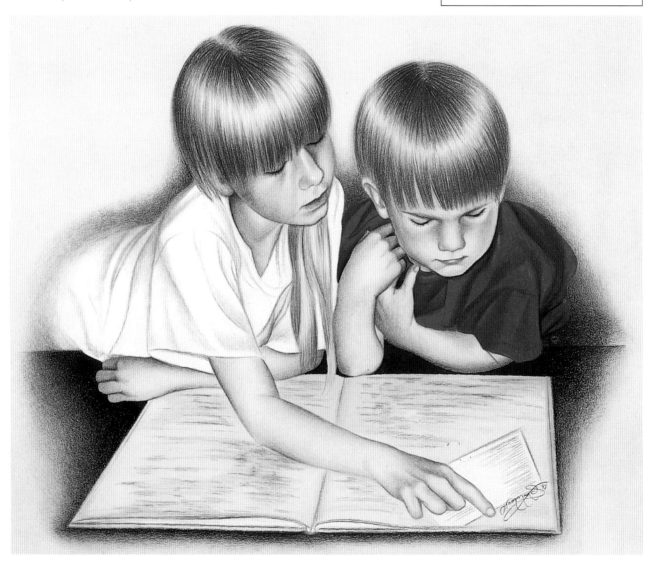

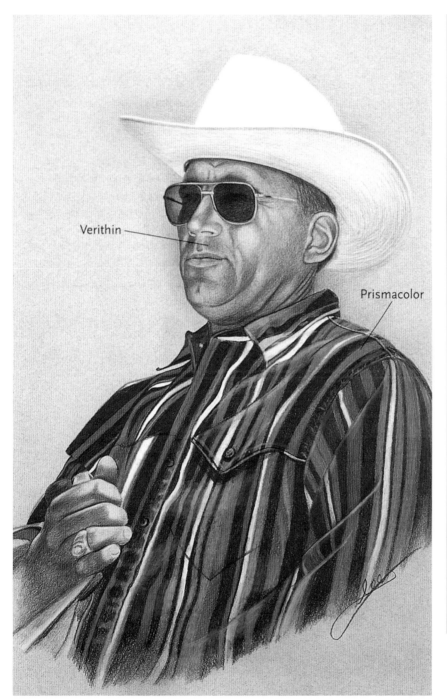

Verithin

Prismacolor

COLORS USED

Skin Tones: Dark Brown, Tuscan Red and Terra Cotta Verithin pencils.

Face: Verithin Dark Brown, Tuscan Red and Terra Cotta

The Shirt: I used the Prismacolor pencils to capture the vivid colors of his shirt. I was very careful to follow the direction of the stripes, making sure they followed the contours of his body. I then used White to burnish over the colors for the highlight areas.

Stripes: Prismacolor Black, Peacock Blue, Parrot Green and Process Red

Background: To increase the blue around the figure, I applied some Verithin True Blue around him, letting it gently fade into the paper color.

The Hat: Burnish with White, Sand and Yellow Ochre Prismacolor pencils for the golden hues. Use Dark Brown and Terra Cotta Prismacolors were used to create the rim and shadow where the hat encompasses the head.

Combination of Prismacolor and Verithin Pencils
I used Verithins to create his my brother's skin tones and textured face. I thought Prismacolors might make his face and hand seem too waxy looking. I also used Verithins for the color in his sunglasses so they would appear transparent, allowing the color of the paper to shine through.

Bill at Wickenburg
Verithin and Prismacolor pencils on Storm Blue Artagain paper
24" × 19" (61cm × 48cm)

I think suede paper gives portraits such a beautiful look. Like the other colored-pencil techniques covered in this book, it's important to choose a paper color that will help create the colors of the skin. This drawing has been done on no. 7132 Whisper.

Look at how smooth the skin tones appear. The light application and even pressure of the pencil are crucial for this gradual blending of colors. However, firm pressure can also be applied for dark, crisp lines and edges. For example, look at the jewelry, as well as the eyelashes and brows. These lines are very precise.

The smoothness of the suede mat board gives the illustration its beautiful look. The soft nap of the board takes the pigment of the pencils and softens it to create the subtle look of a pastel drawing. While Prismacolors are often used to create bold, smooth color, the suede board softens the colors, allowing the pencils to be used in a whole new way.

COLORS USED

Skin tones: Peach (for the basic skin color), Henna, Terra Cotta, Burnt Ochre, Tuscan Red and Light Umber (for the darker areas). Add a warm glow with small amounts of Yellow Ochre. Highlight some areas with Cream and White. Base the lips with Mahogany Red, add the crease with Tuscan Red and use White highlights.

Hair: Use a no. 1 Nero pencil for the hair's deep tone. Streak the highlight with Light Aqua Prismacolor.

Background: Start behind the face with Blue Violet Lake, then then transition into Light Aqua and Deco Blue.

Jewelry: For the necklace, use a very sharp no. 3 Nero pencil. Give it a hint of color with Parrot Green, and then add White highlights. Use Yellow Ochre and Mahogany Red for the gold jewelry, then add White highlights. The pearls on the headpiece are White. The red ornaments are Mahogany Red and Tuscan Red.

Clothing: Base the green areas with True Green and Olive Green, and highlight with White. Firmly draw in the White areas. Detail the outfit with Yellow Ochre and a bit of Scarlet Red for interest. Soften the edges where they fade into the paper using Deco Blue.

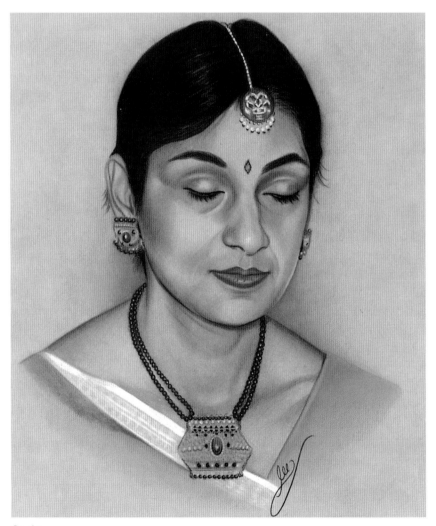

Sonia
Prismacolor pencils on no. 7132 Whisper suede mat board
11" × 14" (28cm × 36cm)

Derwent Studio pencils have a unique formulation that allows a heavy application of color as well as a soft, blended look. This drawing incorporates both of these qualities.

To achieve a smooth, blended look, the pencil lines must be put down lightly and evenly first and then blended out with a tortillion. It is important to use a paper color suitable for the skin tones.

COLORS USED

Skin Tones: The skin tones are are made with Terra Cotta, Copper Beech, Burnt Carmine and the warm glow of Deep Chrome Yellow added in. I used this color as well as Burnt Carmine and Lemon Cadmium for the background. The left side of the face has more of a yellow tone to it. The right side seems cooler with more Madder Carmine.

Clothes: The outfit is Ivory Black, with Sky Blue for the highlights.

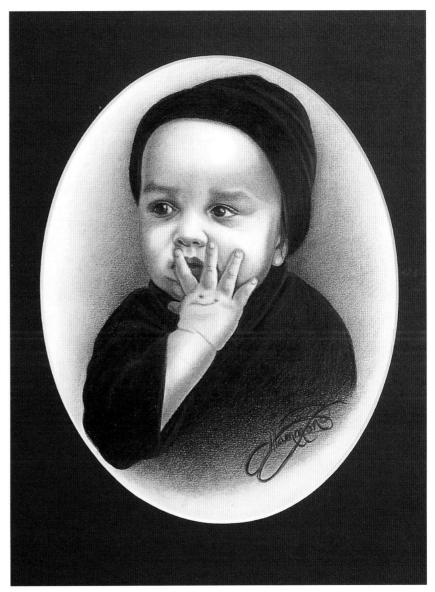

Mat Boards Accentuate Your Drawings
This portrait of Sydney is done on no. 1008 Ivory mat board. I used a lot of background color and repeated the colors in the skin tones. The oval mat balances the dark tones and makes the light tones stand out.

Again, note how these pencils go from very light to very dark. The black outfit contrasts sharply against the smooth, light baby skin. (We laughed at this outfit, saying she looked like the world's youngest cat burglar!)

Sydney
Studio pencils on no.
1008 Ivory mat board
10" × 8" (25cm × 20cm)

PORTRAIT POINTERS WITH WATERCOLOR PENCILS

Watercolor pencils are a unique way to combine the application of colored pencils with the look of traditional watercolor painting. The application of a little water turns your drawing into a painting.

Since the techniques and applications used with watercolor pencils are so different than those of other color pencils, it is helpful to go back to the basics.

The sphere is the best subject for practicing a new technique. Use these illustrations as a guide to help you learn the process before you attempt a full portrait project.

To create a portrait with watercolor pencils, you begin very much the same way as you would for a traditional colored-pencil drawing. Always start with an accurate line drawing, and build your colors just like you did with the other projects in this book.

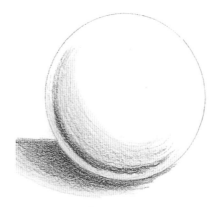

Draw the Sphere and Overlap the Colors
Using Blue and Magenta, I lightly drew the characteristics of a sphere. The pencil is applied very lightly, since the addition of water will deepen the colors considerably. By overlapping the two colors, I created a purple color.

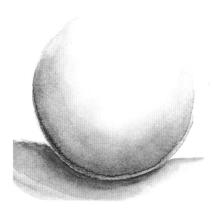

Blend the Colors With Clean Water
With a damp paintbrush, I was able to blend all of the colors together. In the full-light area, the pigment has been blended with water to fade to the white of the paper color. (These have been drawn on watercolor board.)

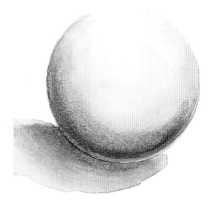

A Sphere Completed With Flesh Tones
I used Dark Brown, Burnt Carmine and Terra Cotta. A hint of Black was used in the cast shadow, directly under the sphere.

Draw a Portrait Using Watercolor Pencils

Watch how a little water applied with a fine brush will melt the drawing down into a painting. The following is a step-by-step exercise in drawing a portrait of a man with watercolor pencils.

<div style="border:1px solid">

COLORS USED

Watercolor Pencils: Terra Cotta, Dark Brown, Indigo Blue and Black.

</div>

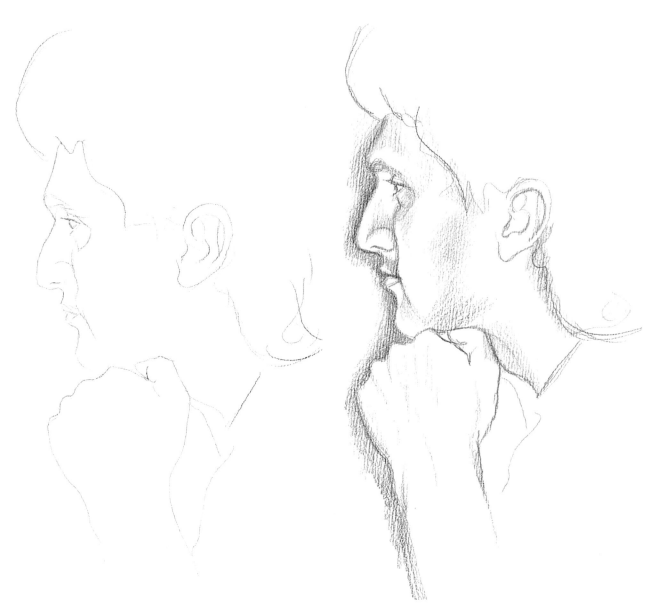

Step 1: Complete a Line Drawing

Draw an accurate line drawing with graphite.

Step 2: Lightly Start the Skin Tones

Begin with a layer of Terra Cotta, then use a small amount of Dark Brown along the jawline and above the upper lip. To help the edge of the face stand out, use Indigo Blue behind it.

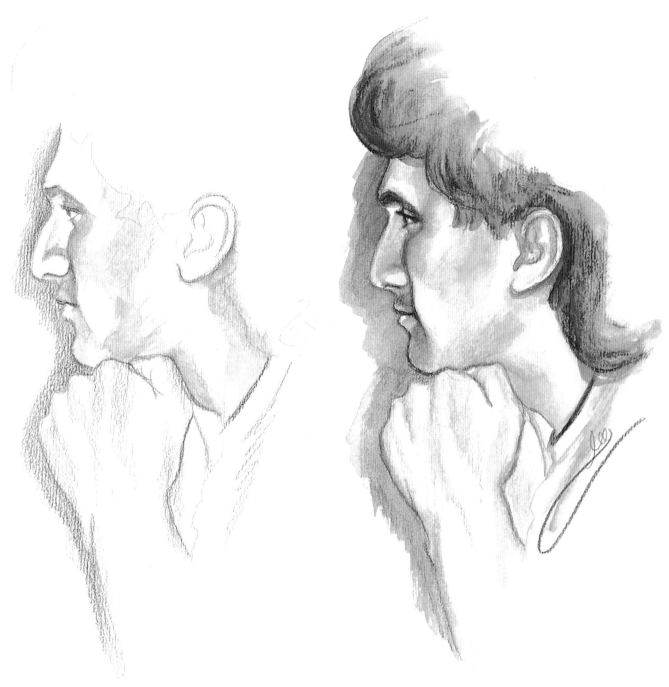

Step 3: Blend the Facial Tones

Softly blend the facial tones with a damp paintbrush. Don't use a lot of water, just enough to hydrate the pigment into a wash.

Step 4: Finish the Drawing

Use Dark Brown and Black to create the hair. Place the pencil lines going with the direction and curve of the hair. After blending the hair with a wet paintbrush, use the color on the brush to go into the shadow areas of the face, deepening the tones. You don't have to wait for it to dry and then reapply pencil; borrowing color from another area and brushing it in is easier, quicker and smoother.

With a wet brush, blend the Indigo Blue background. Can you see how much darker it gets with the addition of water?

Portrait on White Velour Paper
This paper is called Aquavelour and is manufactured by the Atlantic Paper Company. It is actually a velour paper that has been mounted onto a piece of museum board developed for water-color applications. Using this surface is more of a challenge than using regular watercolor paper because the water soaks in so fast, that you cannot manip-ulate the color as well. Because of that, it creates very hard edges, which I think is neat. I had always wanted my water-color paintings to have a certain look to them, which I just couldn't seem to get. I almost gave up until I tried this paper. Now I'm ecstatic.

COLORS USED

This piece was done using a very small range of colors: Brown, Black and Purple. I think it has a nice, fresh look because of this.

Ray Charles
Watercolor pencils on mounted White
Aquavelour paper
14" × 11" (36cm × 28cm)

Drawing Animals in Color

Drawing animals requires the same attention to detail as drawing portraits of people. Animals have distinct qualities and personalities that must be present in your drawing to make them appear believable and realistic.

I start my students off with the same advice as if I were teaching them portraiture: (1) Practice! Practice! Practice! and (2) begin with the basic features. The more you do, the more fully you will understand the anatomy and its shapes. Let's begin with the eyes.

I always start my drawing with the eyes of my subject. They are where the life of my subject appears, and the soul of that life is revealed.

Although human eyes carry many of the same characteristics from person to person, animals all have very distinct traits attributed to their species.

Look at the shiny nature of eyes. When drawing them, be sure to place a catchlight in the eyes. This is a reflection that should be placed in the eye so it is half in the pupil and half in the iris. If your photo reference shows more than one catchlight, eliminate one of them. If it covers the pupil, change it.

Not only does the shape of the eye differ between the species, but so does the shape of the pupil. The round iris we are familiar with in our own eyes is not always present when looking at animals. Some species have elongated pupils. The pupil of a cat varies due to the light and can appear as a mere vertical slit or a round circle.

Some reptiles also have a vertical slit for a pupil; sometimes it appears vertical, and other times it appears horizontal. These are important features that are distinct to that particular species.

Horses or deer have pupils that are wide and oval and appear more horizontal. They also have eyelashes that must be captured when drawing them.

The eyes of many monkeys resemble those of humans. However, the sclera, or white part of the human eye, appears brown in monkeys. Rarely will you see the white area of the eye when observing animals.

On eyes like those of squirrels and some other rodents, the pupil and iris are not easy to see. The eye looks almost entirely black.

Whatever species you are drawing, it is always important to accurately capture the shapes before adding color. Also, place the iris and pupil in the eye right away to be sure you have it looking in the right direction before continuing on with your drawing.

Cat Eyes
The eyes of a cat are very colorful and shiny. Prismacolor pencils capture these qualities the best.

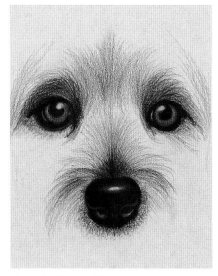

Eyes of a Shaggy Dog
The shadows around the eyes make them look deep set.

EYES HAVE DISTINCT CHARACTERISTICS

Notice the catchlight in each of these examples. I have placed it half in the pupil and half in the iris.

All of these eyes illustrate distinct characteristics seen in specific species. To enhance the appearance of the eyes, I used both a layered and burnished approach for all of them.

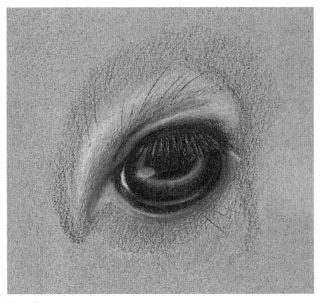

Deer Eye
The eye of a deer closely resembles that of a horse. Notice the long eyelashes.

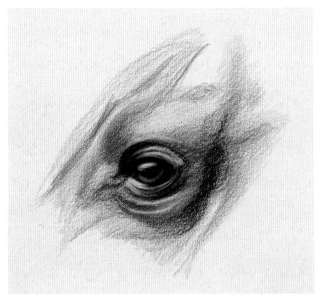

Horse Eye
This eye's pupil has a horizontal shape. Because of the dark color of the eye, the pupil is sometimes hard to see.

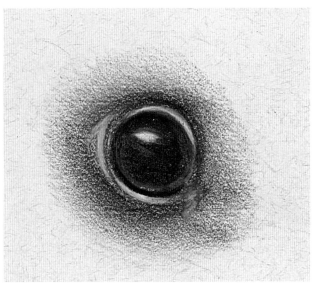

Eye of a Rodent
In this example of a squirrel, the eye is very black. It is hard to see where the pupil and iris separate.

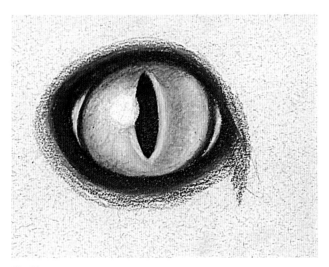

Cat Eye
The pupil of a cat's eye will vary according to the light. In bright light, the pupil appears as a vertical slit.

NOSES AND MOUTHS ALSO VARY

Noses and mouths of animals also vary from species to species. Because of the different needs and living conditions animals have, their noses and mouths are designed differently to aid in their existence. For instance, the soft nose and mouth of a vegetarian bunny do not have the same requirements and characteristics found in a meat-eating tiger.

Study the various noses and mouths presented here. Ask yourself what importance the shapes have to each particular animal. Is it an animal that uses its ability to smell to exist, thus having larger nostrils? Does it have large teeth to hunt and kill its prey? All of these things are important for you as an artist, to truly "see" your subject matter.

In the animal kingdom, the nose and mouth are closely connected, so I generally have my students practice drawing them together.

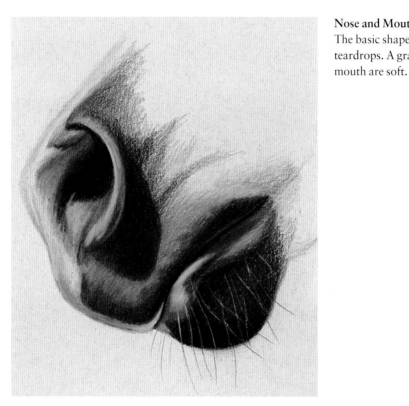

Nose and Mouth of a Horse
The basic shapes of the nostrils look like teardrops. A grazing horse's nose and mouth are soft.

Nose and Mouth of a Rabbit
Like the horse, the nose and mouth are very soft. This is a characteristic of vegetarians and grazing animals.

Open Mouth of a Tiger
You can clearly see the large teeth it uses for hunting. Each of these teeth has the five elements of shading and many colors that must be captured. Using Prismacolors makes the teeth look shiny and wet.

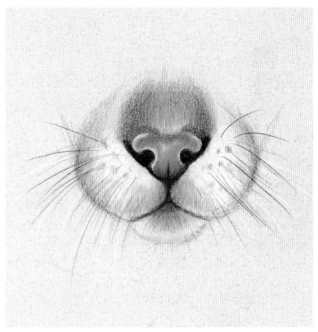

Nose and Mouth of a Wild Cat
A domestic cat has the same general shapes, only smaller.

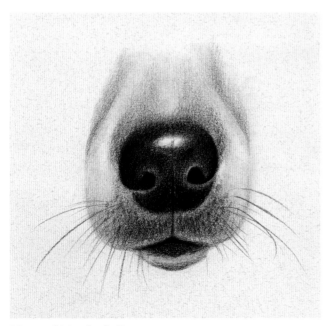

Nose and Mouth of a Dog
The highlight on the tip makes the nose look shiny. Prismacolors also work well for this animal.

SEEK OUT THE PROPER EAR SHAPE

The ears of your animal can make or break your artwork. They must have the proper shape and depth to look realistic. Ears are very complex at close examination. They are layered, and your drawing must show the overlapping features and details.

Study the large variety of ears seen in animals of various kinds. Some are huge and hang down while others are barely discernable. Some are pointy while others are almost perfect circles. Whatever shape and size they are, be sure to accurately draw them in your work.

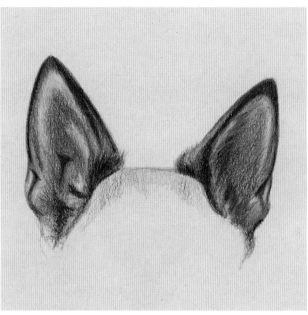

Pointy Dog Ears
The shapes inside the ears are very important.

Droopy Dog Ears
Look for the reflected light seen along the edges.

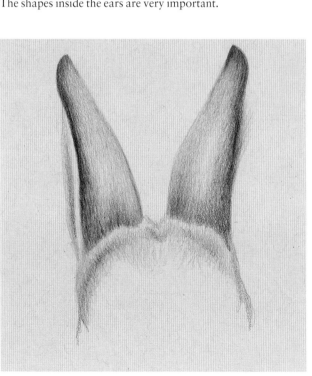

Pointy Bunny Ears
You cannot see the insides of these ears because of how they connect to the head.

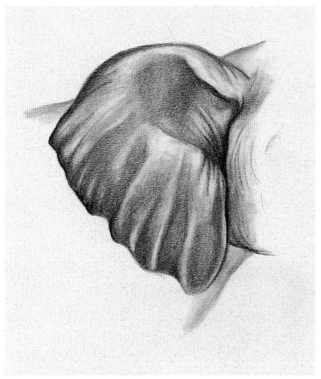

Ear of an Elephant
An elephant's ear has many folds, which create interesting shading patterns. Refer back to the five elements of shading on page 13 as necessary.

Horse Ears
The hair inside these ears is very visible. Draw it just as you would any other hair with long, tapered strokes.

NOTE

When drawing animal ears, the area inside of the ear is as important as the outside. Look how the many intricate shapes and tones are like puzzle pieces.

Round Mouse Ears
The insides of these ears have many small shapes to capture. This is another instance where my graphing technique will help you break down the various shapes.

FEET FEATURES

You may think that studying animal feet sounds silly, but animals would look funny without feet! Again, the differences between the species are enormous.

I think of the feet in terms of basic shapes and go from there. Look for the five elements of shading when you study their shapes. Shading must be present in order for them to look realistic.

As with the other features, the feet have distinct characteristics that apply to their use. A small squirrel has tiny fingers with sharp little claws that grip. That is how they dig for food and hold on to round nuts and berries.

Some animals have claws while some have hooves. Some feet are designed for climbing while others are designed for running or walking. A primate has useful hands and feet that resemble our own. Study these differences carefully.

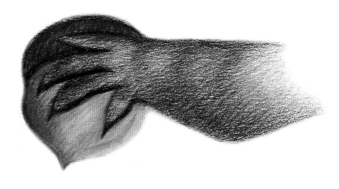

Paw of a Squirrel
This paw has sharp claws and a handlike quality that makes it very useful.

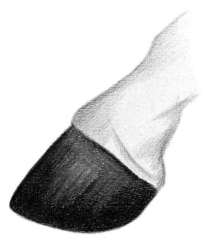

Horse's Hoof
The hoof of a horse is solid in shape.

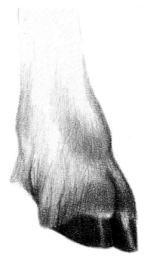

Sheep's Hoof
The cloven hoof of a sheep is divided in the middle.

LAYER THE LOOK OF HAIR AND FUR

One of the drawbacks of drawing animals is the amount of time it requires to accurately depict the fur. This is the area in which I receive the most grief when teaching my art classes. The hundreds of layers necessary to build up the look of hair and fur can be time-consuming and laborious, but it's worth it when you see the results!

This drawing of a koala bear doesn't look that complex, but this animal has very short, coarse hair. It requires many short, quick little strokes to make it look authentic. A close-up portrait of an animal makes the need for showing the hair even more important.

An Example of What *Not* to Do
Don't make your pencil lines harsh and deliberate!

The Correct Way to Draw Hair
Do use a quick stroke to taper the end of the line.

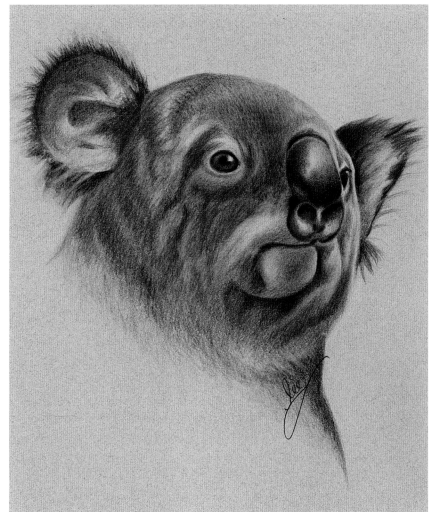

Verithins Work Best for Short Hair
Verithin pencils, with their sharp leads and fine points, helped create the short, coarse fur of this koala bear. It takes many layers of quick, short, overlapping pencil strokes.

Koala Bear
Verithin pencils on Strathmore Renewal paper
14" × 11" (36cm × 28cm)

COLORS USED

Verithin Pencils: Dark Brown, Dark Umber, Terra Cotta, Black and White

Draw Short Hair

The following example shows how to apply the pencil lines to make them appear as hairs. Use a quick stroke to make the pencil lines taper at the ends—flick your wrist, lifting up as you end the line.

A hard, deliberate stroke makes the pencil line too harsh and even in width, which makes the line fat and unnatural looking.

<table>
<tr><td>COLORS USED</td></tr>
<tr><td>Use a dark or earthtone pencil to create the fur.</td></tr>
</table>

Step 1: Fill In Light Tone First

Always start by filling in some light tone first. When drawing hair you never want the color of the paper coming through your pencil lines.

Step 2: Add Darker Lines

Begin by adding pencil lines in the direction that the fur is growing.

Step 3: Continue Until the Fur Is Filled In

Continue to add pencil lines with quick strokes until the fur fills in. Build up the layers until you have the fullness you need.

LENGTHEN YOUR LINES FOR LONG HAIR

The length of the hair is represented by the length of your pencil lines. For the long hair of this orangutan, I used long, sweeping lines that followed the hair direction.

Because of the many layers of hair on this animal, various shades of light and dark were created. These tonal changes are important to the overall look of the hair. It is the contrast of light and dark that gives it depth. Highlights are added on top to make them appear as reflections and not white streaks of hair.

This drawing was done on suede board. Its surface helped give the illusion of the softness of the orangutan's hair. The paper also makes it easy to create the blurred background, which makes it appear as though it is in the distance. To make something appear farther away, it should have less detail and

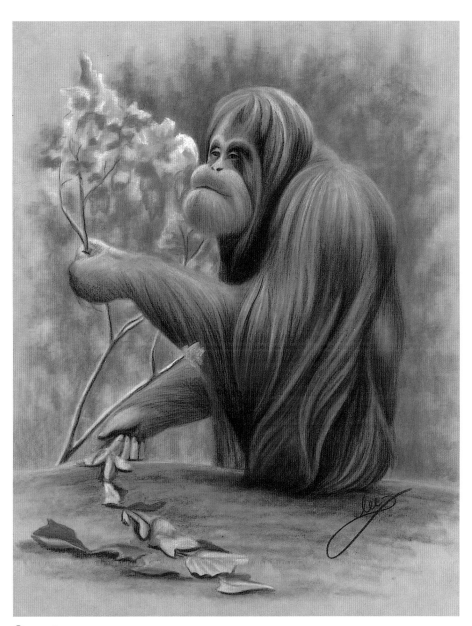

The Correct Way to Draw Hair
Do use soft, gentle lines that follow the shape of the hair.

An Example of What *Not* to Do
Don't use harsh, deliberate lines!

Orangutan
Prismacolor pencils on no. 7102
Dune suede mat board
14" × 11" (36cm × 28cm)

NOTE

Because Prismacolors do not burnish on suede board, it is not necessary to spray the piece when you are finished.

COLORS USED

Orangutan: Dark Brown, Light Umber, Terra Cotta, Peach, Pumpkin Orange, Black and White

Foliage: Apple Green, True Green, Dark Green, Chartreuse, Olive Green, Pumpkin Orange, Dark Brown and White

Ground: Dark Brown, Black and White

Practice Long Hair

The following example shows how to draw long hair. Notice how the length of the pencil line represents the length of the hair. All hair, short and long, requires many layers to make it look real. Again, a quick pencil stroke is essential. This makes the lines thinner at the ends. Drawing too deliberately will make the lines look unnatural.

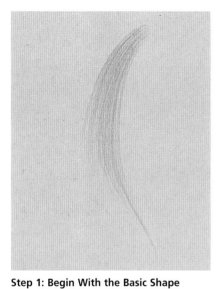

Step 1: Begin With the Basic Shape

Place some base tone down in the shape of the wave.

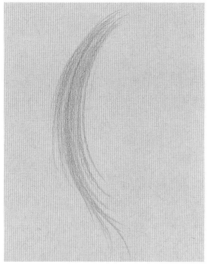

Step 2: Fill In the Hairs

Using quick pencil lines that follow the direction of the hairs, start to fill in the hair strands.

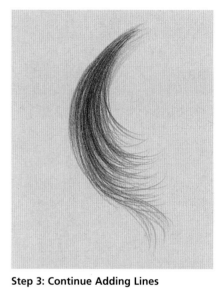

Step 3: Continue Adding Lines

Keep adding pencil lines until the hair looks thick and full.

DRAW ACCURATE PATTERNS AND MARKINGS

Many animals have built-in camouflage due to the colors and markings of their fur. This makes the job of an artist much more of a challenge. Each of these drawings were complicated by the patterns seen in the fur, but they were fun to do.

The tiger has some of the most beautiful markings seen in nature, especially the various colors contrasting against the black stripes.

To draw the colors and patterns seen here, it is important to draw in the lightest colors first. If the black is applied first, it will smear into the other colors.

Since whiskers overlap the rest of the face, they are added last.

When using Prismacolors you must first scrape out the area where you will draw the whiskers using the tip of a craft knife to get through the heavy, dark layers of wax buildup.

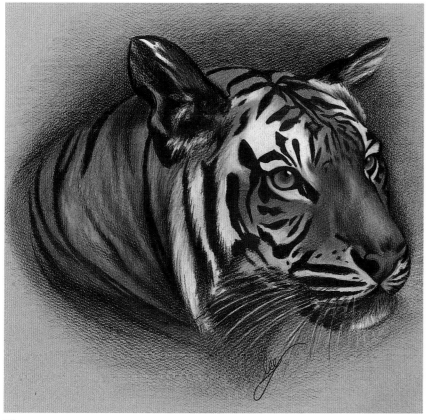

Tiger
Prismacolor pencils on no. 3347 Ashen mat board
16" × 20" (41cm × 51cm)

COLORS USED

Fur: Dark Brown, Light Umber, Terra Cotta, Mineral Orange, Yellow Ochre, Deco Yellow, Black and White

Nose: Mineral Orange, Black and White

Eyes: Dark Brown, Light Umber, Yellow Ochre, Deco Yellow, Black and White

Whiskers: White

Background: Dark Green, Black, Olive Green and Yellow Ochre

BLEND SPOTTED PATTERNS FOR A SMOOTH LOOK

The leopard was done in much the same way as the tiger on page 181. I used Studio pencils the same amount of time on the leopard as I used the Prismacolor pencils on the tiger, but the colors were not as vivid. The leopard's markings required less texture than the tiger's fur. I drew in the lighter colors first, then blended them in with a tortillion to make them appear soft and smooth. I filled in all of the black spots after I completed the color.

COLORS USED

Fur: Terra Cotta, Copper Beech, Sienna Brown, Chocolate Brown, Indian Red, Straw, Ivory Black and White.

Eyes: Sienna Brown, Straw, Ivory Black and White.

Background: Bottle Green, Sienna Brown, Terra Cotta, Delft Blue and Magenta.

Foreground: Sienna Brown, Chocolate, Terra Cotta and Delft Blue.

Whiskers: White

Leopard
Studio pencils on no. 1008 Ivory mat board
16" × 20" (41cm × 51cm)

Draw a Grizzly Bear

Anytime I want to show a lot of individual hair strokes and texture, I choose Verithin pencils. Their hard, thin leads produce nice thin lines. Verithins are perfect for this grizzly bear, which is full of bristly fur.

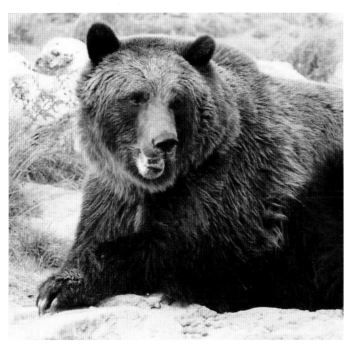

Reference Photo

<div>

COLORS USED ─────

Fur: Black, Dark Brown, Dark Umber, Terra Cotta, Yellow Ochre.

</div>

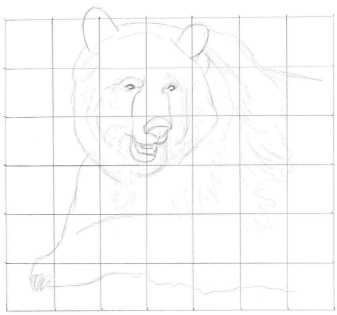

Step 1: Graph a Line Drawing

Check your drawing for accuracy, and remove the grid lines with a kneaded eraser.

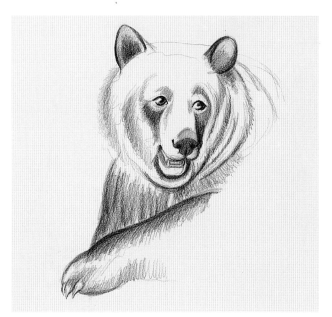

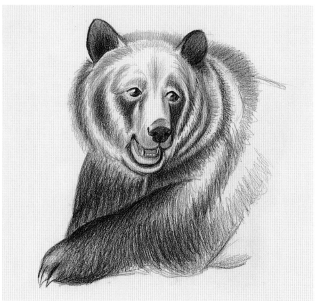

Step 2: Lay In the Base Tone

With a sharp Black pencil, begin with the eyes and nose. Then place tone in the ears and begin the dark areas of the fur. Be sure to look for the direction of the fur and place your pencil lines in accordingly. This stage already starts creating form.

Step 3: Continue Developing the Depth of the Tone

Begin with Black, then continue filling in the fur with Dark Brown and Dark Umber. Be sure to overlap the Black. Dark Brown is a little lighter than the Dark Umber; it gives the fur a touch of red. Keep following with the hair direction.

Step 4: Deepen the Look of the Fur

Add some Terra Cotta to deepen the red tones in the fur, and add some Yellow Ochre in the face. Keep adding your tones until you have enough layers to depict the fullness of the bear's fur. Be patient! This process takes a lot of time, so don't quit too soon. The biggest error that beginning artists make is not going far enough with their work. Add some green and brown tones in the background to give the illusion of ground and grass.

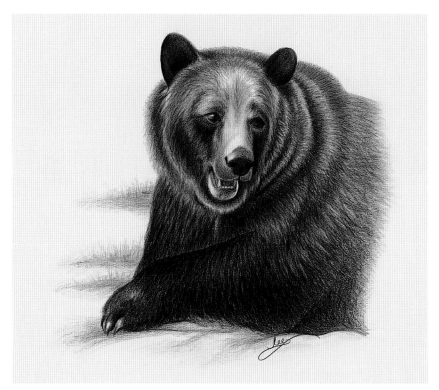

Draw a Dalmatian

Prismacolor pencils are excellent for creating rich color with good coverage. When I decided to draw this dalmatian, I knew Prismacolor was the pencil I needed to create the bright white areas. On gray paper, the white stands out even more.

Compare your line drawing to the photo, and check your shapes for accuracy. Once you are happy with the results, remove the graph lines with a kneaded eraser.

Step 1: Create a Line Drawing

This line drawing resembles a map. It is a large grouping of many shapes.

Reference Photo

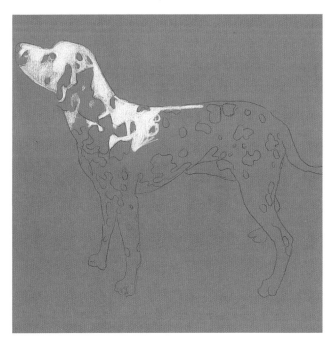

Step 2: Start With the Light Colors

Begin by placing in the light colors. Remember, if we put in the Black first, it will smear into the White when it is applied. Looking at the drawing as a map, begin filling in the White.

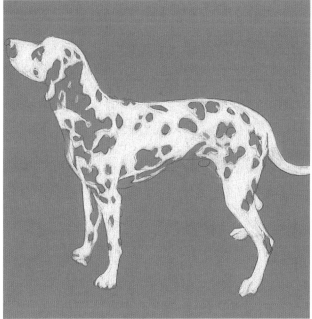

Step 3: Fill In the White Areas

Continue filling in White until the entire dog is completed.

COLORS USED

Prismacolor Pencils: White, Yellow Ochre, Mineral Orange, Warm Grey 50%, Light Umber, Peach, Dark Brown and Black

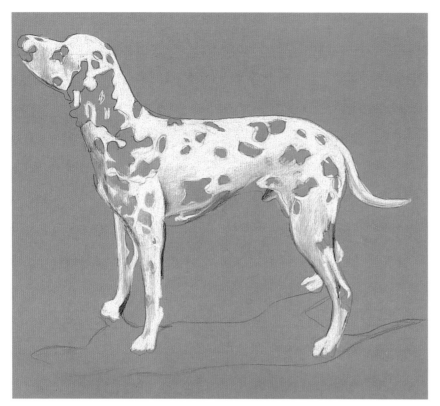

Step 4: Blend In the Shadow Areas

Look at your shadow areas. There are many colors reflecting into the white areas that need to be blended in. Use a variety of the colors listed on page 185 to achieve the look you like best. This is what makes your drawing look real.

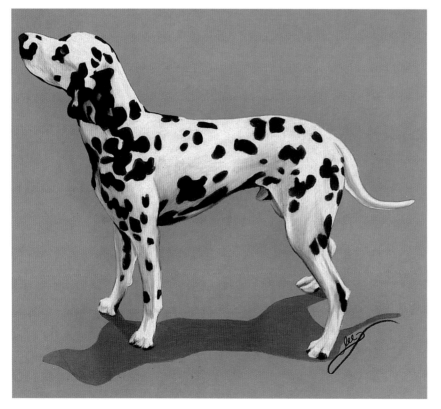

Step 5: Finish the Dog

Fill in the spots with Black, and add the shadow under the dog with Warm Grey 50%.

NOTE

Because Prismacolors are such a waxy medium, it is very important to spray your drawings with a fixative when you are finished. When left unsprayed, the wax in the pencils rises to the surface of your drawing, causing it to look hazy and foggy. This milky film is called wax "bloom." Once the drawing is sprayed, this no longer happens, so your colors look more vivid and pure.

Draw a Squirrel

I am using Studio pencils more and more in my artwork. I like the ability to use my blended technique with color to create soft tones, especially in background areas. These pencils can also be used heavily for a filled-in look. This small project of a squirrel will give you practice using the pencils both ways, for textured and blended areas.

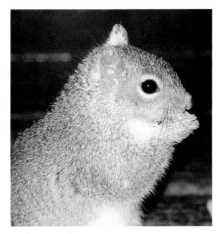

Reference Photo

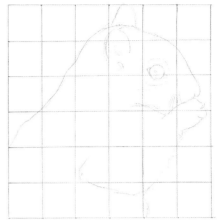

Step 1: Make a Line Drawing

Check your drawing for accuracy, and then remove the graph lines with a kneaded eraser.

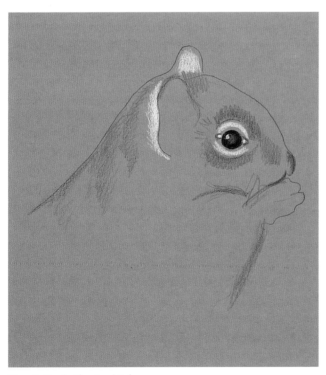

Step 2: Begin the Squirrel

Using Ivory Black and Sepia, draw in the pupil of the eye. Use the Sepia for the inside of the eye, with the Black around the rim. Be sure to leave a spot for the catchlight. Add some color around the eye and into the nose with Burnt Sienna. Add the White to the catchlight and around the eye. Place some additional White into the ear. With Copper Beech, begin the brown tones in the back and front of the squirrel.

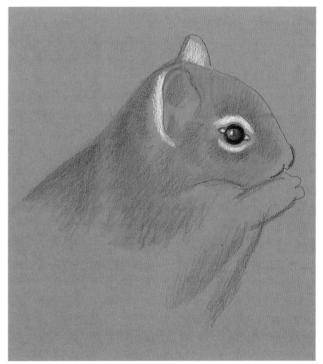

Step 3: Draw In the Fur Foundation

Add some more Copper Beech and Sienna Brown into the body of the squirrel. With a clean tortillion, blend the tones until they look nice and smooth. This will act as a foundation for building the rest of the fur.

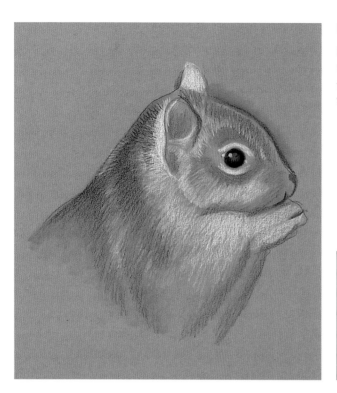

Step 4: Start Developing the Fur

Use quick strokes with a sharp point on the pencils for the fur. Use White, Copper Beech and Ivory Black, watching for the patterns of color and hair direction. Also, add Burnt Sienna and White to the inside of the ear and blend it smooth.

COLORS USED

Squirrel: Ivory Black, Sepia, Burnt Sienna, White, Copper Beach, Sienna Brown and Raw Sienna

Background: Juniper Green, Copper Beech and Ivory Black

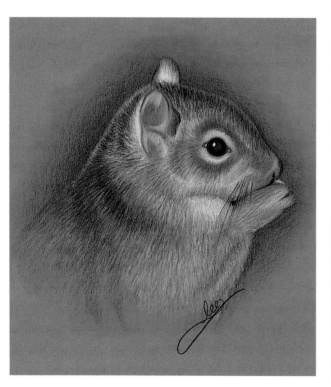

Step 5: Finish Adding Color and Blend

Add more color to the face of the squirrel with Raw Sienna. Add some to the tips of the ears as well. Continue to add to the overall fullness of the fur with quick, short pencil lines. Use the White, Ivory Black and Copper Beech.

Create the background by using Juniper Green, Copper Beech and Ivory Black. Add the colors lightly, and blend them together with a tortillion.

NOTE

When using tortillions, it is very important to keep them segregated according to color. You will not want to accidentally use a tortillion that has been previously used for a different color. I've accidentally blended blue into a brown area because I wasn't paying attention!

MORE OPTIONS FOR DRAWING ANIMALS

There are unlimited options for drawing and literally hundreds of surfaces that can be explored—enough to fill another book. My goal when I write is to help you see and explore as many options as possible.

This drawing is drawn on suede board and is one of my favorites.

Although the colors of the kitty are very rich, the paper makes them go on smoothly and look very soft.

Sometimes you will want to completely fill in your background. That will make the drawing look like a photograph instead of a portrait. It helps illustrate the scene and tell a story.

This little kitten had such soft color to its fur and I wanted the background darker to make him stand out. Although it took a while to fill in the background to make it look smooth, it was well worth the effort.

Because the dark background contrasts with the colors of the kitten, the eyes really stand out. By making the tail section of the kitten darker, it appears to be farther back in shadow, giving the drawing a real sense of dimension. It actually looks like the kitten is walking toward you!

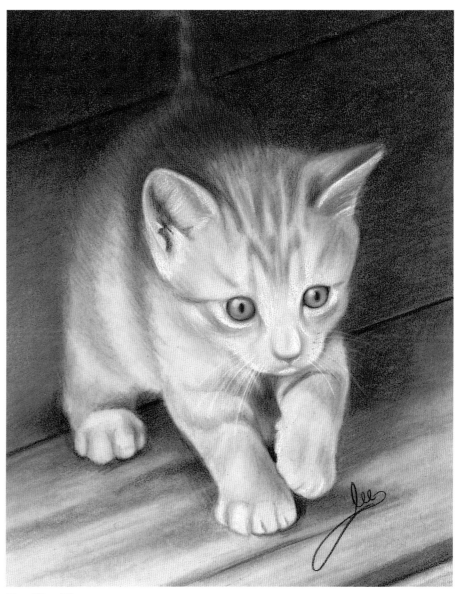

Here Kitty Kitty…
Prismacolor pencils on no. 7132 Whisper suede mat board
10" × 8" (25cm × 20cm)

COLORS USED

Eyes: Indigo Blue, Black and White

Fur: Sienna Brown, Peach, Terra Cotta, Mineral Orange, Tuscan Red, Dark Brown and White

Background: Black, Cool Grey 70% and Indigo Blue

There is a touch of Tuscan Red in the shadow under the kitten.

Drawing Flowers & Nature in Color

Drawing and photographing flowers is one of my favorite things to do. No other subject matter seems to have the myriad of colors, shapes and varieties so readily available to the artist. Being that they are mostly outside and subject to the effects of light, the extreme highlights and shadows make them appear differently every time you look at them.

Flowers lend themselves to almost every type of art. It is no wonder they can be seen throughout history in the art of every culture. Flowers are portrayed realistically and abstractly. They are found in drawings, paintings, clothing, jewelry, sculpture, stained glass, mosaics and more. The possibilities are endless for you.

One theory important to drawing flowers and nature is the use of hard and soft edges. A soft edge is found where something curves. The shadow edge of the flower is a soft edge.

A hard edge can be seen wherever two surfaces touch or overlap. Looking at the drawing of the poinsettias, you will see many areas of overlapping shapes within the petals and leaves. Wherever two petals overlap one another, it creates a hard edge.

Reflected light and cast shadows are essential when drawing hard edges. This is what keeps the subject from looking "outlined." Any time you draw a hard edge, it is important to take the tone out, away from the edge, to prevent an outlined appearance. Also, an edge of reflected light will place the tone underneath, instead of appearing as an outline on the surface itself.

Anything that has an edge or a rim will have an edge of reflected light. It will clearly be seen where the edge overlaps a cast shadow area.

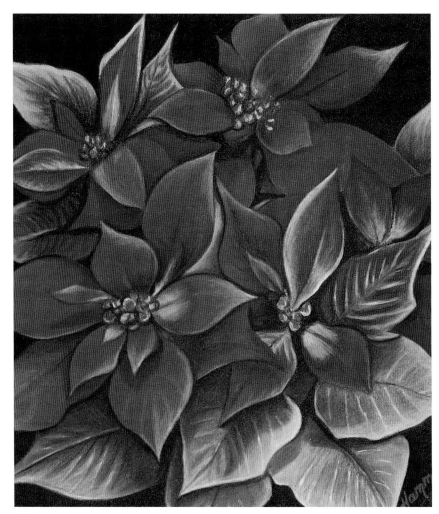

Poinsettias
Prismacolor pencils on no. 1008 Ivory mat board and sprayed with satin tole finish spray
12" × 11" (30cm × 28cm)

Draw Poinsettia Leaves

Let's draw poinsettia petals together to learn how to draw a hard edge. Also, look for the soft edge, where the petal gently curves. Without soft edges, the flower petals would look flat, like sheets of paper.

> **COLORS USED**
>
> **Prismacolor Pencils:** Poppy Red, Black, Tuscan Red, White and Crimson Red.

Step 1: Begin the Poinsettia

Begin this exercise with a light outline of the petal's shape. Place a layer of Poppy Red down as a base color. Add some Black behind the petal for a shadow.

Step 2: Define the Petal

Add some Tuscan Red into the shadow area where the two petals overlap. Add some White to the edge of the petal to create reflected light.

Step 3: Blend the Colors and Burnish

Add Crimson Red to the petal with firm pressure, blending the colors together. Reapply both the Tuscan Red and the White. Use the lighter colors to soften into the darker ones to blend the colors together.

Recall that Verithin pencils have a dry, thin lead. They can be sharpened to a fine point, which is their most valuable characteristic. They come in a range of thirty-six colors. Be sure to have a quality pencil sharpener handy at all times. I recommend a battery-operated or electric style.

Examine the value scale below right. The colors layer without mixing together. The surface of the paper still shows through, creating a somewhat grainy effect. This is a wax-based pencil, but it does not have enough wax in it to build up and completely cover the paper. I like Verithin for this reason. The layered approach looks very artistic to me.

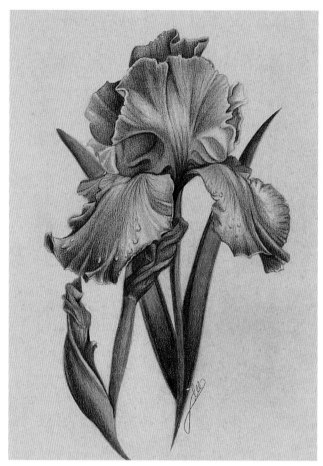

Drawing of an Iris
Verithin pencils on Strathmore Shell Renewal Paper
11 " × 14 " (28cm × 36cm)

NOTE

The petals of this flower are very delicate, with many folds and creases. These recessed areas must be studied carefully for the dark shapes they create. They are especially obvious in areas where the petals overlap, creating hard edges.

The light shining on the flower creates these shadows. Look at the flower as a puzzle of interlocking light and dark shapes. These small patterns will help you develop the shape of the flower. Dark shapes help to define lighter ones. Look at the areas of reflected light along the edges of the petals. These help the flower look real and dimensional. The addition of the water droplet also adds to the realism.

Value Scale
This value scale of colors shows how the Verithin pencils layer. The colors do not build up and become heavy. The color of the paper shows through, creating a grainy effect.

COLORS USED

Flower: Canary Yellow, Carmine Red, Orange, Poppy Red, Rose and Tuscan Red.

Leaves and Stem: Apple Green, Dark Green, Olive Green, True Green and Tuscan Red.

Stem Casing: Pumpkin Orange and Yellow Ochre.

DON'T FORGET THE BACKGROUNDS

These two examples are drawn using the same colors; the backgrounds are what set the two apart. This shows how different a drawing can look with the introduction of a background color.

The drawing of the hollyhock is a wonderful example of extreme light and dark. This is the type of lighting I like best for drawing and is what I try to achieve with my photography. Look at how the extreme dark green of the leaves makes the light, delicate colors of the flower stand out. The grainy texture that the Verithin pencils provide helps illustrate the actual textures of the plant. I love the way the pencil lines in the petals help create the uneven surface of the flower.

This rose is a good example of overlapping shapes, hard edges and shadows. Each petal of the rose has all five elements of shading applied. The feel of bright sunshine is very obvious because of the strong full-light areas.

Because the edges of the flower petals are so light, I used a background color to make them stand out. By doing this it looks like a light surface edge against a darker background. Without it, there would be no way to define the edges of the petals without placing a line around them. Anything with an outline appears flat. This is an important lesson: Always create "edges" instead of outlines.

Example of Extreme Lighting
This is an excellent example of the use of extreme contrasts of light and dark.

Pink Hollyhock
Verithin pencils on no. 1008 Ivory mat board 8" × 10" (20cm × 25cm)

Background Colors Change the Appearance of Your Work
The addition of a background color helps create the light edges of the rose petals.

A Pink Rose
Verithin pencils on no. 1008 Ivory mat board 8" × 10" (20cm × 25cm)

COLORS USED

Flower: Carmine Red, Rose and Tuscan Red.

Stems and Leaves: Apple Green, Black, Dark Brown, Dark Green, Grass Green and Yellow Ochre.

COLORS USED

Flower and Rosebud: Carmine Red, Crimson Red, Poppy Red, Rose, Tuscan Red and Yellow Ochre.

Leaves and Stem: Dark Green, Grass Green and Peacock Green.

Background: Apple Green, Aquamarine and True Green.

Draw an Iris With Verithin Pencils

Let's try an iris together using the Verithin pencils. Examine the photograph. Look beyond the shapes to the colors of the flower. The base color of the iris is white. That's why I selected a white board to work on. Follow the instructions, step by step, to complete the drawing.

Reference Photo

COLORS USED

Verithin Pencils: Dahlia Purple, Tuscan Red, Parma Violet, Rose, Canary Yellow, Poppy Red, Peacock Green and Apple Green.

Step 1: Complete a Line Drawing and Begin Placing Color

You can use a grid to help you work out the various shapes in the iris, or you can simply try to freehand the drawing. Once your drawing is complete, begin placing Dahlia Purple into the dark areas of the flower. In the very center add some Tuscan Red on top of the Dahlia Purple.

Step 2: Switch to Lighter Colors

Switch to Parma Violet, which is a lighter shade of purple. Continue adding tone to create the shapes of the petals. Add some Rose to the lighter petals.

NOTE

For more practice, refer to seed catalogs and magazines for beautiful pictures to draw from. The more you practice, the better you will become. Remember to draw all types of flowers in various colors. Experiment with different colors of paper to see how this changes the look of the colored pencils. Most of all, have fun!

Step 3: Define the Petals

In this stage, add more Rose to the petals. Place some Canary Yellow in the far left petal and the center. Add Poppy Red to complete the center, and also add some to the petal on the far right.

Step 4: Set the Flower Apart With a Background

Add a smooth, even layer of Peacock Green behind the flower. This helps separate the white edges of the flower from the white background of the paper. Add a small amount of Apple Green to suggest the stem.

The previous section showed you how to achieve soft, layered color with Verithin pencils. But what about capturing flowers that are brightly colored with shiny surfaces? A layered approach would not create those qualities.

I've mentioned before that not every pencil will create the look you need: It takes more than one type to be successful. For bright, vibrant color, the best pencil to use is Prismacolor. It has a wonderful range of 120 colors.

Remember that Prismacolors are thick, waxy pencils with a very rich, opaque pigment. The high wax content allows the colors to blend easily and completely cover the surface of the paper. For this reason they can be used on any color of paper, even black.

The examples in this section show how realistic Prismacolor pencils can look. They could be confused with oil paints.

Burnishing
Look at the value scale drawn with Prismacolors (below left). If you compare it to the value scale done in Verithin pencils (below right), you can see the differences between them. Unlike the Verithin example, the paper surface is completely covered, and the rich pigments blend together like paint. This technique is called burnishing. It is the process of taking a lighter color over the darker ones to blend and soften them.

Using Damar Varnish
To make a drawing shine even more, making it resemble a painting, I spray it with a coating of gloss damar varnish (a varnish designed for oil paintings) when finished. Not only will this make your drawing look better, it will prevent the wax bloom that occurs with Prismacolors. Don't worry about this when you are working. Lightly buffing with your finger or a tissue will make the cloudiness disappear for a while, and spraying when you are finished will seal the drawing permanently.

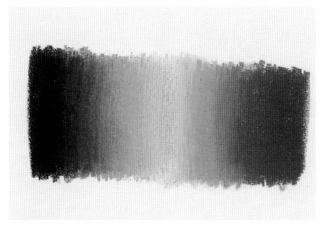

Prismacolor Value Scale
This value scale shows the heavily blended technique known as burnishing. The wax of the pencil allows the pigment to build up and blend together, resembling oil paints.

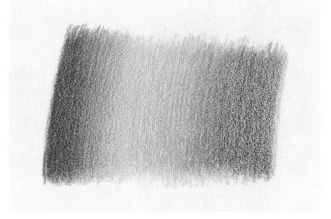

Verithin Value Scale
This value scale shows how the Verithin pencils layer. The colors do not build up, and the paper shows through the pencils.

COMPLEMENT THE COLORS OF A DAYLILY

This is an unusual approach to drawing a flower. I used this example in one of my art classes to discuss contrasts. You can create a visual contrast between graphic patterns and a realistic rendition by placing a checkerboard behind the flower. Since opposite colors complement one another, I placed Parma Violet in the checkered background to enhance the yellow of the flower.

COLORS USED

Flower: Canary Yellow, Orange and Poppy Red.

Stamen and Pistils: Black, Burnt Sienna, Grass Green and White.

Background: Black and Parma Violet.

Markers: Canary Yellow and Black.

A Lily on Checkerboard
Prismacolor pencils and marker on White bristol board
5" × 5" (13cm × 13cm)

Draw a Hibiscus Using Prismacolor

Let's try another flower using Prismacolor pencils. Follow these easy step-by-step instructions to re-create this red hibiscus.

Using Prismacolors is a wonderful way to create bold, realistic color. I urge you to look for reference photos of brightly colored flowers and practice drawing as many of them as possible. You can use this method to re-create any image you see.

<div style="border:1px solid">

COLORS USED

Petals: Scarlet Lake, Poppy Red, White, Carmine Red, Black.

Stems and Leaves: Chartreuse, Dark Green, Dark Brown, Canary Yellow, Grass Green, True Blue Verithin.

</div>

Photo Reference

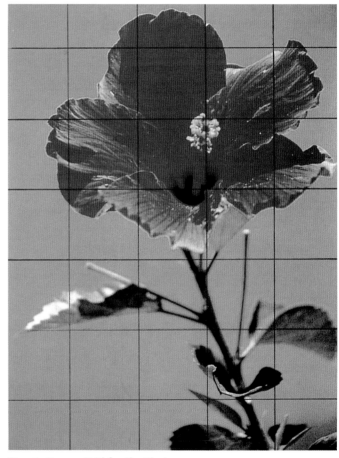

Step 1: Draw a Grid for the Photo

Using an enlarged copy of the photograph, draw lines to create your grid.

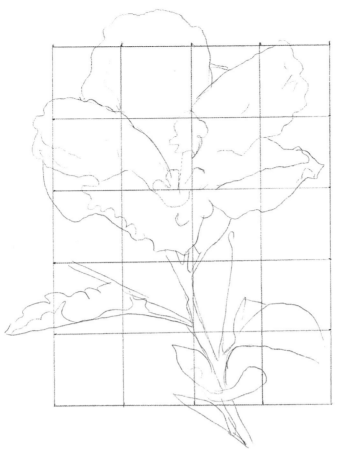

Step 2: Create a Line Drawing

Study the photograph. Create a line drawing using the graphing method. Check your drawing once again for accuracy, erase your graph lines, and then we'll begin adding color.

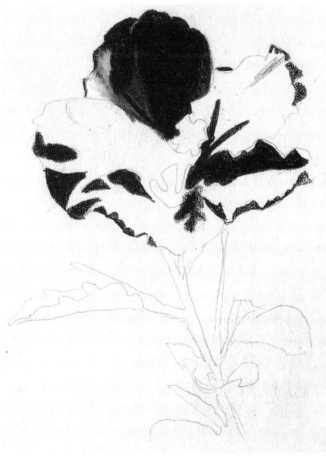

Step 3: Place In the Dark Areas

Begin placing in the darker areas of the hibiscus with Scarlet Lake. Look at these areas as shapes. Study the completed petal on the top. Once the Scarlet Lake is applied, burnish over it with Poppy Red. The two blend together. Next add White for an area of highlight.

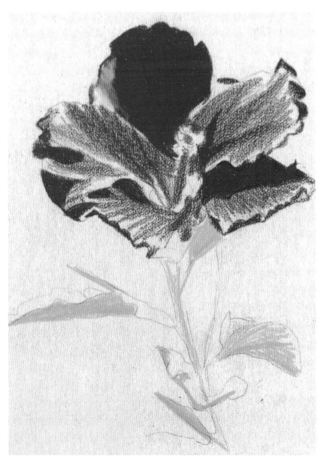

Step 4: Complete the Petals

Proceed in the following manner with the rest of the petals.
Apply the Carmine Red over the Scarlet Lake to fill in the color
of the petals. Begin the stems and leaves by basing them in
with Chartreuse.

Step 5: Burnish the Colors

This is what the petals should look like after applying pressure
with the pencil and burnishing the colors together. To create
the center, apply some Black.

Step 6: Add the Finishing Touches

Continue with the stem and leaves by adding Dark Green over the Chartreuse. Also add Dark Brown to the stem.

To finish the hibiscus, add Canary Yellow to the top of the stamen. Then add more of the details to the leaves with Dark Green and Grass Green. Continue the details of the stem with Dark Brown. To complete the drawing, add more White for highlights to the flower, leaves and stem, and bounce the Carmine Red into the stem areas. To create the gentle blue background, use a light application of True Blue Verithin and let it fade gently into the color of the paper.

FLOWER FACTS: COL-ERASE AND STUDIO PENCILS

When I teach my graphite techniques, I use a tortillion to gradually soften and blend out the tones. The result is a polished look with an extremely smooth transition of tones and no visible pencil lines. This blending technique can also be applied to colored pencil by using Col-erase pencils by Sanford, or Studio pencils by Derwent.

Both the Studio and Col-erase pencils are clay based. For that reason, they look entirely different than Prismacolors or Verithins. The non-wax formulation of Studio and Col-erase pencils allows the pigment to be rubbed and blended together with a tortillion—a spiral-wound cone of paper designed to blend pencil, pastel and charcoal. Blending is the process of taking a tortillion to the pencil you have applied to the paper and rubbing it into a smooth, gradual tone.

The Studio line of pencils has a range of seventy-two colors. They are heavier than the Col-erase pencils and can be applied darker and thicker. The blend is not quite as smooth, as illustrated in the value scales below.

Col-erase pencils have a range of only twenty-four colors, but because they can be blended, the ability to create colors is nice. They are also erasable (as is evident by the name). This makes them good for lifting highlights and other details with an eraser.

It will be very important for you as a colored-pencil artist to experiment and familiarize yourself with all of these techniques. Study various photographs of flowers and plants and ask yourself which pencil you feel would do the best job of capturing their individual characteristics.

Practice will be your key to success!

Value Scales

Compare these value scales to the previous ones and you will see how different these pencils appear. Because of their ability to softly blend, they are excellent for drawing light-colored flowers.

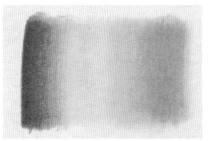

Value Scale (Col-erase pencils)
A value scale of Col-erase pencils (blended).

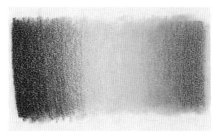

Value Scale (Studio pencils)
A value scale of Studio pencils (blended).

BLEND WITH A TORTILLION

This water lily was drawn using Col-erase pencils. This drawing was completed on Very White mat board using only four colors: Lavender, Magenta, Tuscan Red and Canary Yellow. All of the tones, with the exception of the center, have been blended out with a tortillion to make them gradual and smooth.

COLORS USED

Col-erase Pencils:Canary Yellow, Lavender, Magenta and Tuscan Red

A Water Lily
Col-erase pencils on no. 918 Very White mat board
8" × 10" (20cm × 25cm)

WHEN TO USE SPRAY FIXATIVES

These lilies are another example of a drawing done with Col-erase pencils. You can see the soft blend in the background, but for this drawing I changed the appearance of the pencil by spraying with workable fixative when I was finished. Because these pencils have no wax in them, they are sensitive to the moisture of spraying. This will cause the colors to "melt," changing their look into an almost inklike appearance. Practice this before you apply it to a finished piece of art. The colors change dramatically, as shown in the example.

A Color Swatch of Col-erase
The section on the right has been sprayed with fixative; the section on the left has not. Look at how the colors have changed.

COLORS USED

Flower: Brown, Canary Yellow, Orange and Vermilion.

Background: Indigo Blue, Light Blue and Magenta.

Spray Fixative Will Melt Col-erase Pencils
The pigment of the Col-erase pencils will melt when exposed to fixative. This example looks almost like an ink wash in areas. Unless you want your colors to change and deepen like this, leave Col-erase drawings unsprayed.

Draw a Coneflower

Let's try a project using the Studio pencils. Study the photograph and follow the step-by-step instructions to complete the coneflower.

COLORS USED

Studio Pencils: Magenta, Spectrum Orange, Deep Vermilion, Naples Yellow, Black, Bottle Green and Cedar Green

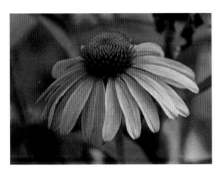

Reference Photo

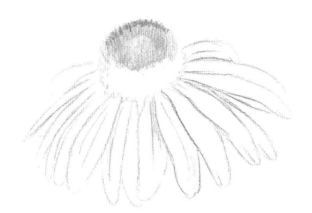

Step 1: Replace the Lines With Color

Replace the graphite lines with Magenta. Begin the center with Spectrum Orange.

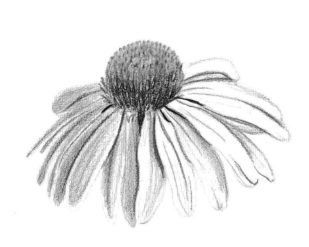

Step 2: Add Color to the Petals

Add Deep Vermilion to the petals on the left side. Begin the color and texture of the center with Deep Vermilion, Naples Yellow and Black.

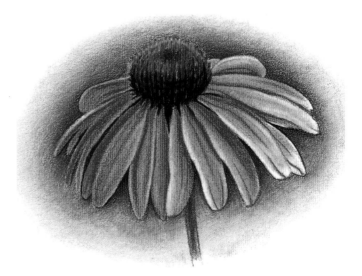

Step 3: Finish and Blend the Tones

Add Bottle Green and Cedar Green behind the flower for a background.

Soften the tones with a tortillion. Studio will not blend as smoothly as Col-erase and will still appear a bit grainy.

Draw a Pink Rose

This pink rose is another example of the very smooth tones that can be created with the Col-erase pencils. Many of the white highlights of the petals were lifted from the paper with a kneaded eraser. The veins of the leaves were erased with the point of a typewriter eraser.

Follow these instructions to complete the project using Col-erase pencils. I used no. 3315 Porcelain mat board for the drawing surface.

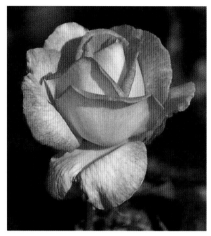

Reference Photo

<table>
<tr><td>COLORS USED</td></tr>
</table>

COLORS USED

Col-erase Pencils: Tuscan Red, Carmine Red, Rose, Canary Yellow, Green and Dark Brown.

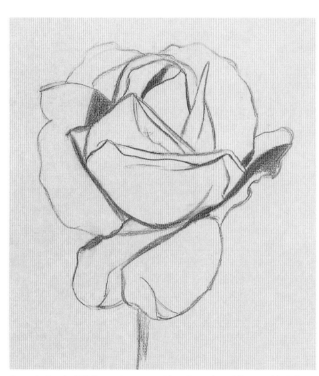

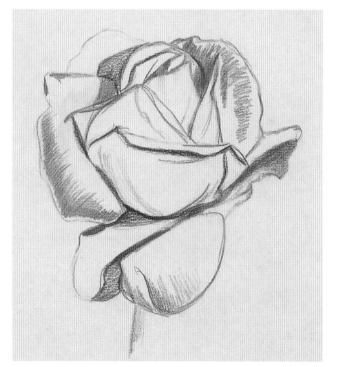

Step 1: Begin With an Accurate Line Drawing, Then Add Color

Replace the graphite lines from your accurate line drawing with Carmine Red. This will prevent the gray of the graphite from blending in and dulling your color.

Step 2: Fill In Shadow Shapes

Use Tuscan Red and Carmine Red for the shadows. Begin placing color in the front petal with Rose.

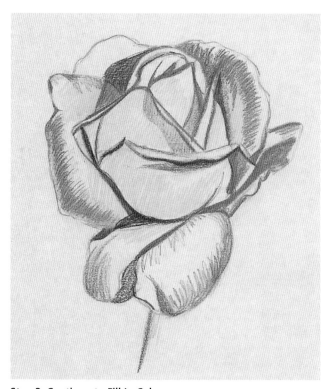

Step 3: Continue to Fill In Color

Add Canary Yellow to the drawing.

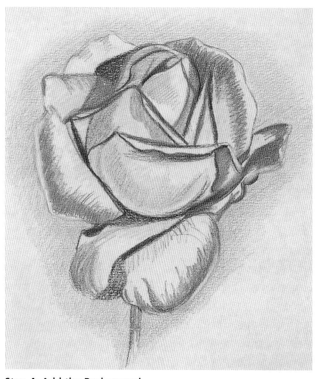

Step 4: Add the Background

Apply Green around the rose for a background color.

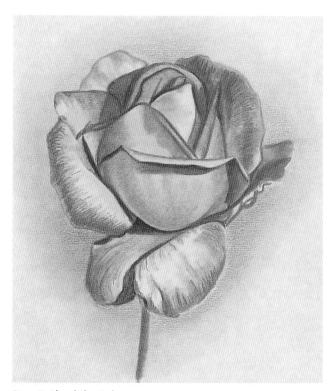

Step 5: Blend the Colors

This is the finished rose after all of the colors have been blended with a tortillion. It has a beautifully soft impression.

NOTE

It is not necessary to push very hard on tortillions to blend the colors. Pushing too hard will collapse the tip and rough up the paper surface. A light, soft touch is all that is required for a smooth blend of tone with Col-erase. This drawing has not been sprayed, which creates a much softer look.

WATERCOLOR PENCIL BASICS

There certainly is more to colored pencil than meets the eye. There are so many different looks that can be captured, but who would have ever thought that you could create a painting with colored pencil? You can with watercolor pencils.

Actually, watercolor pencils have been around for over thirty-five years; they just weren't very popular in the fine art community. They were marketed more for schoolkids—for mapmaking and such. But now they have taken the art field by storm.

There are quite a few brands on the market today, and all of them are very good. For this book and my own personal use, I have used both Derwent and Prismacolor brands. I think Prismacolor is my favorite.

Watercolor pencils are just what the name implies: pencils with the lead made of actual watercolor pigment. Drawn on paper, they look like ordinary colored pencils and actually feel a lot like the Studio pencils. They can be used dry, like regular colored pencils. But with a little water and a damp paintbrush, you can turn your drawing into a beautiful watercolor painting.

Watercolor Value Scale

The value scales on top are drawn with watercolor pencils. They look very much like those of any other colored pencil.

The bottom illustrations show what the value scales look like with the addition of water. When drawn lightly, the wash produced is very transparent and fluid. Now look at the difference when the colors are drawn dark in the dry stage: They become even darker when wet. Keep this in mind in the drawing stage so things don't get out of control when you add water.

Dry Watercolor Pencil Value Scales
These value scales have been applied in dry form. The one on the left is a light layer of pigment; the one on the right has been applied heavily.

The Same Value Scales With the Addition of Water
The one on the left, which was applied lightly, now looks like a light wash. The one on the right, with more pigment, now looks more like opaque paint.

WHEN TO USE WATERCOLOR PENCILS

This is an example of a watercolor pencil drawing/painting. Study it closely and you can see where part of it looks drawn while the other part looks painted. It is a nice combination of techniques that results in a unique appearance.

NOTE

This is a combination of drawing and painting. Some areas look drawn and very controlled; others look like they have been painted with a paintbrush.

Look closely at the glass vase. All of the colors above it are reflected into its surface. The bright highlight areas streaking across the colors were lifted with a typewriter eraser after the artwork was completely dry.

The background was created with a technique called borrowing. This is where you take pigment from the tip of your pencil with a wet brush, and then paint it onto your paper.

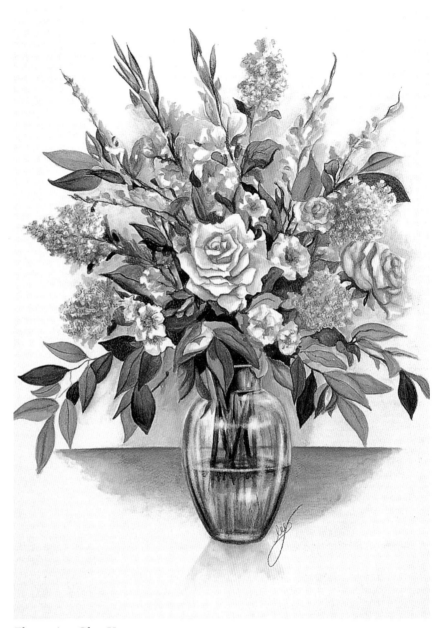

Flowers in a Glass Vase
Watercolor pencils on watercolor board
20" × 16" (51cm × 41cm)

WATERCOLOR PAPER BASICS

It is very important to use a paper made for watercolor when using watercolor pencils. Mat board can be used if you aren't planning to use much water, but it is a paper made of plies. The plies can separate when wet, making the board warp and buckle. I recommend you use a good watercolor paper or watercolor board.

To further illustrate the look that watercolor pencils can create, I have drawn the same picture two ways. The first drawing of the columbine is drawn with the watercolor pencils dry. The picture is beautiful like this in its dry form.

The second example is what it looks like using the wet approach. It has a looser, more impressionistic appearance and looks more like a painting than a drawing.

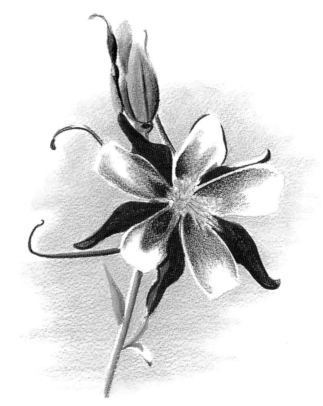

Example Done With Dry Watercolor Pencils
This drawing of a columbine has been left dry, like a traditional colored-pencil drawing.

Example Done With Water Applied to the Watercolor Pencils
This is the same drawing with water applied. It looks like a watercolor painting now.

EXAMPLES OF WATERCOLOR PENCIL DRAWINGS

The following examples have been done with watercolor pencils. Each one of them has a unique look resulting from the technique applied.

Yellow Rose
Watercolor and Col-erase pencils on watercolor paper
10" × 8" (25cm × 20cm)

Use a Complementary Color Scheme
I used a complementary color scheme of yellow and violet to really make the rose pop. The combination of drawing and painting gives it an interesting appearance.

COLORS USED

Watercolor Pencils: Canary Yellow, Dark Umber, Grass Green, Orange, Poppy Red, Spring Green, Sunburst Yellow, Terra Cotta and Lavender.

Purple Water Lily
Watercolor pencils on watercolor board
10" × 15" (25cm × 38cm)

A Simple Painting Using an Uncomplicated Color Scheme
The pure white background keeps the artwork looking clean and uncluttered. I like the way the water has made the edges of the flower look so crisp.

COLORS USED

Watercolor Pencils: Dark Purple, Olive Green and Spring Green.

Try Watercolor Pencils for a Flowering Bush

This photograph of a flowering bush has all of the elements I like for this technique: It has areas of bright highlights, which the white of the paper can represent, and it also has extreme dark areas to make the highlights show up. The blurred background lends itself to a watercolor approach.

This project was drawn on a thick watercolor board by Strathmore. Its rigid surface can take any amount of water without warping.

Some artists feel that watercolor painting is unforgiving and that there is little control in its outcome.

I do not agree and have devised many tricks for creating the look I want in my work.

Look closely at the finished example. I have used both a typewriter eraser and a craft knife to create the light textures of this wood. After your work is completely dry—I usually wait overnight—a typewriter eraser can easily lighten an area for you. It will lift some of the pigment off of the paper, and the point gives you the control you need. I used it to lighten the middle of the branch to create more roundness.

I also used it to lighten any petals that lost their highlights in the washing process.

Can you see the small white dots of texture in the limb? I used the edge of a craft knife to scrape the pigment away. This is a wonderful technique for creating texture; just be sure to approach it with a light touch to keep from gouging the paper.

Watercolor pencils are a fun deviation from traditional colored-pencil techniques. I encourage you to play with them and see if you can develop a style all your own.

Reference Photo

COLORS USED

Watercolor Pencils: Dark Umber, Crimson Red, Terra Cotta, Carmine Red, Dark Green and Grass Green.

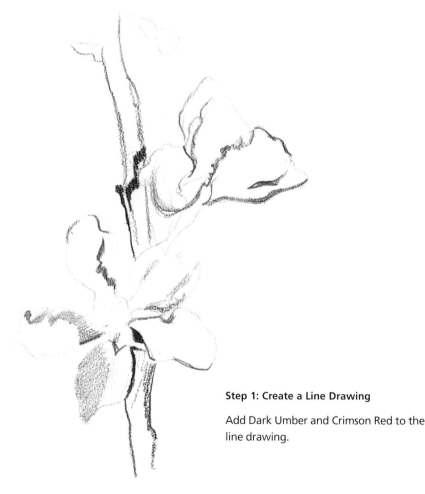

Step 1: Create a Line Drawing

Add Dark Umber and Crimson Red to the line drawing.

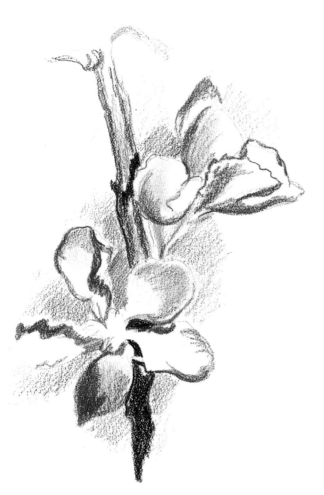

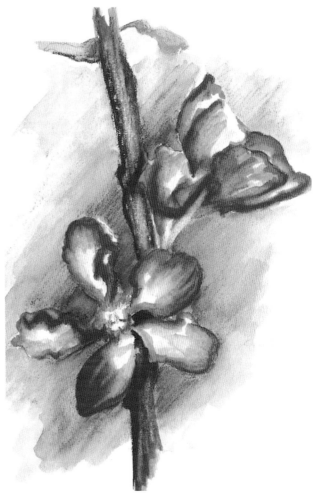

Step 2: Build the Colors

Increase the color of the branch with Terra Cotta, and add Carmine Red to the petals. Create the background with diagonal lines of Dark Green and Grass Green.

NOTE

You can create textures of a drawing or painting by lifting them with a typewriter eraser or scratching them out with a craft knife. When using this method with a watercolor painting, wait overnight to be sure the paper surface is completely dry.

Step 3: Melt the Colors With Water

Now for the fun part! Dip a pointed watercolor brush in a jar of clean water. Lightly paint over your drawing with the water, allowing the pigment on your paper to melt. You have to be careful at this stage and use some control in your shapes. You are still drawing here and creating shapes—not just blobbing on water. You may want to experiment on a separate piece of paper before completing this project. It is important to see how the pigment reacts to the water and what kind of stroke you will need. It is also important to maintain the edges of your drawing. Do not use so much water that it bleeds outside the lines.

This type of drawing usually has to be done in stages, allowing one section to dry completely before moving to the next. For instance, on this piece I finished the flower and branch and allowed it to dry before wetting down the background. This kept the two areas from bleeding together and maintained the crisp edges of the subject matter.

VELOUR AND SUEDE PAPER INFORMATION

To me, there is nothing more beautiful than the look of soft realism. It is the effect I seek most when drawing or painting. Although I often try to vary the techniques and looks of my art, the soft, blended approach always calls me back.

This is an approach that is rather new. It is the process of using colored pencil on a fuzzy, flocked paper called velour. Velour paper is popular with pastel artists due to its soft, velvety surface. The nap of the paper holds and retains the chalky nature of pastel and provides a very delicate look.

Suede board is similar to velour. It is actually a board used for cutting mats for framing. I saw it and decided to try it as a drawing surface. It is remarkable paper and is probably my favorite board to draw on. The look is soft and makes flowers appear to be almost touchable.

This drawing was drawn on Whisper suede board. Its soft beige color is a good background for many types of subject matter. It worked wonderfully for this pink flower. The light color of the suede board helps create the light color of the flower. The sharp contrast between the flower and the background is impressive.

Value Scales

Compare the two value scales on this page. The first one shows what Prismacolors look like when applied to regular mat board. The second shows what they look like when applied to suede board. The difference is very noticeable. You must decide—before you begin your art—which surface will give you the look you want to achieve.

Prismacolors on Mat Board
This is what Prismacolor pencils look like when applied to regular mat board.

Prismacolors on Suede Board
This is what Prismacolor pencils look like when applied to suede board.

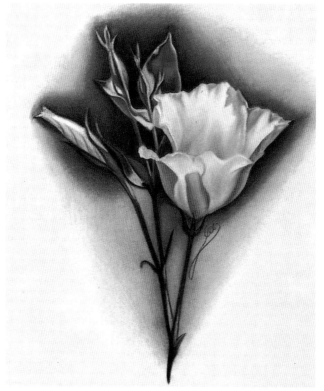

A Study in Pink
Prismacolor pencils on no. 7132 Whisper suede board
11" × 11" (28cm × 28cm)

DRAWING ON VELOUR AND SUEDE PAPERS

Look at how smooth and soft the color is in this piece. The extreme contrasts between the dark and light areas are beautiful. Colored pencils appear extremely soft on velour paper and require a very light touch to master this technique. I find myself holding the pencil way back toward the end to keep the pressure off the tip. By holding the pencil less upright, you reduce the occurrence of pencil lines, allowing the pencil to gently fade out onto the paper like pastel. When you need a hard edge or line, a sharp pencil with firm pressure will work well. This paper does not interrupt the line quality and still allows you to achieve the sharp details you need.

Because of the sensitivity of this paper, I do not recommend spraying it with fixative when you are finished. Colored-pencil pigment does not build up with this technique. It diffuses across the surface of the paper, so you will not see a wax bloom cloud your work. Spraying then becomes unnecessary.

One of the downsides to this paper is its ability to attract dust, lint and hairs. I have pets in my studio and am always having to check the paper for hairs. You can, however, lift up debris with a piece of tape without damaging your work. Always be sure you have cleaned up your drawing before placing it into a frame.

COLORS USED

Prismacolor Pencils: Dark Green, Dark Purple, Deco Aqua, Hot Pink, Indigo Blue, Mulberry, Process Red and White.

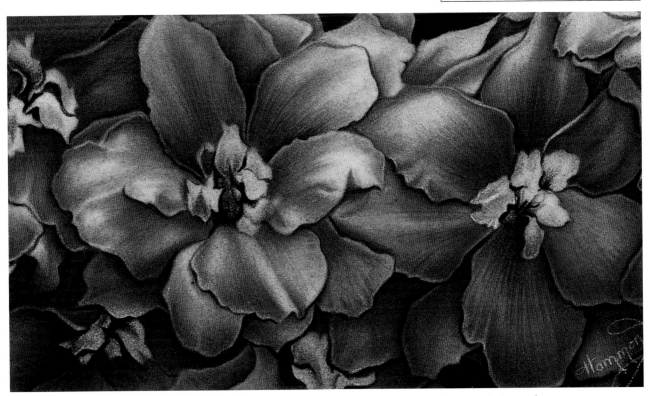

Create the Soft Appearance of Flowers With Velour Paper
Even complicated subject matter looks great on this surface. I used white velour paper for these flowers. I exaggerated the overlapping of the flowers by enhancing the shadows and giving them bright reflected light along their edges. It has a very dimensional look and an almost abstract appearance.

Flowers in Lavender
Prismacolor pencils on
White velour paper
6" × 10" (15cm × 25cm)

POWERFUL PRISMACOLORS ON VELOUR PAPER

Often when I'm looking at photographs to work from, I'll spot one that is just perfect to capture on suede or velour. When I saw this photo, I knew immediately it would be perfect!

NOTE

The red tones of this plant closely match the color of the paper. Having it show through in the drawing perfectly replicated the color of the leaves. By adding green in the background as a complement, the plant really jumps out.

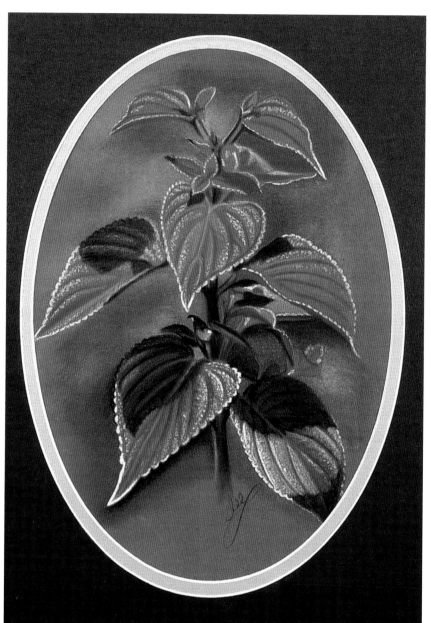

A Study in Red
Prismacolor pencils on Red velour paper
12" × 9" (30cm × 23cm)

A Photograph in Red Tones

USE WATERCOLOR PENCILS ON VELOUR PAPER

This is an example of something extremely unique. Although I had always used Prismacolor pencils on velour, I wanted to try something new. A manufacturer of the velour paper was interested in seeing how its paper performed using watercolor techniques. The manufacturer mounted the paper to a board to keep it from warping under the effects of moisture and then asked me to experiment with it.

The results were interesting. I explored both traditional watercolor paints and watercolor pencils to see how they would react on a flocked surface. I came up with this bouquet of roses. I love the effect.

I do not recommend this technique for newcomers to watercolor. It does not perform like anything I have ever experienced before. The paper surface absorbs the water immediately, making it difficult to manipulate the watercolor pencil that has been drawn on. The pigment soaks in and stays there. But despite all that, once you get the feel—and get used to the hard-edged look it produces—it is rather fun to work with. It just takes some getting used to.

You can see areas where the water melted the pigment so completely that you see no pencil lines at all. In areas where I used less water, such as in the stems, the lines remain crisp.

To keep the background smooth and gradual, I resorted to traditional watercolor paint so I could apply a large area of color with a lot of water. The result was a unique piece of art with a very definite creative flair.

Bouquet of Roses in a Crystal Vase
Watercolor and watercolor pencils on mounted White velour paper
20" × 16" (51cm × 40cm)

Draw on Suede Paper

This is an example of a detailed drawing on suede board. To purchase this board for your own projects, check with your local frame shop. Most of them either have it in stock or can order it from their framing suppliers.

The softness of the bee and the background made me select this photograph for a project on suede board. I chose a white board for this drawing. While velour paper has an even surface, the surface of this suede paper has a "swirled" quality. Because of this, you wouldn't necessarily have to draw in a background (but it would look pretty plain without one). I like the suede board because of this characteristic.

This has become one of my favorite techniques, and it can be used for a variety of subjects. I hope you will try this fun, interesting approach to colored pencil.

Reference Photo

COLORS USED
Magenta, Process Red, Canary Yellow, Blush Pink, Poppy Red, Burnt Ochre, Apple Green and Black

Step 1: Transfer Your Line Drawing and Begin Adding Tones

Graphing on velour or suede paper isn't a good idea because you cannot erase the graph lines. Use a projector or transfer paper to make your line drawings.

Begin the drawing by replacing the lines with Magenta. Begin filling in the shadow shapes with Process Red and Magenta. Use Canary Yellow to begin the center and the bee.

Step 2: Fill In the Leaves

Add Blush Pink to the petals. Warm the shadow shapes with Poppy Red. Also add Poppy Red to the center of the flower and the edges of the bee's wings.

Step 3: Create the Background and Finish the Drawing

Create the background using a combination of blended green tones. Apply Black to the wings and body of the bee, and add Burnt Ochre to the tips of the wings. Add Black last to keep it from smearing into the colors and dulling them. Create the stem using Apple Green and Black.

LEAVES AND PLANTS

To truly be able to draw nature, you must also learn to draw the other things that grow with flowers, such as leaves and ancillary plants. Drawing leaves presents just as much of a challenge as the flowers themselves, and some leaves are just as colorful.

Always look for the lighting when doing photography or artwork. Draw not just the subject but also the effects of light on the subject.

Shadows

This drawing looks pretty simple, but I think that sometimes the simple ones are quite nice. This little plant sitting in the sun created a very cute composition. Actually it was not the plant but the shadow of the plant that captured my eye.

Study the shadow. Look at how the lighting affects its color. As the shadow goes farther back, it takes on a warm look with the addition of Terra Cotta, which was placed into the outside edge.

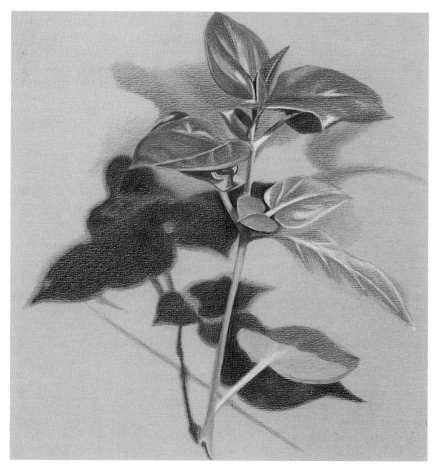

The Shadow
Verithin pencils on no. 1026 Rose Gray mat board
8" × 10" (20cm × 25cm)

LOOK FOR THE DETAILS

These two photographs clearly show the fine details you should look for when drawing leaves. Each is from a different view, allowing you to see different elements.

The front view of a leaf has bright sunshine washing across the surface. Look closely at the veins of the leaf and how the light makes the recessed areas appear dark. Study the edges of the leaf. Look at the light edge of reflected light standing out against the dark background. Remember: Everything with an edge, lip or rim will have reflected light running along that edge.

The photo below right shows the back side of the leaf. Notice how everything that was recessed on the front view is now a raised surface. Look at the veins and how they now appear light against the darker surface of the leaf.

Front Side of a Leaf
The veins appear recessed into the surface.

Back Side of a Leaf
The veins are now seen as raised surfaces.

PRACTICE BASIC LEAVES

To get some practice drawing
leaves, try drawing one of the
leaves from this photo of a limb.
This has a wonderful lighting situa-
tion that creates beautiful areas of
light and shade.

The Prismacolor pencils did a
great job of capturing the details.
The marbleized paper gave the
illusion of the leaves being seen
against the sky.

Reference Photo
Use this photo to practice drawing a leaf
and berry.

Create the Illusion of the Sky
Using marbleized paper gives the illusion
of the sky in the background.

Limb and Berries
Prismacolor pencils on Strathmore Blue
Marble paper
14" × 11" (36cm × 28cm)

DRAW SPECIAL LEAVES

The following illustrations show some very different approaches to drawing leaves. Each one has its own special quality and characteristics created by the type of pencil used to render it.

Since Col-erase pencils cannot be used for deep, dark hues, I used the Studio pencils on the second study. They are good for blending darker colors. The dark, rich tones at the end of the leaves were captured perfectly with the Studio pencils. The lack of background color in the second drawing makes it seem uncluttered and fresh.

Try a Blended Background
The blended background adds a soft quality to this drawing.

My Houseplant
Col-erase pencils on no. 3297 Arctic White mat board
10" × 8" (25cm × 20cm)

Soften the Colors With a Tortillion
These colors were softened with a tortillion. The light areas are the color of the paper coming through.

A Study of Leaves
Studio pencils on no. 1014 Olde Grey mat board
10" × 8" (25cm × 20cm)

Draw a Leaf and Berry

Follow the step-by-step instructions for drawing this leaf and the cute little berry.

<div style="border: 1px solid black;">

COLORS USED

Prismacolor Pencils: Olive Green, Tuscan Red, Limepeel, Sand, White and Black.

</div>

Step 1: Begin With the Greens

Begin with a light pencil outline of the leaf. With Olive Green, completely fill in the leaf to the left of the center vein. Lightly apply the Olive Green to the right side, creating the pattern of the veins. Leave the edge of the leaf empty.

Step 2: Darken the Leaf With a Complement

Apply Tuscan Red to the left side of the center vein and up the stem. This complementary color will darken the Olive Green. Apply a light layer of Limepeel to the light edge of the leaf, overlapping the Olive Green and the vein areas.

Step 3: Finish the Leaf

Apply Sand to the center vein and burnish it into the colors on the right side of the leaf. This will blend the tones together. Apply some White and burnish it into the right side of the leaf. Finish with a small amount of Black to emphasize the edges of the veins.

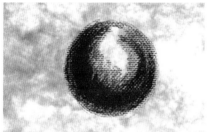

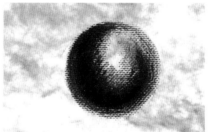

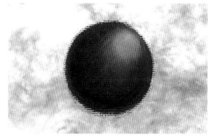

Step 1: Begin the Berry

Begin the berry with an outline of a circle. Apply a light application of Henna to begin the overall color. With firm pressure, apply Tuscan Red to create the shadow edge.

Step 2: Draw In the Shadow Areas

Add Black to the shadow edge to enhance the roundness.

Step 3: Finish the Berry

Burnish over the berry with Henna to blend the tones. Apply Henna to the outer edge of the left side. For the reflected light, apply White to the full light area for a highlight. To transition the White and keep the berry from looking too pink, burnish Sunburst Yellow into the Henna. This gives the berry a warm glow of color.

When you are finished with both the leaf and the berry, spray the drawing with a varnish or fixative to prevent the pigment from blooming (the waxy haze associated with Prismacolors).

COLORS USED

Prismacolor Pencils: Henna, Tuscan Red, Black, White and Sunburst Yellow.

So far in the chapter you have been concentrating on what nature looks like up close, but that is not always the way artists see things. You learned how to see and draw the details of a leaf; what about seeing and drawing the whole tree! You must approach the drawing in an entirely different way.

Whenever I draw trees, I look at them through squinted eyes. This blurs the impression, making the tones of light and dark more intense and obvious. It also makes the tones look more like interlocking shapes. Replicate the patterns in your drawing; it will make the trees look airy and natural, without looking too filled in. Resist the habit of making the same shapes over and over again. This will look unreal. Each grouping of leaves should look unique in its shape and appearance.

NOTE

I used Blue Marble paper again to give the illusion of the sky. I used a Black Prismacolor pencil for the entire drawing.

Draw the Entire Tree
I first sketched some of the branches and limbs of this tree using a sharp pencil to keep the lines thin and tapered. Then, I began adding groups of leaves. I used small, irregular circular marks, holding my pencil somewhat on the side. I continued adding circular marks. I filled in some areas and left others empty, allowing the sky to come through.

Silhouette of a Tree
Black Prismacolor on Strathmore Blue Marble paper
14" × 11" (36cm × 28cm)

Look at the drawing of the tree on the previous page. It has thousands of leaves—but none of what you learned about drawing leaves applies. To draw these we must see them not as individual leaves but more as abstract patterns of light and dark.

NOTE

I drew the trees around this windmill much the same way as for the previous drawing, only this time I used color. I used Prismacolor pencils to make the colors seem bright and vivid.

Each grouping of foliage had a different color. These colors overlap one another, creating patterns. I used the same type of flat, circular pencil marks to create this tree.

With the point of a very sharp black pencil, I added the small limbs, being sure they wove in and out of the foliage.

Windmill Behind the Trees
Prismacolor pencils on no. 972 French Blue mat board
8" × 10" (20cm × 25cm)

CHALLENGE YOURSELF WITH TREE BARK

Tree bark can be a fun challenge. This tree with the squirrel had an extremely rough surface. However, it didn't have much color. I captured the detail of the tree bark with Black Verithin. I used dark pencil lines for the recessed areas and lighter ones for the texture. The squirrel was drawn with Terra Cotta and Black, using an extremely sharp point to make his fur look soft. For using only a few colors, the drawing still has a very realistic look.

The tree with the bird's nest, on the other hand, has a very smooth surface. The tubular shapes of the branches are cylindrical. Look for the five elements of shading when drawing these shapes. Can you see the reflected light and shadow edges on each of the limbs? Because of those elements, these branches look very rounded and dimensional.

This drawing was also done in Verithin pencils using only three colors: Terra Cotta, Dark Brown and Black. All of the light areas are where the color of the paper shows through. The small light areas of the bird nest were erased with a typewriter eraser.

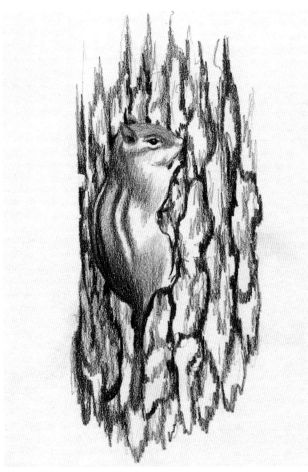

Realistic Drawings Can Be Created With Very Few Colors
I completed this drawing with only three colors, but it still appears very realistic.

Ground Squirrel
Verithin pencils on no. 1008 Ivory mat board
10" × 8" (25cm × 20cm)

Look for Basic Shapes in Your Drawings
Look for the cylinders and the five elements of shading in this drawing.

The Bird's Nest
Verithin pencils on no. 912 India mat board
10" × 8" (25cm × 20cm)

TREE TEXTURES

This photograph of a knothole is another excellent example of the interesting colors and textures you can find in nature. I just had to draw it! This photograph has some extreme lighting coming from the left. Because of the dark background, the light side of the tree really shows up.

To create the texture of the tree bark, I made loose, layered vertical lines using Verithin pencils. The inside of the knothole was drawn with brown, circular strokes. I then placed some vertical, black strokes over them to look like wood grain.

Squint your eyes when you look at the photograph. Can you see the patterns the leaves, lighting and tree bark create? Look at the different colors. If you can capture the patterns, you can draw the tree.

Reference Photo
This is an interesting combination of colors and textures.

Draw the Rough Texture of Tree Bark
Tree bark can be created with loose vertical pencil lines. The lighting in this picture helps the light side of the tree stand out, giving it contrast.

Knothole
Verithin pencils on no. 912 India mat board
10" × 8" (25cm × 20cm)

MORE ABOUT TREE DETAILS

Nature is full of interesting textures, shapes and surfaces. All of them present challenges to the aspiring artist. Maybe I can take some of the mystery out of drawing some of them.

Let's begin with pine needles. Close observation will show you that they are made up of very quick, tapered pencil strokes. The key to drawing them is to be sure to use layers of quick strokes that overlap. The finished drawing looks better due to the many layers of pencil strokes. Can you see how the twig down the middle looks like needles are coming out from all around it, and not just out from the sides like the other example?

This drawing of an acorn is one of my favorites. Not only have I always loved the shape of acorns, with their little "hats," but I also love what they represent in the circle of life. To me it is always awe inspiring to see the small acorn, with all of its potential, hanging among the branches of an already huge tree.

These acorns look very small compared to all of the leaves surrounding them. The combination of lights and darks makes this a pretty composition.

There are many other complicated textures out there and, unfortunately, not enough pages here to cover them all. Look around you and see what other challenges you can find to test your skills. The more you do, the better you will become!

Create the Look of Pine Needles
Quick, tapered strokes create the look of pine needles. Don't make the strokes hard, deliberate or all the same length, like the small example on the left. This looks harsh and unnatural.

Acorns
Verithin pencils on no. 903 Soft Green mat board
13" × 10" (33cm × 25cm)

FUN FACTS ABOUT FRUITS AND VEGETABLES

There is an old saying about saving the best for last. For this book, that saying may hold true. Every time I see the brilliant colors and shine of a piece of colorful fruit, my mouth waters—not because I want to eat it, but because I want to draw it!

Fruit lends itself to many different colored-pencil techniques. Like flowers and plants, fruits have different surfaces and colors that make them perfect for discovering color. The following projects will give you a chance to see for yourself how much fun drawing fruits and vegetables can be.

This illustration of a pear was done in Verithin pencils. This was an interesting piece due to the many colors found on the pear's skin. The smooth yet speckled surface meant working in layers.

First, I created the overall color of the pear without the speckles. I used various shades of yellow and brown. Once I was happy with the basic color and the shape, I added the speckled appearance on top with Tuscan Red. To make the whole thing look shiny, I added White.

The leaves were done much like the ones in the previous sections (pages 224-225), looking carefully for the veins and their direction. The background is nothing more than a subtle addition of True Blue used to accent the pear and make it stand out from the paper color.

Pears and a Leaf
Verithin pencils on no. 1026 Rose Gray mat board
10" × 8" (25cm × 20cm)

COLORS USED

Pears: Canary Yellow, Yellow Ochre, Dark Brown, Tuscan Red, Apple Green and White .(The drip was created with Tuscan Red and White.)

Leaves: Dark Green, Apple Green, Tuscan Red and White.

Stem and Branch: Dark Brown, Black, White and True Blue (reflecting from the background).

Background: True Blue

DRAW STRAWBERRIES AND BANANAS

Here are two more popular fruits for you to draw. The seeds and uneven surface make this simple strawberry a challenge to draw. Look at how the seeds are recessed, creating a craterlike surface. Both shadow and reflected light areas can be seen around them.

The black background around the strawberry makes the colors appear bright and vivid. An application of varnish completes the shiny appearance.

Displaying these bananas in the grapevine basket is like bringing the beauty of nature inside.

Strawberry
Prismacolor pencils on no. 901 Apricot mat board
4" × 4" (10cm × 10cm)

COLORS USED

Prismacolor Pencils: Poppy Red, Crimson Red, Tuscan Red, Yellow Ochre, Apple Green, Dark Green, Black and White

Bananas in a Basket
Prismacolor pencils on no. 971 Daffodil mat board
10" × 8" (25cm × 20cm)

COLORS USED

Bananas: Canary Yellow, Yellow Ochre, Spanish Orange, Burnt Ochre, Yellow Chartreuse, Terra Cotta, Dark Brown, Black and White

Basket: Dark Brown, Terra Cotta, Burnt Ochre, Tuscan Red, Light Umber, Black and White

Background: Tuscan Red; use Ultramarine and Indigo Blue for the background in the upper-left corner.

LAYER THE LOOK OF ARTICHOKES

These artichokes were drawn with Verithin pencils. When drawing them, I was startled by their similarity to pinecones. Not only was the basic shape the same, but overlapping segments are used to create both.

I used a light, layered approach to render the artichokes using very few colors. The light green of the paper coming through helped create their color. It only required a few different colors of pencils to achieve this look.

I think the most important element of this drawing is the way the surfaces overlap, creating definite hard edges as well as cast shadows. There are subtle areas of reflected light on just about every leaf.

The sharp pencils that I used created the look of texture. Look closely and you will see how important the line direction was for giving it this appearance.

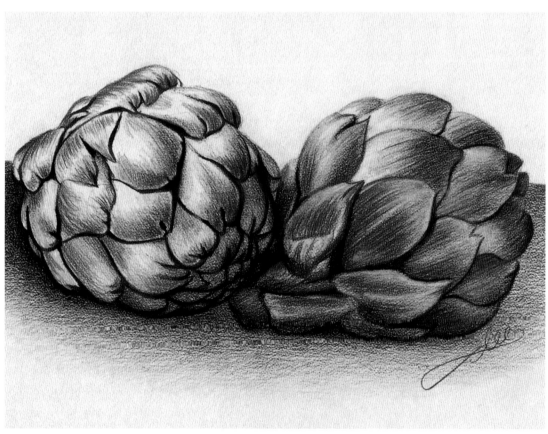

Artichokes
Verithin pencils on no. 903 Soft Green mat board
9" × 11" (23cm × 28cm)

Add Spice With Chili Peppers

Step 1: Lightly Sketch and Fill In the Pepper

To begin the drawing, lightly sketch the pepper in pencil on no. 962 French Gray mat board. Be sure to establish where the White highlights will be.

With Poppy Red Prismacolor, start placing color in the pepper, inside the edge. With Dark Green Verithin, begin layering color into the leaf.

Step 2: Continue the Pepper

Add Crimson Red Verithin next to the Poppy Red. Fill more Dark Green in the leaf.

Step 3: Define the Colors

Apply Canary Yellow Prismacolor to the far left edge of the pepper. Erase the graphite lines to prevent them from becoming dark and permanent. You will not be able to cover them up.

Use Tuscan Red Prismacolor to create the dark areas of the pepper. This creates the unique shape of this veggie.

Add Tuscan Red Verithin to the leaf to create the shadow areas and the vein. Leave a light area for the vein itself.

Step 4: Burnish and Finish the Drawing

To finish the drawing, burnish over the highlight areas of the pepper with White. This makes the whole pepper look shiny and reflective. Add Peacock Green Verithin to the leaf to give it more color. Finish the drawing by adding a smooth layer of Dark Green around the pepper and leaf.

COLORS USED

Prismacolor Pencils: Poppy Red, Canary Yellow, Tuscan Red and Peacock Green

Verithin Pencils: Dark Green, Crimson Red and Tuscan Red

Just Add Water Drops

You can make any flower, fruit or vegetable look even more attractive by adding some water droplets. Look at the drawing of the pear. The moisture on its surface makes it look juicy enough to eat!

The following instructions show you how to draw water drops. Add them to your art to make your subjects gleam!

Don't be afraid of things that look complicated. Take it a small area at a time. Go slow. Do not confuse requiring time to complete with a subject being difficult. The time invested is always worth it, especially when you finally reach the finish and can proudly display the beautiful work you have done. And remember to have fun!

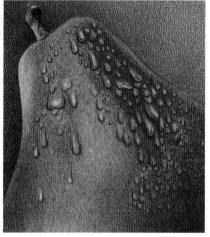

Add a Fresh Look to Your Work
These water droplets are little sphere exercises. Although they are time consuming to draw, they can give your fruit a fresh, realistic appearance.

Pear
Verithin pencils on no. 912 India mat board
6" × 6" (15cm × 15cm)

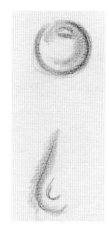

Step 1: Begin With a Round or Teardrop Shape

Use the darkest color of the surface you are drawing on. These drops would be found on something red, like an apple, a tomato or a plum. Establish where the light would be coming from by outlining the highlight area.

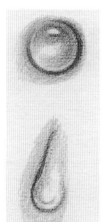

Step 2: Develop the Shape

Develop the shadow edge, keeping in mind the sphere. Using a lighter color, add tone to the shape.

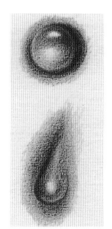

Step 3: Build Up the Color

Build up the color, being sure to leave bright areas of highlight and reflected light. Place the surface color around the edge of the water droplet.

Water droplets can vary in shape, depending on if they are still or dripping. Study catalogs or grocery advertisements for pictures of fruits and vegetables and see how different each drop can look.

Draw an Apple a Day

The drawing was done with Prismacolor and then sprayed heavily with gloss damar varnish when completed. It almost has the look of an oil painting because of the varnish.

Step 1: Apply the Base Colors

Lightly apply a layer of Carmine Red to the red apple. Apply a small amount of Tuscan Red and Yellow Chartreuse.

Apply Yellow Chartreuse and a small amount of Tuscan Red to the green apple.

COLORS USED

Apples: Carmine Red, Scarlet Red, Crimson Red, Yellow Chartreuse, Tuscan Red, Black and White.

Leaves: Olive Green, Grass Green, Apple Green, Tuscan Red, Black and White.

Background: Black

Step 2: Fill In the Color and Burnish

Apply heavier applications of the same colors to both apples. Use firmer pressure to begin the burnishing process.

Step 3: Add the Finishing Touches

With Carmine Red, firmly fill in the red apple everywhere but the highlight area on top. Use White to burnish over the highlight area. Create the stem with Tuscan Red and White.

Burnish over the green apple with Yellow Chartreuse. Use White to burnish the highlight areas. Spray the finished drawing to prevent the wax from blooming.

CONCLUSION

There is nothing more colorful and more beautiful
than drawing the world around you. It is where we
can see the past, the present and the future all at once.
Good luck to every one of you as you follow your
artistic desires. I hope I have been some help in guiding
you along your way!

Try a New Surface
The red apples were drawn on a board with a surface that
resembles the weave of linen cloth. I had to work very hard to
fill in all of the texture, but the work was worth it. Gloss var-
nish was applied to the finished piece. This drawing looks as if it
has been painted on canvas.

Red Apples
Prismacolor pencils on Lin-coat board
6" × 8" (15cm × 20cm)

INDEX

The best in drawing instruction comes from North Light Books!

These books and other fine North Light titles are available from your local art & craft retailer, book store, online supplier or by calling 1-800-448-0915 in North America or 0870 2200220 in the United Kingdom.

Walt Reed's classic, proven instruction has been refined and tested through years of use in the classroom. The principles and step-by-step techniques he stresses uniquely illuminate the art of drawing the human form. You'll also find detailed anatomy studies examining bone and muscle structure, plus special guidelines for drawing the head, hands and feet.

ISBN 0-89134-097-1, paperback, 144 pages, #7571-K

Bert Dodson's successful method of "teaching anyone who can hold a pencil" how to draw has made this tome one of the most popular, best-selling art books in history-an essential reference for every artist's library. Inside you'll find a complete system for developing drawing skills, including 48 practice exercises, reviews, and self-evaluations.

ISBN 0-89134-337-7, paperback, 224 pages, #30220-K

Clem Robins shows you how to render accurate human figures in the elegant style of the old masters. Distilling his lifetime of experience into a complete figure drawing course, Robins provides special step-by-step guidelines for drawing heads, hands, hair, and feet. You'll also learn how to draw from life, transforming what you see into realistic, classically rendered images.

ISBN 1-58180-204-8, paperback, 144 pages, #31984-K

Discover the limitless creative possibilities of colored pencils! Janie Gildow shows you how to mix colored pencils with watercolor, pastel, acrylic, ink and more. Gorgeous galleries, inspirational art and 24 step-by-step demonstrations showcase a stunning variety of creative combinations.

ISBN 1-58180-186-6, hardcover, 144 pages, #31956-K

A sketchbook journal allows you to indulge your imagination and exercise your artistic creativity. Let Claudia Nice provide you with invaluable advice and encouragement for keeping your own. She reviews types of journals along with basic techniques for using pencils, pens, brushes, inks and watercolors to capture your thoughts and impressions.

ISBN 1-58180-044-4, hardcover, 128 pages, #31912-K

Learn how to act upon your artistic inspirations and joyfully appreciate the creative process! This book shows you how to develop the skills you need to express yourself no matter what unusual approach your creations call for! Experiment with and explore your favorite medium through dozens of step-by-step mini demos. No matter what your level of skill, Celebrate Your Creative Self can help make your artistic dreams a reality!

ISBN 1-58180-102-5, hardcover, 144 pages, #31790-K